AMERICAN MINIATURES
1730-1850

Library of American Art

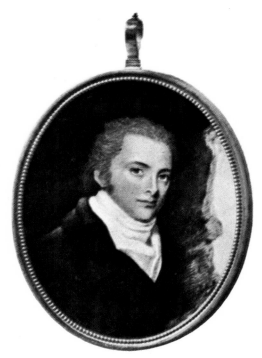

EDWARD GREENE MALBONE BY HIMSELF

AMERICAN MINIATURES

1730-1850

One Hundred and Seventy-three Portraits
Selected with a Descriptive Account

By Harry B. Wehle

&

A BIOGRAPHICAL DICTIONARY OF THE ARTISTS
BY THEODORE BOLTON

Kennedy Galleries, Inc. • *Da Capo Press*
New York • *1970*

This edition of *American Miniatures, 1730-1850,* is an unabridged
republication of the first edition published in Garden City, New York, in 1927. It is
reprinted by special arrangement with Doubleday & Company, Inc.

Library of Congress Catalog Card Number 71-87684
SBN 306-71708-5

Published by
Kennedy Galleries, Inc.
20 East 56th Street, New York, N.Y. 10022

and

Da Capo Press
A Division of Plenum Publishing Corporation
227 West 17th Street, New York, N.Y. 10011

Printed in Japan

AMERICAN MINIATURES

AMERICAN MINIATURES

1730—1850

ONE HUNDRED AND SEVENTY-THREE PORTRAITS
SELECTED
WITH A DESCRIPTIVE ACCOUNT

by

HARRY B. WEHLE
ASSISTANT CURATOR OF PAINTINGS,
THE METROPOLITAN MUSEUM OF ART

&

A BIOGRAPHICAL DICTIONARY
OF THE ARTISTS

by

THEODORE BOLTON

GARDEN CITY · NEW YORK
Published for The Metropolitan Museum of Art
by
DOUBLEDAY, PAGE & COMPANY
1927

FOREWORD

THE American public has registered of recent years a very widespread and vivid interest in the personalities and in the fine and applied arts of this country in earlier days. In response to such a growing appetite for the finer things of America's past, the authorities of the Metropolitan Museum of Art determined to hold this year an exhibition of early miniature portraits, feeling that this was one of the American arts which had thus far failed to receive its due share of attention.

The miniature portrait, because of its very size, presents peculiar difficulties of attribution and classification. The factor of pictorial composition plays little part in such works, while important considerations are the artists' personal chords of colour and the almost microscopic minutiæ of individual style. Neither of these qualities of the miniature lend themselves particularly well to recording by means of the photograph, which has proved such an important factor in the classification of other sorts of art objects. Thus the bringing together for the purposes of exhibition of a considerable number of the miniatures themselves gave such a valuable opportunity for direct comparison that it seemed well to improve the occasion. Hence this book, which contains certain new attributions but which I well realize is only a step in the exploration of this sufficiently appealing branchlet of art. The value of the book will depend largely upon the numerous illustrations both in colour and in black-and-white, which are in practically all cases the same sizes as the miniatures themselves.

Before me have gone William Dunlap, the "American Vasari," who was by no means a stupid man, and from whose pages I am not ashamed to draw copiously, and also Anne Hollingsworth Wharton, who writes with delightful style and, metaphorically speaking, knows the American social register of four and five generations ago as intimately as any living social aspirant knows the sacred contents of such actual volumes up to date.

To place at the reader's disposal many matters of fact concerning the lives of the miniature painters under consideration, the compilation of which would have daunted me and which would have badly clogged the flow of the General Introduction, Theo-

dore Bolton, who has written before this on the subject of American miniatures, was called upon to supply his Biographical Dictionary. I am also indebted to him for certain suggestions, as I am to Mr. Ruel P. Tolman, Mr. John Hill Morgan, and Mr. Arthur P. Howard. To the courtesy of Mr. Horace Wells Sellers I owe the knowledge of certain facts about the Peale family, and I have Miss Eleanor B. Saxe of the Metropolitan Museum of Art to thank for her great kindness in dating for me many miniatures by means of the sitters' costumes and styles of dressing the hair. The photographs and notes at the Frick Art Reference Library have been of value in helping toward tracing some of the miniatures. Naturally, also, I owe very special gratitude to the owners who have so courteously allowed me to study their precious miniatures and to use them as illustrations in this book. The owners' names are to be found in the List of Illustrations.

Perhaps I should add here some explanation of the chronological groupings into which I have divided my material. The division of early American objects into Colonial, Revolutionary, and Early Republican (or Early Constitutional) has become so customary as to seem almost obligatory, and I have no doubt that some students, if any should read this book, will consider as quite beside the point my chapter headings which are based old-fashionedly upon the Eighteenth and Nineteenth centuries. This simple old classification was reverted to quite deliberately, however, for it has seemed to me that, by a rare stroke of good luck for our fallible memories, the passage from the one century into the other coincides about as nicely as one could wish with a certain change in the spirit of American painting.

Art has, in fact, not to do with underlying philosophic or political causes but simply with their social consequences. These social consequences which, in the instance we are considering, no doubt sprang from the high cost of European wars, the writings of Rousseau, and a score of other causes well back in the Eighteenth Century, are sharply noticeable in America around the year 1800. The Declaration of Independence came in 1776, but it is the general enthusiasm over Thomas Jefferson's rumpled woollen stockings which times the actual percolation of the republican idea into the American mind. Applied to miniature portraits this idea surely never came with the Revolutionary War, or else the confusion, e.g., of Copley's miniatures, painted before 1774, with Dunkerley's and Benbridge's, painted twelve to fifteen years later, would never have occurred. No observer with the slightest experience would hesitate to recognize as an Eighteenth Century work the average miniature by Ramage, most of whose tiny portraits were painted around 1790, just. as he would recognize such works as Robert Field's miniature of James Earle (1802) and Jarvis's Portrait of a Man (a very

few years later) as having distinctly the Nineteenth Century flavour. The entire cultural revolution of the period, the transition from a polished aristocracy, of which Federalism was the last stand, to the ardent romantic naturalism of the Jeffersonians, may without frivolity be said to be symbolized by the change from the powdered wig to the (no doubt studied) informality of the natural hair cut shortish and brushed forward in the style called "*au coup de vent.*"

<div align="right">H. B. W.</div>

New York, 1927.

CONTENTS

LIST OF ILLUSTRATIONS

[The miniatures are painted in water colours on ivory except where otherwise stated.]

xi

AMERICAN MINIATURES
1730–1850
by
HARRY B. WEHLE

AMERICAN MINIATURES

I. THE APPEAL OF THE MINIATURE

Horace Walpole, who was a connoisseur of miniatures, as he was of most forms of art, wrote in praise of one of the greatest of miniaturists,[1] "If a glass could expand Cooper's pictures to the size of Van Dyck's, they would appear to have been painted for that proportion." The implications of this penetrating remark were patently developed and particularized some years later by the American miniaturist, Thomas Seir Cummings.[2] "Miniature painting," according to Cummings, "is governed by the same principles as any other branch of the art, and works in miniature should possess the same beauty of composition, correctness of drawing, breadth of light and shade, brilliancy, truth of colour, and firmness of touch as works executed on a larger scale. . . . It may be asked, what is the proper preparatory course of study for the miniature painter? We should unquestionably answer, the same as for any other branch of the art. It is in the mechanical part only that it differs."

The immediate success which certain great portrait painters have achieved when they occasionally turned to painting in miniature would seem to indicate that even the mechanical part of the miniature is no important deterrent to the painter who knows the general basis of his art. Holbein, as we shall see, was said by Van Mander to have "needed only to see some work in miniature to know how to do it himself," and brilliant occasional miniatures are known by such masters of the oil technique as Goya, Fragonard, and Sir Thomas Lawrence. In the miniatures of Goya and Lawrence we see a diminished reflection of their work in oil, the work of Fragonard recalls the style of his spirited wash drawings, while a close examination of Holbein's miniatures reveals again the thrilling rightness of his drawing and hatching in the crayon portraits. In America, miniatures by such artists as Inman and Sully can readily be rec-

[1]See Walpole's Anecdotes of Painting in England, 1762–1771, II, 145.

[2]See William Dunlap, History of the Arts of Design in the United States, 1834 edition, II, pp. 10–14.

ognized as the work of painters accustomed to working in oil, so broadly is the colour laid on. The single beautiful miniature by Gilbert Stuart is another case brilliantly in point.

Yet such works as these are the exception rather than the rule, and the remarks of Walpole and Cummings, like most illuminating observations, need some qualifying. The great miniaturists, especially since the coming of ivory as the substance upon which to work, have in general used a method of painting which contains common elements peculiar to this genre and quite unlike the procedure followed in oil painting. Something may be added to our understanding of the art of the miniaturist if we give a little consideration, first, to the peculiar methods of his craft, and second, to two attributes of miniatures which make for their popularity with collectors.

As compared with the liberties allowable in painting in oil, the ivory, where its qualities are properly exploited, makes rather exigent demands. It requires of the painter a surface texture without so much as a pinhead's area of flaw. In a head painted upon so tiny a scale the slightest injustice in the values, the minutest inconsistency in the handling mars the perfection, the least clotting of the background disturbs the vibration and purity of the effect. But once the painter has laid his washes on the ivory, any attempt of his to correct his surface in the quest for perfection becomes hazardous almost to impossibility. For even though he were to wait years (or centuries) for the water colours to set in the ivory surface, he would find at the end that one vigorous pass of a moist brush or rag would suffice to wash the pigments clean away.[1]

Naturally, therefore, in order to obtain reliable results, painters of miniatures with few exceptions have learned to build up their textures and to state their forms by the cautious means of stippling and hatching which becomes often so minute, painstaking, and dexterous as to remind us of the technical marvels of the great French engravers. Cummings describes as follows two of the technical methods of miniature painting, i.e., hatch and stipple:[2] "In the first named the colour is laid on in lines crossing each other in various directions, leaving spaces equal to the width of the line between each, and finally producing an evenly-lined surface. The second is similarly commenced,

[1]For an account of the technique of miniature painting, see George C. Williamson and Percy Buckman, The Art of the Miniature Painter, 1926.

[2]See Dunlap's History, etc., 1834 edition, II, p. 12.

2

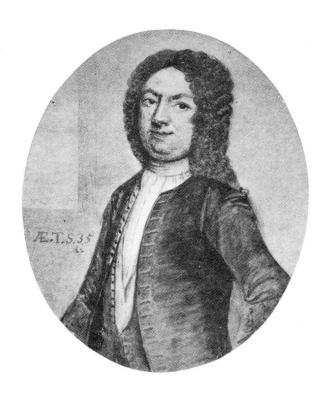

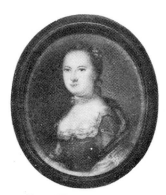

JOHN WATSON BY HIMSELF
REBECCA CLAYPOOLE PRATT—ARTIST UNKNOWN

PLATE I

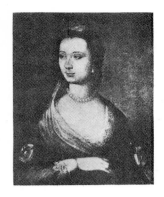

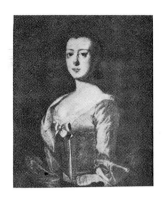

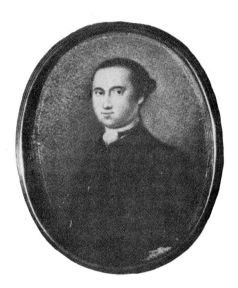

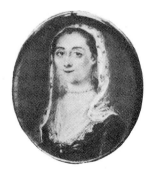

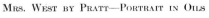

MRS. WEST BY PRATT—PORTRAIT IN OILS ELIZABETH ROTHMALER BY THEÜS—PORTRAIT IN OILS

BENJAMIN WEST BY HIMSELF

MRS. THOMAS HOPKINSON BY PRATT MRS. JACOB MOTTE BY JEREMIAH THEÜS

PLATE II

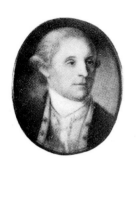
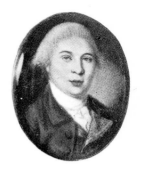
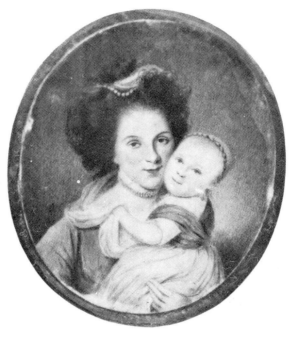
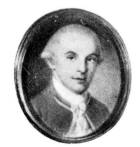
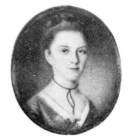
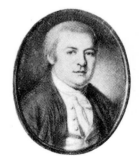

Washington—1777—by C. W. Peale Andrew Summers by C. W. Peale

Rachael Brewer Peale and Daughter Eleanor by C. W. Peale

Rochambeau by C. W. Peale Mrs. Michael Taney by C. W. Peale William Bingham by C. W. Peale

PLATE III

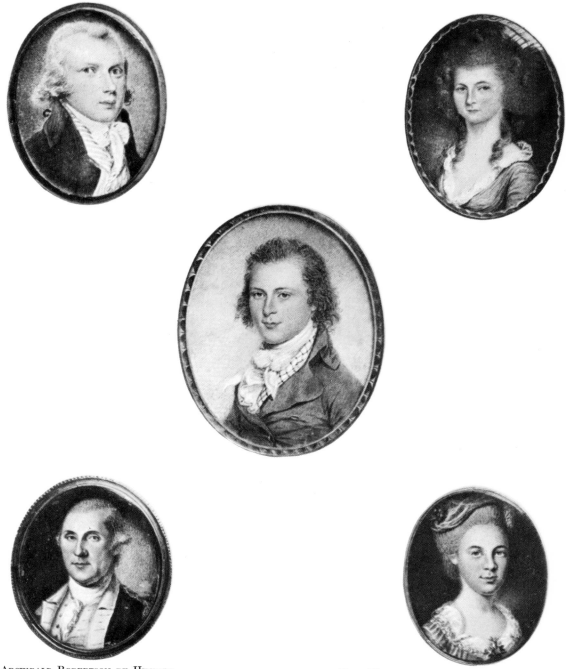

Archibald Robertson by Himself

Mrs. William E. Hulings by James Peale

Rembrandt Peale by James Peale

George Washington by C. W. Peale

Hannah Summers by C. W. Peale

PLATE IV

[The above reproductions are larger than the originals as 11:10]

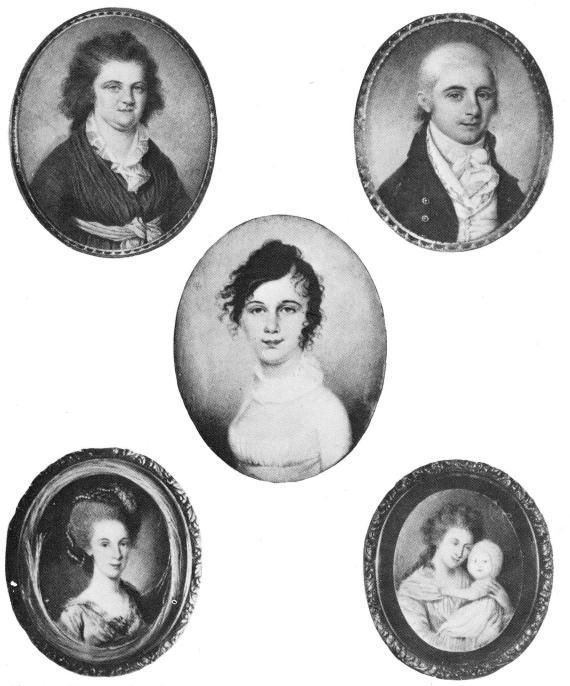

MRS. JOHN WILSON BY JAMES PEALE PAUL BECK BY JAMES PEALE

ANNA CLAYPOOLE PEALE BY JAMES PEALE

MARIA C. PEALE BY JAMES PEALE MARIA C. PEALE AND DAUGHTER BY JAMES PEALE

PLATE V

and when advanced to the state we have described, is finished by dots placed in the interstices of the lines until the whole has the appearance of having been stippled from the commencement." Such elaborate stippling as that described may actually be observed with the aid of a magnifying glass in the backgrounds of miniatures by Cummings and others, though many miniaturists stippled merely by means of dots, whether round or squarish, made with the point of the brush.[1]

The results obtained by successfully employing processes so exacting and refined as these naturally invite the closest examination. To see properly an object so small and so finely contrived as a miniature portrait requires of us a distinct effort of the attention, an actual temporary arrest of the breathing. But, unless we are feeling jaded or distracted, we willingly undertake the effort, and the overcoming of this slight resistance is a process pleasant enough in itself, provided we find the game is worth the candle. The area is tiny, but for that very reason it must give us abundant return if we are to feel satisfied. The forms must posses clarity; the textures must be pure and perfect, i.e., the miniature must offer much value in little space. It must possess the quality called "preciousness."

Such preciousness, such elaborate and perfect manipulation within a small area of materials pleasing in themselves—the intrinsic loveliness of the glowing ivory surface seen through a fine texture of colour, delicate and unsullied by time—furnishes us, at its best, a species of delight peculiar to painting "in little." It is a delight in its modest way not unlike the breathing of mountain air, a quality of sensation associated in our minds with clarity and transparency which, until the developed exploitation of the miniature on ivory, had not been supplied by paintings since the decay, early in the Sixteenth Century, of the great tradition of the Van Eycks.

Closely connected with the pleasure which the collector takes in the preciousness of his miniatures is his delight in a second quality which painting "in little" possesses. And this quality we may call the "marvellousness" of the miniature, an attribute which is inherent in its very littleness. Enthusiasm for such marvellousness as this is, perhaps, not a purely æsthetic emotion, but is, nevertheless, based upon a more or less

[1] The attempt is to convey here some understanding of the technique of the miniaturist during the period covered by the present volume. Many miniature painters of the present day intend their works to be seen at a distance of several feet as against the earlier six to eighteen inches, and modern methods often resemble those employed in painting with aquarelle on paper.

sound appreciation of craftsmanship. It depends upon sympathy and hence upon experience (whether direct or vicarious) with the technical difficulties involved in the creation of such a diminutive work of art, and perhaps for that reason we hear more about such enthusiasm in earlier times when people lived on more intimate terms than now with the processes of the craftsman. For the satisfaction of such an eminently human taste as this must have been carved such astonishing objects as the Flemish rosary beads of boxwood illustrating scenes from the Passion,[1] which have their admirers to-day also, for most of us have whittled at wood. Yet the Crucifixion in this series with its twenty-odd figures struggling through their drama within the space of an inch and a half's diameter would doubtless seem vulgar enough if magnified twenty times. In the same way, petty tinklings to which no sensible person would ordinarily give ear, provide us a childlike delight when they issue from a musical watch fob, and we are all familiar with the classic story of the Shield of Achilles, the marvels of which were sung by Homer, to the delight of all listeners, for the better part of half an hour. On the shield's metallic surface, the god Hephæstus fashioned with cunning skill the heavens with their constellations, and the earth with its cities beleaguered and torn with strife, or rejoicing in peaceful festivities. And around about the cities he showed the fertile farm lands and vineyards with labourers at their work and youths and maidens shouting and dancing.

Thus, surely man delights in the marvellousness of little things cunningly and ingeniously wrought and, this being so, surely the miniature portrait at its best and most precious might well be expected to give pleasure to many—as indeed it does.

[1]Examples are to be found in the Morgan Wing at the Metropolitan Museum of Art.

II. THE ORIGIN OF MINIATURES

Miniatures, in the sense of small portraits complete in themselves, are in spirit very different from the book miniatures which flourished in the East as well as the West practically throughout the Middle Ages. The miniatures in books were intended to illuminate the text and to decorate the page, and their smallness was conditioned only by the size of the page itself. Here portraits occur only occasionally, and when they do they usually represent with marvellous skill and honesty the great personage himself for whom the book was made. The intention in such cases was evidently not to commemorate the personage portrayed so much as to do him homage or to celebrate some event, whether secular or devotional, with which the courtly illuminator wished to connect him.

The detached portrait miniature, with which this book has to do, is painted for a different purpose. It is designed simply as a memento, its purpose being essentially that of an intimate personal document, not to be kept by the subject of the likeness, but intended to serve the owner as an aid in visualizing the admired or beloved person portrayed. In its emotional appeal to the original owner it partakes thus a little both of the companion and the talisman. The Eighteenth Century practice of setting a lock of the sitter's hair in the back of the frame served to reinforce the association, and in some cases a conventional mourning motif or a word of farewell cut from a letter written by the sitter was introduced to add pathos. During its heyday, the miniature was always small, for it was designed to be carried on the person or set into some such personal article as a snuffbox or a memorandum case, or at the very least to be kept in one's own desk, probably secreted in the smallest and most private of its drawers.

That this form of art, celebrating the individual as it does, should have arisen with the Renaissance was no mere accident. It was but one minor expression of the fresh interest in human personality which everyone in those days of eager curiosity began to feel. And it is also surely not without significance that we, if we wish to go back of the Renaissance in search of the closest spiritual analogue to our miniature portraits, must

join the Renaissance scholar in rummaging among the artistic treasures of the Classical world. It is in the portrait gems once set into the finger rings of Greeks and Romans that we shall discover the identical species of human appeal: a delight in the faithful delineation of the human countenance on a scale small enough to wear on the person as a memento.

At the Boston Museum of Fine Arts is a rare and beautiful gem portrait of this sort dating as early as the Fifth Century B. C. In Hellenistic times, and especially during the Augustan age, portraits engraved on gems became more and more common. Augustus himself wore a portrait of his hero Alexander the Great. The followers of Epicurus wore his portrait on their signets, and cultured Romans wore beautiful heads of Homer, Socrates, and Demosthenes. The decadent Commodus wore in his ring a portrait of his mistress Marcia as an Amazon, while Tom, Dick, and Harry, or their Roman equivalents, wore portraits of friends, relatives, or sweethearts.[1]

During the thousand years which follow the fall of Rome the private portrait on a tiny scale practically ceases to appear. The intellectual world is preoccupied with allegories and abstractions, the individual is presumably lost in the hive. Subjects for the artist usually concerned episodes from the Christian legend, or, when occasionally some gay and dainty object was decorated with a secular theme, it illustrated nothing more personal than the occupations of the months or the homiletic tale of Virgil in his basket, or Campaspe and Aristotle, or the Siege of the Castle of Love.

It is not until the resurrection of Classical ideas in Renaissance Italy that the small private portrait recurs. At first it is not in the medium of paint but in bronze that it appears. When Pisanello, inspired probably by Roman models, began in the forties of the Fifteenth Century to make his unsurpassed portrait medals, it was before the invention of engraving, and medals were the only way of making speedily a number of replicas of a portrait which could be sent about as presents. Medals answered a human need and the vogue for them quickly spread.[2]

Some fifty years after the great time of Pisanello the city of Lyons celebrated the state entry of Anne of Brittany by presenting her with one hundred copies of a medal by native artists portraying herself and Charles VIII, while in Germany, especially

[1]See Gisela M. A. Richter, Catalogue of Engraved Gems, Metropolitan Museum, 1920, pp. XXII, 90.
[2]See G. F. Hill, Medals of the Renaissance, Oxford, 1920.

during the second quarter of the Sixteenth Century, numerous small circular portraits of delightful precision and unflinching characterization were cast in bronze or carved in boxwood or lithographic stone. These reveal scarcely a trace of Italian influence. They are a peculiarly Germanic expression of the Renaissance spirit.

In England no native medallist of note appeared, and it was in England, perhaps not by a mere coincidence, that the art arose of making portrait medallions by painting them on vellum or on cardboard. The exact year when the first portrait miniature was thus "limned"[1] we do not know, but it would almost appear that it was the wave of Henry VIII's royal sceptre which commanded its appearance. During the first generation of its existence the miniature was invariably the size of a small medal and circular in form,[2] the figure being designed with medallion-like style and clarity against a background of clear ultramarine blue.

All the English miniatures of that generation and well past the middle of the century used to be attributed to Hans Holbein, for the fact that he died as early as 1543 came to light only in comparatively recent years. At the other end of his activity as a miniaturist, it appears unlikely that he painted "in little" before his second sojourn in England, commencing in 1532; and the authorities on his art now recognize a scant dozen little portraits as by him. One portrait of Henry VIII painted in 1535 or earlier, before he had his head "polled," is close to Holbein's style but scarcely up to the Holbein standard, and 1536 is the first year that we have evidence of Holbein's being in Henry's service.

But the much-married king was a great patron of the arts, and Holbein was not the only artist he imported. Among those on his payroll at this time were two talented children of the Flemish illuminator and tapestry designer, Gerard Horenbout (also spelled Hornebout, Hornebolt, etc.). One was his daughter Susanna, who had painted at the age of eighteen a miniature picture of Christ as Saviour which Albrecht Dürer in 1521 marvelled at and bought direct from the youthful artist. The other was his son

[1]At least as late as the middle of the Seventeenth Century, the verb *to limn* was used strictly to indicate painting in miniature. Pepys at this time speaks of *paintings in little*, but Horace Walpole, less than a century later, invariably uses the word *miniature*. *Limn* is derived from *illumine*, while minium, the red lead commonly used in early manuscript initials, gave its name to miniatures.

[2]Holbein's portrait of Thomas Wriothesley in the collection of the Metropolitan Museum of Art is oval but gives clear evidence of having been cut down by some vandal.

Lucas. Both had been trained in the great Flemish tradition of manuscript illumination. The services of such artist families as the Horenbouts and Benings[1] knew no national boundary lines, and it may well be that Lucas Horenbout, before he was called to England, saw a certain book belonging to Francis I of France which would furnish the prototype of the miniature portrait of the court of Henry VIII. This manuscript book of Commentaries on the Gallic War was made in 1519 and contained among many things seven circular medallion-like portraits about one and one-half inches in diameter with blue backgrounds. Drawings for these portraits of the seven Preux de Marignan who had championed Francis's cause in battle have been identified through drawings at Chantilly as by "the presumed Jean Clouet."[2]

Whether or not Lucas Horenbout actually saw these miniatures of Jean Clouet we shall probably never know definitely, nor shall we know whether it was he to whom the simple but important idea first came of cutting such a portrait out of its book, or of being so revolutionary even as deliberately to paint a small portrait upon a small circle of parchment or cardboard having no connection with any book whatsoever.

Lucas Horenbout was naturalized in England in 1534, and the royal accounts mention payments to him (of a salary higher than was ever paid to Holbein) until 1544, in which year he died. Not long after Lucas Horenbout came to England, Holbein appears to have become acquainted with him (if Van Mander's statement made in 1604 is correct) and to have learned from him the technique of painting in water colours on vellum. "With Lucas," writes Van Mander "he kept up mutual acquaintance and intercourse, and learned from him the art of miniature painting, which since then he pursued to such an extent that in a short time he as far excelled Luke in drawing, arrangement, understanding, and execution as the sun surpasses the moon in brightness." Nicholas Hilliard, the great miniature painter of Queen Elizabeth's time, writes about the year 1600 in his *Treatise Concerning the Art of Limning*: "Yet had the King in wages for limning divers others, but Holbean's manner I have ever imitated and howld it for the best."

Thus we find in Henry VIII's England the art of the detached miniature portrait

[1]Alexander Bening (also spelled Binnink, etc.) was one of the greatest illuminators, and is given credit for many marvellous works including most of the pages in the Grimani Breviary. His daughter Lievine was employed in England after 1545 by Henry VIII, Mary, and Elizabeth.

[2]See L. Dimier, French Painting in the XVI Century, 1904, p. 31.

well established. In France we have already noted the little circular portraits painted supposedly by Jean Clouet some years earlier than the English examples but not yet liberated from the setting of the book. In the reign of Henri II, however, we find the portrait miniature flourishing in the delicate art of the school of Jean's son François Clouet.

Concerning the miniature in Italy, we have a statement made by Vasari in the middle of the Sixteenth Century which seems to indicate that Giulio Clovio had begun to paint miniatures in the newer sense of the word in addition to the famous portraits which he painted in books. "I know," he writes, "some private persons who have little cases containing beautiful portraits by his hand, of sovereigns, of their friends, or of ladies whom they have loved."

III. THE USE OF IVORY

THE development of the art of the miniature, once it was established, is not for us to trace here. There is, however, one pivotal event in miniature history which may be touched upon appropriately, and that is the introduction of ivory as the material upon which to paint.

As we have remarked, miniatures by Holbein, and by his contemporaries who followed the same practice, are painted either directly upon pieces of cardboard cut out of playing cards or on fine vellum pasted over such cardboard. The background is painted with ultramarine blue made from lapis lazuli and diluted with white. The portrait itself is painted as a rule in gouache, i.e., opaque or body colour, with transparent flesh, though Professor Ganz[1] describes Holbein's miniature of Anne of Cleves painted in 1539 as being in "finest aquarelle technique" (i. e., transparent) on paper in an ivory box with a rose carved on the top.

For two full centuries following the time of Holbein the characteristic technique of painting miniatures remained virtually unchanged. Parchment, sometimes paper, is the material and gouache is the medium, with aquarelle for the flesh. Miniatures painted in oil on copper, silver, slate, or wood are not uncommon, especially in the Seventeenth Century, but as a general thing they seem heavy and dark when compared with miniatures in water colour, and are generally felt to be out of the happy spirit of miniature painting.

In the early Eighteenth Century, miniatures painted in enamel became the rage, and it was then also, or a little before, that painting on ivory began to be tried. Bernard Lens, who lived until 1755, often painted on ivory, using transparent flesh tints, but his draperies and backgrounds were painted opaque, in the old manner which, among French miniaturists, was continued until the end of the Eighteenth Century.

The first painter to understand fully and to exploit the qualities of ivory for miniatures was, according to most experts, the Englishman, Richard Cosway. Early in

[1]Klassiker der Kunst, Holbein, 1911.

10

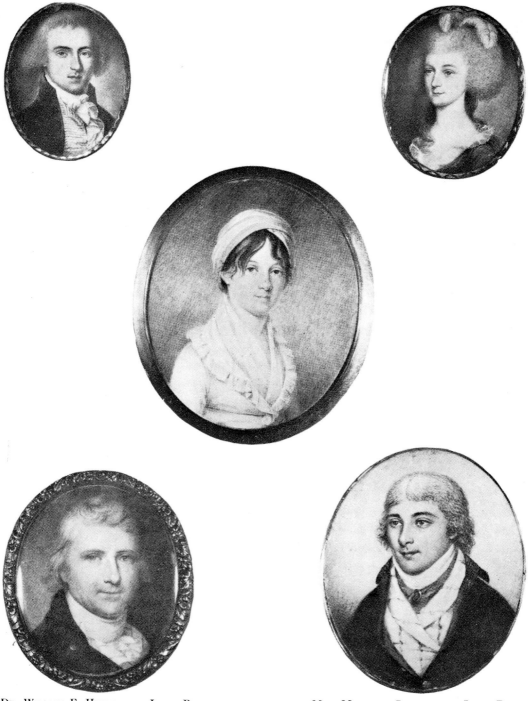

Dr. William E. Hulings by James Peale Mrs. Mordecai Sheftall by James Peale

Mrs. Josiah Pinckney by James Peale

James Peale by Himself A. A. P. B. de Pont by James Peale

. PLATE VI

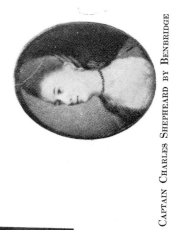

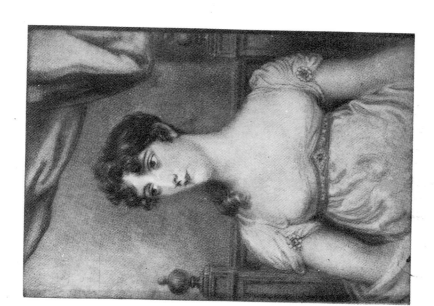

Elizabeth Ann Timothy by Benbridge

Mrs. Christofher Gadsden by Benbridge

Harriet Livingston Fulton by Robert Fulton

Captain Charles Shepheard by Benbridge

Mrs. William Somersall by Benbridge

PLATE VII

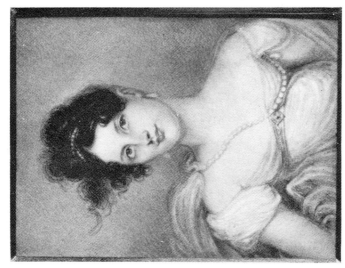

FANCY PORTRAIT BY ROBERT FULTON

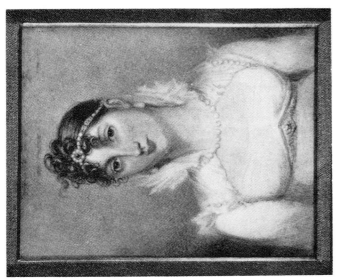

...PHEN VAN RENSSELAER III BY FULTON

PLATE VIII

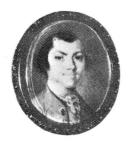

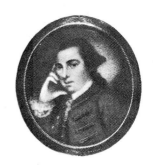

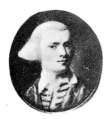

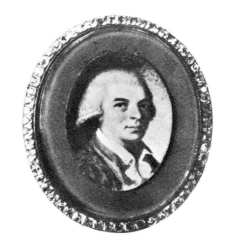

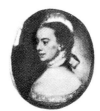

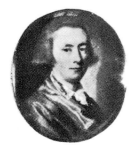

W. S. MILLER ATTRIBUTED TO COPLEY
COPLEY BY HIMSELF

EDWARD SAVAGE BY HIMSELF

JOSEPH BARRELL BY COPLEY
DEBORAH SCOLLAY MELVILLE
BY COPLEY

SAMUEL CARY BY COPLEY

MRS. SAMUEL CARY BY COPLEY

PLATE IX

his career he was employed by jewellers to paint fancy miniatures for snuffboxes. As early as 1761 he was exhibiting miniatures at the Free Society, and he soon became the most popular miniaturist in England. Perhaps it was his training in painting miniatures to be used as adjuncts to gold and jewelled boxes that called his attention to a certain airy translucency and silveriness which could be obtained by letting the smooth surface of the ivory glow through the thinnest possible covering of transparent colour. The soft colour of the unbleached and undisguised ivory could serve as high lights on the flesh and was allowed to give a lightness to clouds behind or a sheen to satin draperies. The lesson of using ivory and of permitting it to speak for itself was quickly learned by the other miniaturists of England, and since it is not until about this time that the history of miniature painting begins in America, it is with miniatures on ivory almost invariably that we shall have to deal in our study of this intimate art "in little" as found in the newer country.

IV. THE EARLIEST AMERICAN WORKS

COLONISTS PORTRAYED IN ENGLAND—JOHN WATSON—THEUS

AMERICAN MINIATURES" as the title of such a book as this should require no apologies or explanation. It includes, as a matter of course, miniatures painted in America by anyone, native or foreign born, whose work was worth remembering and who remained on the scene long enough to contribute something to the æsthetic culture of America. As Walpole pointed out, to write a history of English painting without dwelling on the art of Holbein and Zucchero, VanDyck, Cornelis Janssens, Lely, and Kneller would be utterly meaningless. Less emphatically, a history of American miniature painting without consideration of the talented European artists who worked here, would give only a partial picture of the subject, although it can be stated, without the danger of falling into chauvinism, that most good American miniatures were painted by native-born Americans.

In the history of oil painting in America we find the work of foreign artists confined principally to two periods: first, the early time before the middle of the Eighteenth Century when the Colonies were still too raw to have produced artists of their own; and, second, the period of the 1790's and a little later, when the new Republic was exhibiting tempting signs of wealth and stability, just at a time when many an artist was glad enough to get out of France alive, and England was profoundly upset by the Napoleonic adventure.

In the field of the miniature we know less of such foreign invasion during the earlier period. The history of painting in oils begins in America with the middle of the Seventeenth Century, but few, if any, works in miniature of this early date are known, perhaps because there were none painted, perhaps because they have been lost or destroyed, or perhaps merely because, being small, miniatures are able to hide themselves out of sight in museum cases. The comparatively moderate money value of miniatures, moreover, makes them more apt than larger portraits to remain in the private families where they properly belong. Such Seventeenth Century portraits "in little" as we know

12

showing American personages were painted by Englishmen in England, if one may judge anything of the style of miniatures from illustrations in photogravure.[1] Thus, the miniature of John Winthrop, from which the portraits of him in oils derive, appears to be in the style of Nicholas Hilliard, while that of Isaac Mazyck must have been painted before he left England in 1668, its urbane style apparently resembling that of Laurence Crosse. The miniature of George Calvert, first Lord Baltimore, which is in the Morgan Collection, is signed by Peter Oliver.

The earliest miniature portraits actually painted in America may well have been the little drawings by John Watson. Watson was a Scotsman, who came to East Jersey in 1715 and settled in the then very promising town of Perth Amboy. Here, according to Dunlap, he remained for the rest of his many days and continued a bachelor, amassing considerable wealth by his art and by the shrewd handling of his moneys. The only works by him of which we are sure are little portraits on vellum or paper made either with a brush dipped in India ink (see Plate I) or else with "plumbago," i. e., with a graphite pencil, after the manner of Forster and Johann Faber in England. The portrait of Sir William Keith, the provincial governor of Pennsylvania, now owned by the Historical Society of Pennsylvania, is in India ink, while his Lady's is nicely drawn in pencil.[2]

A delightful early miniature, perhaps the earliest American example known which is on ivory, is the portrait of Mrs. Jacob Motte of Charleston, S. C. Originally set as a bracelet (Plate II), it is a quaint little work, neatly executed, gay in colour and in the rendition of the blue silk dress, and marvellous in the small-scale rendition of lace. The supposed sitter, Elizabeth Martin, married Jacob Motte in 1725, and the costume shown in the miniature indicates an indefinite date between 1740 and 1760. As to the age of the sitter at the time the miniature was painted, it would be risky to dogmatize. Possibly the family tradition has slipped a generation, as it so often does, and we have here a youthful portrait of the wife of Jacob Motte, Jr. This gentleman, who was born in 1729, had his portrait painted in 1750 by Jeremiah Theüs, and the style of Mrs. Motte's miniature immediately suggests that it also was painted by Theüs.

[1] See C. K. Bolton, Portraits of the Founders, 3 vols., Boston, 1919 and 1926.

[2] A confused inscription behind the frame of Lady Keith's portrait seems to indicate that it is merely a copy made in 1856.

Most of our information about this artist was brought out in an article by the Reverend Robert Wilson some years ago.[1] We do not know in what year Theüs emigrated from Switzerland to South Carolina, but in 1740 he advertised himself as having removed his establishment into Market Square near Mr. John Laurens, the saddler, where he was prepared to paint portraits, landscapes of all sizes, and crests or coats of arms for coaches and chaises. Until 1773, the year before his death, he had practically a monopoly of the portrait painting of Charleston.

"It is not known," writes Mr. Wilson, "whether Theüs ever painted miniatures, and one of his 'landskips,' still existing, does not evince any special ability, but his portraits came to be in great vogue." An entirely characteristic portrait in oils by him is that dated 1757, of Elizabeth Rothmaler, afterward Mrs. Paul Trapier (Plate II). Its colour is, perhaps, its greatest charm, but there is much that is attractive too in the alert figure with its sharply modelled head. The length from eyes to chin, which we may observe also in his miniature, is exaggerated, the mouth is a full Cupid's bow, and the nose gives a curious impression of cartilages tightly confined by the skin. The recipe for painting the silken dress is an excellent one. In both portraits, the little and the big, we note again the minute attention to lace, the scarf thrown over the farther shoulder, the puckers in the silk beneath the arm, and the use of the forked fold in the sleeve. More than seventy oil portraits by Jeremiah Theüs have already been discovered in Charleston, and doubtless a number of his miniatures would turn up if a search were to be made.

[1]See Year Book, City of Charleston, S. C., 1899, pp. 137–147.

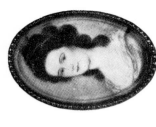

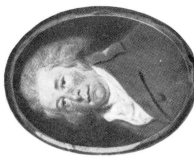

Mary Burroughs by Dunkerley

William W. Stevens by Henry Pelham

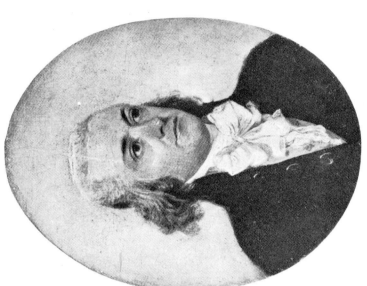

William Loughton Smith by Trumbull

PLATE X

Nathanael Greene (?) by C. W. Peale

A Man by Dunkerley

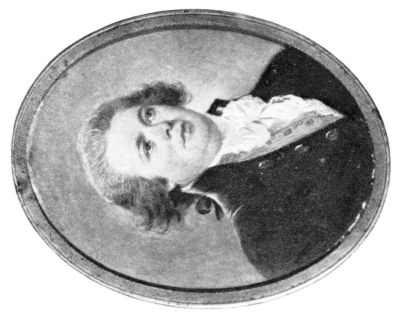

John Laurance by Trumbull

PLATE XI

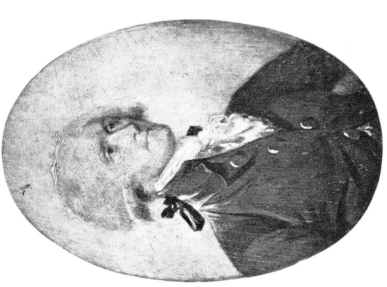

Thomas Jefferson by Trumbull

V. THE EIGHTEENTH CENTURY IN PHILADELPHIA AND FARTHER SOUTH

HESSELIUS—PRATT—WEST—C.W.PEALE—JAMES PEALE— FULTON—BENBRIDGE

THE middle of the Eighteenth Century found Philadelphia the metropolis of the American Colonies and a centre of culture which only Boston could rival. We might naturally expect to find members of the leading families in such a community desirous of having their likenesses taken in miniature to serve as mementoes or keepsakes, and a number of miniatures are indeed known to us which were painted in or about Philadelphia at this time.

Several of these delightful heirlooms, fresh and dainty in colour, very small in scale, and executed with a minute stipple, appear to be by a single hand. A delightful example of such work is to be seen in the portrait of Mrs. Hopkinson, the wife of Judge Thomas Hopkinson[1] and mother of Francis Hopkinson (Plate II). In her enjoyable, lavender-scented *Heirlooms in Miniatures*, Anne Hollingsworth Wharton discusses interestingly and at some length the possible authorship of such early Philadelphia miniatures as this of Mrs. Hopkinson and one of Mary McCall Plumsted, also the somewhat earlier portrait of Mrs. Henry Pratt, born Rebecca Claypoole (Plate I).

The possible attributions offered to us for these early works are, in fact, not a few if we consider the different painters then working in and about Philadelphia; and while it is somewhat hazardous to draw parallels between miniature portraits and larger works in oil, one is tempted to speculate upon any light which such a comparison might throw upon the authorship of these sprightly early works. First, then, there were John Wollaston and John Hesselius, both of whom are known to have worked along the Eastern Shore of Maryland, Hesselius being active, at the least, from 1750 to 1770, while Wollaston was painting in Maryland and in Philadelphia, Richmond, and Charleston from about 1755 to 1767. The "almond-eyed" mannerism of these two artists makes entirely possible the painting by one or the other of them of Mary Plumsted's

[1]The companion miniature of Judge Hopkinson is in less perfect condition.

15

miniature, but it quite precludes either from having painted the little portrait of Mrs. Thomas Hopkinson or that of Rebecca Pratt. As to who may have been the author of this lovely little miniature of Rebecca Pratt we have as yet no clue whatever. It appears to have been painted between 1750 and 1760 at the latest (Mrs. Pratt was born in 1711), and is executed in the opaque French manner.

There still remains for us, then, the agreeable task of speculating upon who could have been the painter of the delicate and appealing little portrait of Mrs. Thomas Hopkinson. Their "almond-eyed" mannerism having eliminated Hesselius and Wollaston as possibilities, there remain to us four Philadelphia artists whose claims should be considered. First, we may mention James Claypoole, if only promptly to discard the thought of him, for the moment at least, because we do not definitely know any paintings by him, and are therefore in complete darkness as to what his style may have been like. Second, there is Benjamin West to consider. But West left America forever at the age of not quite twenty-two, and our miniature of Mrs. Hopkinson betrays nothing of the pronouncedly brown flesh-colour and primitive modelling which we find in his miniature self-portrait painted at the age of eighteen (Plate II), and, moreover, nothing of the gaucherie which we find in his characteristic early portraits of Mr. and Mrs. William Henry, now owned by the Historical Society of Pennsylvania. A third painter who claims our consideration is Charles Willson Peale, whose home was in Maryland but who travelled about extensively painting portraits in oil and also in miniature. But in Peale's case again we are unable to judge with immediate satisfaction whether or not we have found the painter of the miniature in question. For, although we know plenty of Peale's work after he returned in 1769 from his studies in London, we have few clues to his style two years earlier when he had not yet had the advantage of devoted study under competent instructors. Our fourth and final claimant remains as a convenient climax. He is Matthew Pratt the pupil of James Claypoole, best known to us for his picture at the Metropolitan Museum of Art entitled the American School. This qua.nt picture is a group portrait of several young artists at work in West's London studio. Other well-known works by Pratt are his greenish and somehow classic portraits of Benjamin West and his wife Elizabeth, both now owned by the Pennsylvania Academy. If we were to examine in detail and side by side our little miniature of Mrs. Hopkinson and this portrait by Pratt of Elizabeth West (Plate II), we should

find illustrated in both the pleasing characteristic practice of draping a scarf over the head and across the shoulder. In both, also, we should find the identical small crescent mouth and the same simple clarity in the drawing of eyes coupled with a somewhat puffy fulness of the lower lid, distinctive traits which can be found repeated yet again in the less familiar portrait of Elizabeth Colden de Lancey painted by Matthew Pratt and illustrated in the catalogue of the 1917 Exhibition of Early American Paintings at the Brooklyn Museum.

We owe what information we have concerning Pratt largely to the invaluable though not infallible Dunlap. Matthew Pratt was born in Philadelphia in 1734, the son of the goldsmith Henry Pratt, who was a member of Dr. Franklin's famous Junto. At the age of fifteen he was bound out as an apprentice to his uncle James Claypoole, from whom he learned "all the different branches of the painting business," which surely included portrait and sign painting and which we may well suppose included painting in miniature also. Many have testified that the signs which he painted from time to time during his career were extraordinarily good ones. Neagle assures us, "They were the best signs I ever saw," especially the one with a gamecock which designated a beer shop on Spruce Street, one with Neptune, and one which showed the Constitutional Convention, including many diminutive portraits said to have been good likenesses of the delegates.

Pratt was twenty-five years old before he settled down to the profession of portrait painting. In 1764, aged thirty, he went to England, where he divided four years between the London studio of his friend Benjamin West and Bristol, where he followed his profession with fair success. Returning at last to Philadelphia, he reëstablished himself as a portrait and sign painter. He visited New York at times, notably in 1772, when he executed the full-length portrait of Cadwallader Colden for the Chamber of Commerce. He also painted the portrait of Elizabeth Colden de Lancey, already mentioned, and another of Cadwallader Colden with his grandson Warren de Lancey at his knee. At the National Museum, Washington, is a portrait in oils of Mrs. Hopkinson, resting Leonardesque hands in her lap, which is apparently by Pratt and seems to bear some relationship to our miniature of the same lady. But though Matthew Pratt continued to live in Philadelphia until the age of seventy, we know surprisingly few of his works.

With Charles Willson Peale it was quite another matter. Portraiture was his field so long as he continued painting, and the number of his works, as well as the variety of his style during his most enthusiastic years, is remarkable. Born in 1741, Peale was three years younger than Benjamin West. His father, who died when Charles was a boy, had conducted a school where the youngster probably received his first lessons in the art by which he later became famous. A printed announcement of the school told the good parents of Chestertown and the surrounding Maryland countryside that "Young Gentlemen may be instructed in Fencing and Drawing by very good Masters." But young Peale's school days had to be terminated early, and he was apprenticed to a saddler. Upon his release at the age of twenty, his predilection for drawing came again to the surface, and, though he had now set up as a saddler and married him a wife, he began painting portraits, first of himself and then of his young wife and his brothers and sisters. On the strength of these no doubt crude attempts, he soon obtained a commission for two portraits at five pounds each. He sought instruction from a painter in Philadelphia, named Steel, but Mr. Steel was far too eccentric to be of use. Later John Hesselius allowed the young enthusiast to watch him execute two portraits and then gave him a portrait with the left half painted and told him to paint the right. Peale paid for this valuable lesson with a saddle of his own making.

In 1765, when Peale was twenty-four, his services, in some mysterious way, were required in far-off Newburyport, where he painted five portraits. On his way back, he stopped in Boston and was awed by the old portraits and copies in the Smibert shop. Copley received him civilly and lent him for study a painting he had made by candlelight—doubtless the delightful portrait of young Henry Pelham, recently lent to the Boston Museum. It was at this time, according to his journals, that Peale painted his first miniature, a portrait of himself.

Before returning to Annapolis, Peale painted several portraits in Virginia under the patronage of a wealthy planter, but what the quality of his work may have been we do not really know. Some of his father's influential friends sent him to London to pursue his studies in West's studio, and within a year the Free Society of Artists had accepted from him for exhibition two three-quarter-size portraits and three miniatures. It appears to have been chiefly by painting miniatures that he supported himself in

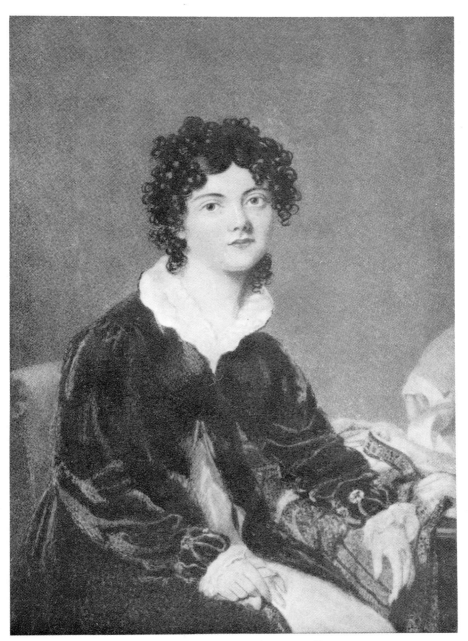

Eliza Abramse Robertson by Archibald Robertson

PLATE XII

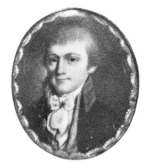

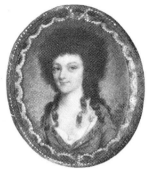

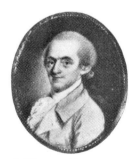

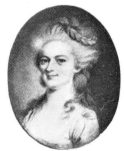

A Man by Ramage Mrs. Gulian Ludlow by Ramage

Elbridge Gerry by Ramage Henry Browse Treat by Elouis Mrs. Elbridge Gerry by Ramage

PLATE XIII

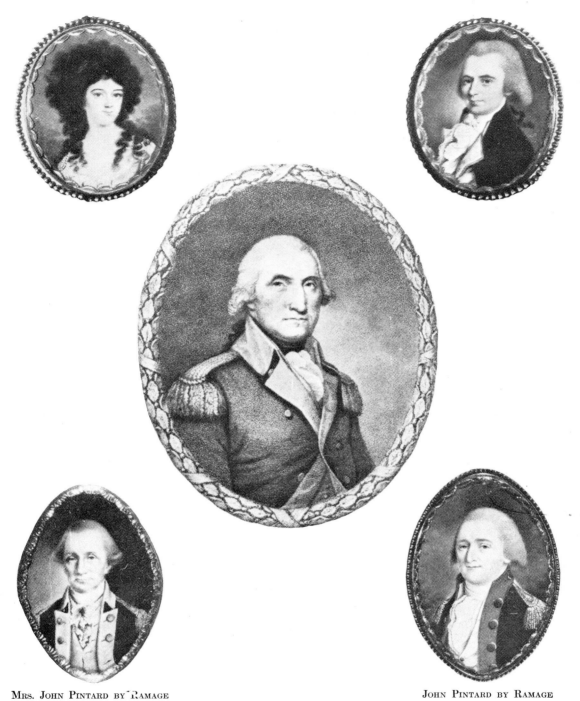

MRS. JOHN PINTARD BY RAMAGE JOHN PINTARD BY RAMAGE

WASHINGTON BY WALTER ROBERTSON—FROM FIELD'S ENGRAVING

WASHINGTON BY RAMAGE AN OFFICER BY RAMAGE

PLATE XIV

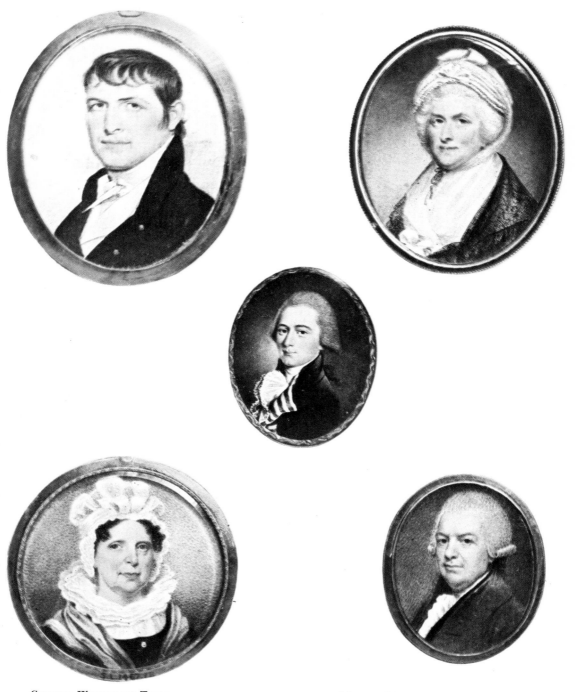

CHARLES WILKINS BY TROTT MARTHA WASHINGTON BY WALTER ROBERTSON

ANTONY RUTGERS BY RAMAGE

MRS. THEODORE GOURDIN BY FRASER STEPHEN HOOPER BY HENRY PELHAM

PLATE XV

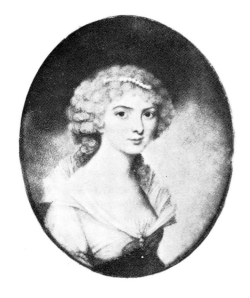

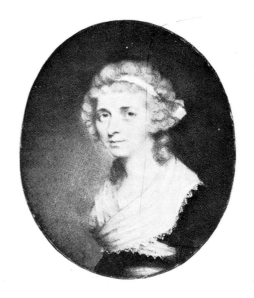

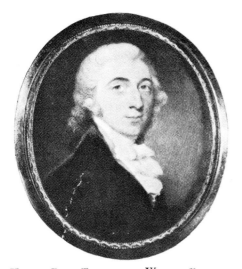

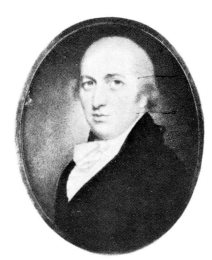

HESTER ROSE TIDYMAN BY WALTER ROBERTSON
AUGUSTUS V. VAN HORNE BY WALTER ROBERTSON

MRS. PHILIP TIDYMAN BY WALTER ROBERTSON
MAJOR HASKELL BY WALTER ROBERTSON

PLATE XVI

London, though he also had commissions for portraits and "conversation pieces" in oils.

Upon his return to Maryland in 1769, after a little above two years abroad, Peale, now twenty-eight years old, entered at once upon the production of his most delightful works, both in oils and in miniature. His portraits have at this time a peculiar delicacy of characterization and subtlety of colour, though some of the pigments have faded. He made many professional journeys during these years into Virginia and Pennsylvania, finally settling in Philadelphia early in 1776.

Miniatures by Charles Willson Peale are almost invariably painted on very small oval slices of ivory, such as he may have seen Copley using in Boston, and such as some of the Englishmen still used in the late 1760's, when Peale was in London. His works "in little" usually exhibit much charm and often much vivacity of colour, the modelling being strong but often insensitively simplified. Technically, his style, which at first consisted of a very fine squarish verticle stipple, became gradually bolder and coarser, though not offensively so. The miniature of Hon. William Bingham, painted in 1770 (Plate III), is one of these earlier miniatures in the fine manner. The portraits of Andrew Summers and his wife (Plates III, IV, and XXX) exhibit the broader stipple.

The life of the soldier, which he volunteered for at the close of 1776, did not entirely smother in Peale the life of the artist. Even during the active years as Captain of Volunteers he is known to have taken his equipment with him and to have painted miniatures of the officers. Especially the winter at Valley Forge, where he seems to have been connected with General Greene's headquarters, gave him an opportunity to paint, and his journals indicate that he made no less than forty miniatures, receiving prices for them of from fifty-six to one hundred and twenty dollars each. One of these miniatures is that of the Commander-in-Chief himself (Plate III), showing him young and handsome, as he appeared to the artist in 1777, immediately before the Battle of Germantown, if Rembrandt Peale's statement is correct. Several later miniatures of Washington, by Peale, reveal the head of the familiar soldier type which we find in the famous portrait of about 1778, the full-length Washington resting his weight somewhat jauntily against a cannon. The original portrait, which was commissioned by the Supreme Executive Council of Pennsylvania, is thought to be the one now in the Pennsylvania Academy. A fine example of this type of Washington miniature is that

lent to the Metropolitan Museum (Plate IV). Another fine Revolutionary portrait by Peale is the portrait of the Comte de Rochambeau, painted in 1780. It is set as a bracelet on a black velvet ribbon, being a very small miniature but a moderate and serious piece of characterization. (Plate III.)

Knowing as we do that Charles Willson Peale lived to the ripe old age of eighty-five, for he did not die until 1827, it is easy to forget the fact that his active life as an artist was virtually ended by 1795. In that year he painted Washington from life for the last time and perhaps with more success than ever before. But beside him sat his son Rembrandt, aged seventeen, also painting a portrait of the President, a portrait which impresses some spectators to-day as being the more convincing likeness of the two.

The elder Peale was now anxious to get his sons Rembrandt and Raphael launched as painters, and allowed his own energies to be drawn away from portraiture into projects for an academy of painting and a museum of natural history and historic portraits. After 1793 the reconstruction of femurs and metatarsals for his mammoth and the collection and amazingly modern installation of his stuffed birds, took him from his easel almost entirely except for such portraits of worthies as were painted to form a row around the gallery above the cases of birds, and very occasional portrait commissions or likenesses which he made of members of his immediate family and kinsfolk. Miniatures he had already ceased to paint, having, sometime before 1790, raised his prices to a point which he reckoned to be an effective deterrent to clients.[1] This he did to make an opening for his younger brother James, whom, after his return to England, he had persuaded to give up his trade of chaise-making, teaching him to paint instead. In 1786 the older Peale writes that he has given up painting miniatures and hopes James may be "going into a hurry of business."

Throughout the Revolution, James Peale had served with honour as an officer of one or another of the Maryland regiments. When he, at last, turned to his peace-time profession, he exhibited in his oil paintings a quaint style at times fairly accomplished yet, on the whole, decidedly uneven. It is as a miniaturist that he is best known and in this field he became a prolific worker. Here, the quality of his work is surprisingly

[1]Much of our information about the Peales has been generously supplied by Horace W. Sellers, Esq., who owns the Peale papers and letters.

uniform and fine. The colour is delicate and often distinguished, and the backgrounds are luminous, but his drawing shows a tendency to sameness, especially in the faces of his men. The majority of his miniatures are signed with the initials I. P. and dated, and those which the writer has chanced to see fall usually within the period 1787–1800, though one portrait of Washington was painted in 1782 and there are miniatures also dated as late as 1812.

A delightfully intimate document dated 1787 is an ornamental oval frame intended to hang from a ribbon in the usual fashion. On one side is James Peale's version of his own face, a kindly matter-of-fact one, and on the other is a small portrait of his wife, holding in her arms a baby, whom we judge by the date to be little Maria, her third child (Plates V and VI). A reminder of the fact that James Peale left Philadelphia at times in search of sitters is found in the portraits of Josiah and Mrs. Pinckney (Plate VI), whom he doubtless painted on one of his visits to Charleston, S. C.

An Eighteenth Century Philadelphia miniature painter, whose name most of us associate rather with New York and Albany, is Robert Fulton, who later in life successfully used the steam engine for propelling boats. He came from Lancaster County to Philadelphia in his seventeenth year and turned his hand to drawing landscapes, maps, or whatever he could get people to pay him for. Soon he was painting miniatures, and his little portraits of Mr. and Mrs. John W. Kittera at the Historical Society of Pennsylvania are attractive though inaccurately drawn, and modelled, if one looks too closely, with clumsy long brush strokes, somewhat like the thatch on a roof. His miniature of Clementina Ross, which must have been painted in 1786, shows already a decided advance. It is somewhat flat, but is dainty in colour and spirit and so close in style to James Peale's work at the time that we must suppose James to have been his teacher.

At the end of the year 1786 or early in the year following, Fulton, now come of age, went to England, where, like all the Americans, he availed himself of the advice (and probably of the supervision) of Benjamin West. For some years, with fair success, he painted portraits and historical pictures inspired by the romantic style of Angelica Kauffmann. This was before his attention became directed, about 1794, to engineering problems. But even his experiments with canal-diggers, submarines, torpedoes, and steamboats, which took him also for seven years to France, failed to deflect entirely his

interest from painting, and from time to time we find him making portraits of his friends the Barlows and others.

Aged forty-one, he returned at last, toward the end of 1806, to America, and on August 17th of the following year, his steamboat made her successful maiden voyage up the Hudson. He continued to paint such occasional portraits as those of John Livingston and Mrs. Walter Livingston. In 1808 he married Harriet Livingston, daughter of the lady just mentioned and second cousin of his friend and patron Chancellor Livingston. A portrait of his wife, by Robert Fulton (Plate VII), belonged until recently to Mrs. Robert Fulton Blight, who was married to a grandson of Fulton. It is entirely different from the miniatures Fulton had painted some twenty-two years before in Philadelphia, but very much like the fancy historical pictures of Lady Jane Grey, and Mary, Queen of Scots, and Louis XVI in Prison, all of which we know from the engravings of 1793. Another miniature showing the same hard and artificial drawing of the hair and eyes, and the same jewelled girdle is the portrait of Cornelia, wife of Stephen Van Rensselaer III (Plate VIII), who was a neighbour of the Livingstons up the Hudson. A third miniature (Plate VIII) is in such an exaggeratedly fancy style, reminiscent, perhaps, more of Lawrence than of Angelica Kauffmann, that one hesitates to call it an actual portrait.

Still another painter of the time, who worked in Philadelphia and farther South, was Henry Benbridge, whose name has been exhumed and is now being gradually resuscitated in the South, thanks to discoveries published a few years ago by Charles Henry Hart.[1] Benbridge, who was a Philadelphian in easy circumstances, is thought by Hart to have had his first lessons in painting from John Wollaston, to whom is attributed a portrait of Benbridge's stepfather, Henry Gordon. At the age of twenty-one his family sent Benbridge to study in Italy with Mengs and Battoni, who had taught Benjamin West. Young Benbridge spent some time in London also, sending a portrait of Benjamin Franklin, among others, to an exhibition of the Royal Academy. After five years away, he returned, in 1770, to Philadelphia with a style of painting of very uneven merit, as we can see in his portrait of the Gordon family, reproduced by Hart. After three years at home, a tendency to asthma led him to move to Charleston. Dr. John Morgan, in a letter dated November 24, 1773, writes: "In a visit I

[1]See Art in America, June, 1918. Also W. Roberts, ibid., Feb. 1918.

lately made to Charles Town, South Carolina, I saw Mr. Benbridge, who is settled very advantageously there, and prosecutes his Profession with Reputation and success."[1] The sight of some of his works in Norfolk in 1801 is said by Dunlap to have inspired young Thomas Sully to try painting in oils, and Benbridge gave him some instruction in the methods of his craft.

Thus, by the age of thirty Benbridge had successfully set up as a painter in the hospitable Southern city. That he was a serious student may be judged by the marked improvement which we see in his portraits painted during the next ten to fifteen years. Small wonder that owners of portraits by him in the South have, in so many cases, confidently ascribed them to Copley, for the painting of gauzy scarves and satin folds is only a little less masterly than Copley's, the hands of his sitters are rendered with strength and character, and the use of light and shade in modelling the heads is strong —almost as strong as with Copley, though the flesh is more thinly painted and the shadows warmly brown instead of cold. The heads are often nobly conceived and beautifully modelled with fine expression of the bony structure and a tendency to breadth and fullness in the upper eyelid. All the qualities mentioned, except for the hands, may be observed again in a considerable number of admirable small oval miniatures found mostly in Charleston, which may safely be said to be by Benbridge. One of these is the little portrait of Elizabeth Anne Timothy (Plate VII), in which the artist gives us, on his ivory less than one inch and a half high, the perfect sense of a handsome young woman of rich personality and high breeding.

[1]See Copley-Pelham Letters, p. 208.

COPLEY—PELHAM—DUNKERLEY—SAVAGE—TRUMBULL

In New England was Boston, and in Boston was Copley, and Copley is a name of such mysterious charm and potency that not only are most Boston miniatures, even up to 1790, stoutly claimed for him, but many miniatures also in Charleston and New York. In this connection it should be borne in mind that Copley left America in June of 1774 and never returned. He was a conservative and deeply serious young man who had not forgotten his family's difficulties in keeping its several heads above water in the hard days before he had made his way as a portrait painter. He had not forgotten how his widowed mother had supported herself and him by carrying on her husband's tobacco shop, and how later on her three additional years of married life with Peter Pelham had still failed to release her from the confinement of shopkeeping.

Thus, before the long-planned break in 1774 which took him on the Grand Tour and then permanently to London, Copley had taken only one journey away from Boston. This event, which he describes in detail in his letters, took him and his young wife during six months of 1771 to New York, a city then woefully lacking in portrait painters of her own. His letters tell us the number of portraits he painted in the strange city, and their sizes, and no miniatures are included in the list. His journey was extended to take in Philadelphia also, but there his stop was very brief and he did not paint at all.

In fact, the number of miniatures which Copley painted appears not to have been great, if we leave out of count his small portraits in oils, which run in size from three to six inches high. His miniatures on ivory are very small indeed and very appealing. They are made with a fine stipple and, like his oils, are distinguished in colour, and strong in construction and modelling. Even his charming ladies are always full of character, sometimes decidedly firm, in fact, for Copley was a true son of New England and in full sympathy with that "stern and rockbound coast." Among the finest of his miniature works that we know are his self-portrait (Plate IX) and the portrait of

24

Deborah Scollay (Plate IX), both ovals only an inch and one eighth high, and his lovely portraits, only a little larger, of Samuel Cary and his wife (Plate IX). His self-portrait, which is vivacious in colour, appears to take this quality as well as its design from the portrait he made of himself in pastels, now owned by Mr. Harcourt Amory. A letter dated October 29, 1769, from Captain John Small, testifies to a similar process when he writes Mr. Copley politely, "The miniature you took from my Crayon Picture has been very much admired and approved of here by the best judges." A receipt for one Guinea[1] received for painting "a picture in miniature of Miss Thank-full Hubbert" shows that Copley was painting miniatures as early as 1758, whereas a second self-portrait in miniature, belonging to Mr. Copley Amory, is said to have been painted after Copley went to England.

Little has been known of the early instruction which Copley received in his art. Smibert, who had been Boston's chief painter for twenty years, died in 1751, when John Copley was barely fourteen, and the lad's stepfather Pelham, who had been a fair portrait painter and engraver of mezzotints, died later in the same year. Copley's abilities as evidenced in his work a year after these events were still far from promising. He may have had some instruction later on from Blackburn, whose style some of Copley's early works resemble, but it seems on the whole more likely that he learned principally by mere study and imitation of pictures by Blackburn and whatever other works of art he could find in Boston. Thus his letters from Europe to his beloved young half-brother, Henry Pelham, describe the paintings he sees in the Continental galleries in terms of the works in Boston they both evidently know by heart—Smibert's copy of this Van Dyck or that Poussin, or the engraving after Rubens' Marie de Médicis series, which both know so well that it is unnecessary for Copley even to mention at whose house they have pored over them together. Later on another great American artist, Malbone, was to teach himself to draw in much the same fashion.

Henry Pelham was twelve years younger than Copley, and Copley treated him with a peculiarly tender affection—an affection more paternal than brotherly and consequently leading to much advice and admonition. Of course, sensitive young Henry must be a painter too, like his adored big brother, and how yearningly and constantly in the early days Copley must have been at his elbow, instilling into him knowledge

[1]See Copley-Pelham Letters.

25

and courage, one may judge from the tone of the explicit and carefully planned letters from Copley later on, discussing the things a professional portrait painter could learn from the Great Masters in the European galleries.

There is plenty of evidence in the Copley-Pelham correspondence that Pelham painted some portraits in oil, and one suspects that they resemble Copley's work just enough to be lost to-day among paintings by the older man. The miniatures we know by him, however, are surprisingly unlike the work of Copley, having a strong and distinct personality of their own. But there are not many of them, at least not from his American period, for he had no more than established himself as a painter when the confusion of the impending revolt became so great that patrons would no longer sit for their likenesses, or, having sat, refused to pay the bill. When Pelham was twenty-four, he painted a miniature of Stephen Hooper (Plate XV), and a letter from the artist to his patron, a merchant of Newburyport, runs, "Agreeable to your directions, I have done your portrait in Miniature and have had it sett in Gold." The note is dated Boston, September 9, 1773.

A year and a half later, Copley having departed for Europe, Peter was in such a state of nerves and apprehension that a rest cure was recommended. Every person of sense was forced to admit that a serious political explosion had become inevitable, and young Pelham saw that, not only was his career threatened by it and his Tory family's economic stability, but also that his chances now of marrying his "very amiable Miss Sally" Bromfield were ruined. He made a visit to Philadelphia where his spirits were somewhat revived. Here his friend Mrs. Charles Startin gave him an order for a miniature portrait of Jonathan Clarke, father-in-law of Copley, and famous as the consignee of the epoch-making shipload of tea. The miniature was executed in May, 1775, and like the portrait of Stephen Hooper is a rugged piece of painting and characterization with little thought for the mere sensuous qualities. A third American work in miniature by Pelham is the portrait of William Wagnall Stevens (Plate X).

At the time of the general Tory evacuation of Boston early in 1776, Henry Pelham took refuge in Halifax, and on May 12th of that year, along with eleven hundred other New England refugees, he embarked for England. For a time he continued his profession of painter, exhibiting at the Royal Academy in 1778 a painting, the Finding of Moses, and two miniatures. In 1779 he sent a case with four miniatures, two being

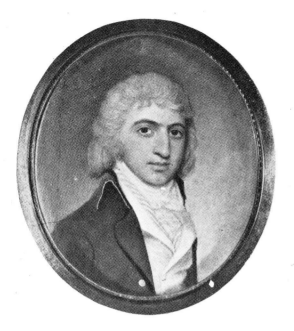

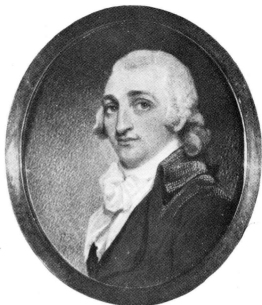

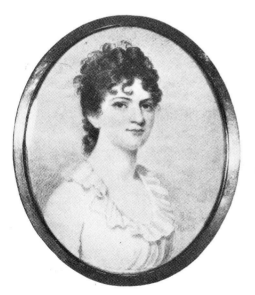

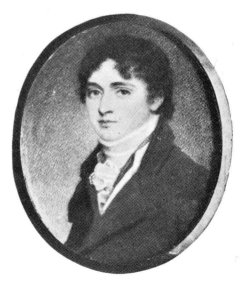

LAWRENCE REID YATES BY W. ROBERTSON
FRANCES TOWNLEY CHASE BY FIELD

DR. JAMES SERGEANT EWING BY FIELD
RICHARD LOCKERMAN BY FIELD

PLATE XVII

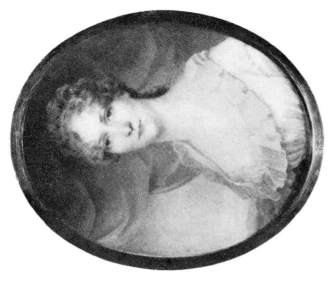

MARY TAYLOE LLOYD BY FIELD

PLATE XVIII

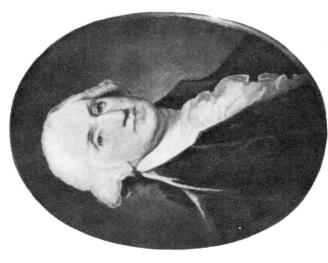

GEORGE WASHINGTON BY FIELD

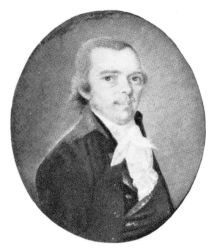

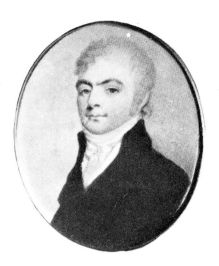

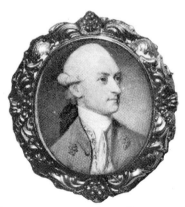

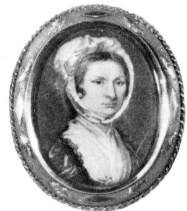

A Man by P. A. Peticolas

Anthony Bleecker by Elkanah Tisdale

Lafayette by William Birch

John Hancock—about 1780—Artist Unknown

Mrs. Peter deLancey—about 1780—Artist Unknown

PLATE XIX

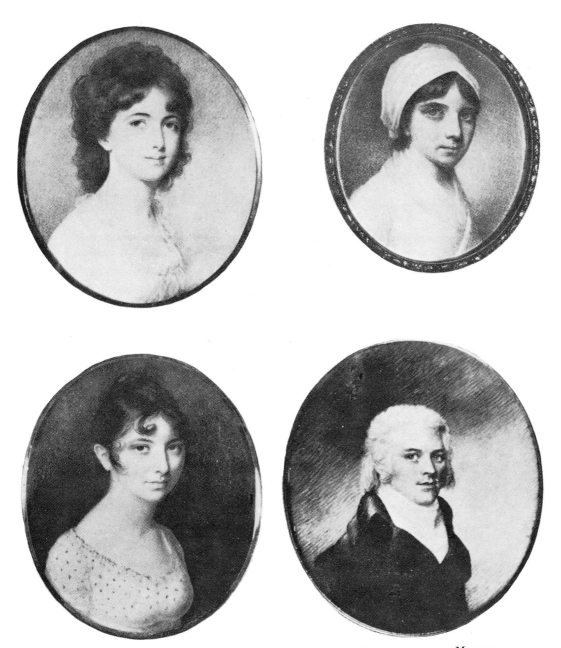

MRS. RICHARD C. DERBY BY MALBONE MISS POINSETT BY MALBONE
REBECCA GRATZ BY MALBONE NICHOLAS POWER BY MALBONE—ACTUAL HEIGHT $2\frac{7}{8}$ INCHES

PLATE XX

in water colours and two in enamels. He later moved to Ireland where, for a few years longer, he continued to follow his original profession.

A delightful miniaturist who worked in Boston and whose works are apt to be confused with those of Copley is Joseph Dunkerley. The memory of Dunkerley was for a long time practically lost except for the notices which he had inserted in the Boston *Independent Chronicle* for 1784 and 1785, where he advertised himself as a painter of miniatures and a teacher of drawing. An exquisite little work by Dunkerley is the portrait of Mary Burroughs (Plate X), which fortunately bears on the back of the gold frame an old engraved inscription giving the sitter's name and the artist's and the year 1787 as the date of painting. The characterization of the sitter is delicate but not without reality. The colour tends toward blue and white[1] with masses of dark hair, while the expression of form is far more dependent upon line than is the case with Copley. Other miniatures which may be given to Dunkerley on the basis of style are the portrait of a man with initials E. B. belonging to the Metropolitan Museum of Art (Plate X) and the well-known and admirable little portrait of Mrs. Paul Revere—probably also those of Charles Bulfinch and his wife. Doubtless many other miniatures will in time be recognized as the work of this comparatively mysterious personality, who came from nowhere and disappeared nowhither, and of whose existence thus far we have proof only from 1784 to 1787.

Two other painters of New England origin whose work as miniaturists deserves at least a brief mention are Savage and Trumbull. Edward Savage was born and grew up in Princeton, Massachusetts, and is best known for his unprepossessing portraits of Washington. We first hear of him when, in 1789, he was given a commission by Harvard College to go to Philadelphia and paint the President's portrait, and he later made replicas of this besides painting and engraving, with assistance, the famous picture of the Washington Family. He probably learned to engrave while on a three-years' visit to London. In 1794 he returned to America and in Boston married Sarah Seaver. His delectably quaint miniature of her, owned by the Worcester Museum, was doubtless painted at about this time and also his self-portrait (Plate IX) and the portrait "in little" of his brother-in-law Eben Seaver.

John Trumbull of Connecticut, whose father Jonathan was governor of that state

[1]The miniature is probably somewhat faded.

from 1789 to 1809, cut a greater figure in the world of art than Savage. In addition to some mediocre work, he painted some splendid portraits, especially those of Alexander Hamilton. But the great work of Trumbull's life, which he himself took with immense solemnity, was the painting of his scenes from (then) recent American history. The original canvases of these were 20 x 30 inches, and for many of the heads studies were made from life, these being small oval portraits in oils on wood panels from three to four inches high. These are probably the finest and most spirited work that Trumbull did, and it is a temptation to overlook the medium in which they are painted and include them among American miniatures.

For his Declaration of Independence alone Colonel Trumbull painted from life on such little panels thirty-six of his characters. John Adams he painted in London early in 1787 and Thomas Jefferson he caught in Paris in the autumn of the same year (Plate XI). For his Surrender of Cornwallis, his Surrender of Burgoyne, and his General Washington Resigning his Commission (all, like the Declaration of Independence, later vulgarized on a grand scale for the Rotunda of the Capitol), he painted many more such small portraits during the next few years. Still others, such as the delightful ones portraying the ladies of his family, he painted apparently as works of art complete in themselves.

VII. FOREIGN ARTISTS AT THE TURN OF THE CENTURY

RAMAGE—A.ROBERTSON—W.ROBERTSON—FIELD—BIRCH—ELOUIS

SEVERAL European miniature painters, mostly from Great Britain and Ireland, came to the young republic toward the end of the Eighteenth Century. These, although they did not in most cases make the United States their permanent home, left a decided impression behind them through the excellence of their art.

The first of this group of visiting artists to appear was the Irishman John Ramage, who set himself up as a goldsmith and miniature painter in Boston at least as early as 1775. When the Revolution broke out, he joined His Majesty's loyal forces which were quartered on the Bostonians, and was withdrawn along with the rest to Halifax in 1776 at the time of the Evacuation. A year later his troops were ordered to New York to hold that city against the Rebels, but when an evacuation was again ordered, Ramage remained behind and resumed his profession of painting in miniature. He succeeded in building up a fashionable, indeed an important, clientèle including military heroes and members of the new federal government, which was then established in New York. Among his sitters were John Pintard and his wife in 1787 (Plate XIV), President and Mrs. Washington in 1793, and Mr. and Mrs. Elbridge Gerry of Massachusetts (Plate XIII).

Ramage's miniatures are always small, rich in colour, and painted with a long stroke so fine that the finished effect is as brilliant and almost as smooth as enamels of the best days. They are, as a rule, framed in chased gold frames of his own making and more beautiful than those used by any other miniaturist in America.

In 1794 Ramage left New York for Halifax, being involved in debt, according to the gossips, owing to fast living and the extravagance of his second wife.[1] (He had deserted his first.) Dunlap, looking back at the Eighteenth Century with interested curiosity, thus describes the details of Ramage's dandified costume: "A scarlet coat

[1] A sheriff's sale of Ramage's household and professional possessions was advertised April 16, 1794.

with mother-of-pearl buttons, a white silk waistcoat embroidered with coloured flowers, black satin breeches with paste knee buckles, white silk stockings, large silver buckles in his shoes, a small cocked hat covering the upper portion of his well-powdered locks and leaving the curls at the ears displayed, a gold-headed cane and a gold snuffbox." His appreciation of elegant apparel is reflected in his miniatures where his ladies are fashionably clothed and *bien coiffées*, while his gentlemen wear the smartest of wigs, the most exquisite waistcoats imaginable, and ruffles and jabots fresh from the deftest and most devoted of laundresses.

Another foreigner who painted some very good miniatures in America and made his home here permanently was Archibald Robertson. He came from Aberdeen in 1791, at the age of twenty-six, and settled in New York. Soon after his arrival he painted on a small slab of marble a portrait of Washington which is now at the New York Historical Society. This and his miniatures on ivory of Washington and his Lady appear to be poor likenesses, showing jaws altogether too prognathous. But his two blue-eyed self-portraits are very good to look at (Plate IV), and the comparatively large portrait of his young wife, Eliza Abramse (Plate XII), whom he married in 1794, is a bonnie portrait, with its blue velvet dress and blue-black hair, yet technically it is fairly brusque. A portrait in the same style of an unidentified American general, which belongs to Mr. Alyn Williams, is signed with the monogram A. R. with a P (for *pinxit*) underneath.

Robertson's brother Andrew remained behind and became one of the foremost miniature painters in London, but his brother Alexander soon joined Archibald in New York, where they established together an art school called the Columbian Academy of Painting. Alexander later set up independently as a teacher, and his teaching was praised by Dunlap in 1834.

An Irishman whose surname happened also to be Robertson came to America in 1793 on the same ship which brought Gilbert Stuart back from Ireland. Walter Robertson, for that was his name, had known Stuart some years before in London, and now, arrived in America, is said by Dunlap to have made pleasing miniature copies of many of Stuart's portraits.

In 1794 Robertson went to Philadelphia and painted a miniature of Washington in his Continental uniform. Whether Washington actually sat to Walter Robertson,

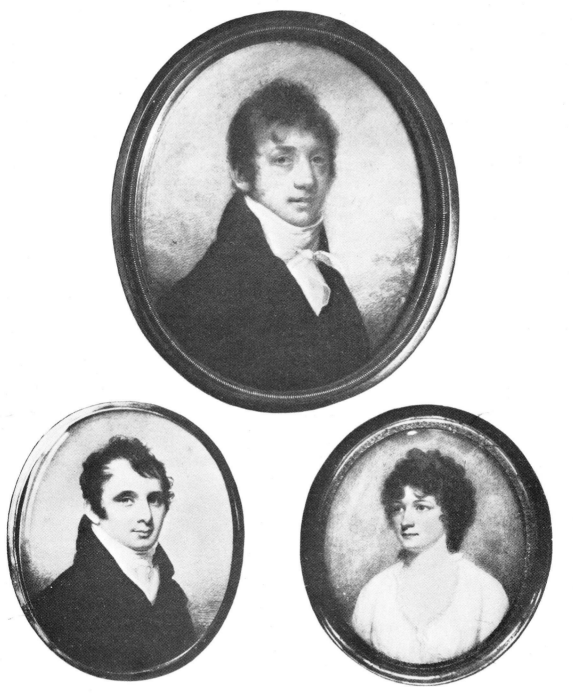

CHARLES HARRIS BY MALBONE

SOLOMON MOSES BY MALBONE MRS. B. F. TRAPIER BY MALBONE—ACTUAL HEIGHT $3\frac{1}{8}$ INCHES

PLATE XXI

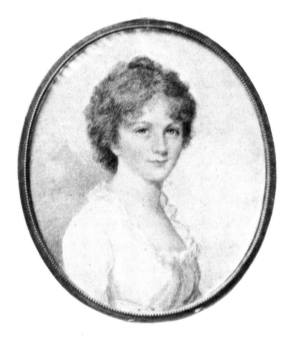
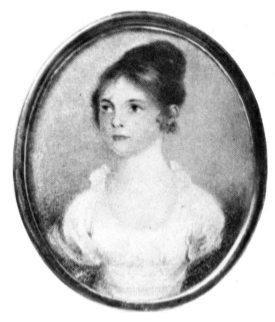
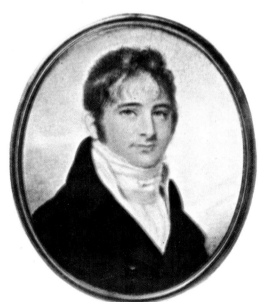
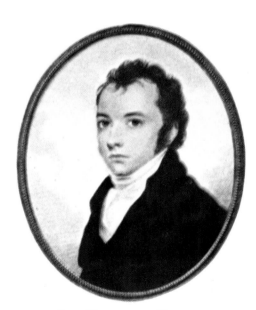

MRS. JAMES LOWNDES BY MALBONE JANE WINTHROP BY FRASER
DAVID MOSES BY MALBONE JOEL POINSETT BY MALBONE

PLATE XXII

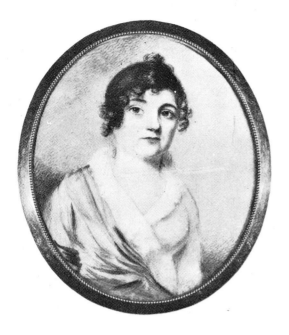

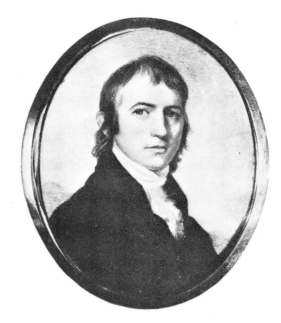

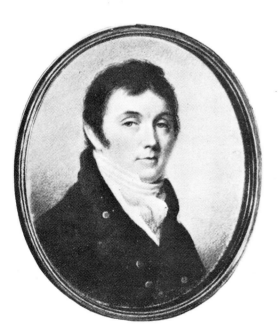

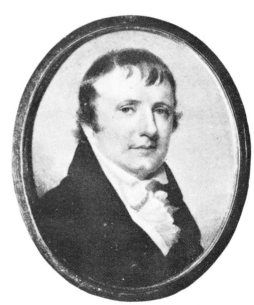

LADY WITH A PINK SCARF BY MALBONE
NICHOLAS FISH BY MALBONE

ARCHIBALD TAYLOR BY MALBONE
THOMAS MEANS BY MALBONE

PLATE XXIII

we do not know. Certainly Washington makes no mention of such an event in his Diary, and it was just such minor engagements which the great man was accustomed to record. The miniature was engraved in stipple by Robert Field, with a very fancy embellishment of eagle, flags, stars, and liberty cap added by one J. J. Barralet. (The engraving minus the embellishment is shown on Plate XIV.)

Robertson's original Washington miniature belongs now to a direct descendant of Martha Custis, later Martha Washington. Every beholder will have his individual opinion of this little portrait as a likeness, for we are confused by the many and divergent statements which Washington's portraitists have made about him. But as a work of art appealing to the senses it is a miniature which must win admiration from most of those who see it, for in it the precious and marvellous qualities of the miniature on ivory are realized about as fully as may be. Field, who having engraved it must have known it very intimately, called this miniature "as good a likeness and as fine a piece of painting as I ever saw." When Robertson made up his mind to go to India, which was probably after a stay of only two, three, or four years in America, he offered to sell his Washington miniature to Field at the enormous price (as it must have seemed then) of one thousand dollars, and Field is reported[1] to have said the miniature might well be worth it, though the price was more than he personally could afford. Dunlap, on the other hand, considered the miniature a complete failure as a likeness. But for all that, Robertson's style fascinated Dunlap. In one place in his *History* he calls it "unique, very clear and beautiful, but not natural," and again, intelligently enough, one would say, he describes it as "very singular and altogether artificial, all ages and complexions were the same hue—and yet there was a charm in his colouring that pleased in despite of taste." As to Trott, himself an exceedingly skilful painter of miniatures, Dunlap tells us that Walter Robertson's miniatures were his despair, almost his obsession, and that he could not be dissuaded from the notion that their excellence depended upon some precious chemical secret.[2]

What, then, has become of the works of Walter Robertson which aroused such a disturbed admiration among his professional contemporaries? F. W. Bayley, in his 1918 edition of Dunlap, reproduces a miniature ascribed to Robertson of Michael

[1]See under Field in D. M. Stauffer, American Engravers, etc.
[2]See p. 107.

31

Nolen which is said to be signed or documented, but the present ownership of this work is unknown. As for Robertson's numerous copies after Stuart's portraits, of which Dunlap wrote, none thus far has come to light. But, if the miniature of Martha Washington which was engraved for Longacre's National Portrait Gallery has disappeared, a second example is fortunately known (Plate XV), differing in drawing from the first, but exquisite in colour and quality and exceptionally convincing as a likeness, It was attributed by Charles Henry Hart, in his catalogue of the Pratt Collection, to Henri Elouis, but may now be definitely identified as by Robertson on the basis of the established Washington miniature. Others of Robertson's works, long attributed to Malbone or to Field, exhibit the same distinguished colour and sparkling sophisticated accomplishment as the Washington portraits, coupled at times, however, with an unconvincing characterization of the sitters. But this was a matter for the sitter and his contemporaries to worry about. For posterity, of which we constitute our humble part, the sensuous beauty of the work may be of equal importance. Typical of Robertson's workmanship are the elegant artificiality of starched frills and powdered hair, the fine cross-hatching of translucent backgrounds, and the astonishingly skilful modelling of the heads by means of very long fine brush lines following the facial contours and usually blue in the depressions, notably the eye sockets.

Dunlap tells us that Robertson made his headquarters in Philadelphia. Other cities which he visited we may guess at from his sitters. The Metropolitan Museum owns a faded but sensitive miniature undoubtedly by Robertson of one of the Calvert ladies of Maryland, formerly supposed to be of Ariana, who died young and unmarried, but who probably died too early for Robertson to have painted her. The fine miniature of Lawrence Reid Yates and those of Colonel and Mrs, Armstrong, Augustus Vallette van Horne (Plate XVI), and Alexander Macomb[1] would seem to point to a stay in New York, as might also a portrait of Major Jonathan Haskell (Plate XVI). That Robertson visited Charleston is indicated by the miniatures of Mrs. Philip Tidyman (Plate XVI) and her daughter Hester Rose (Plate XVI), who married John Drayton in 1794. This portrait, showing Hester Rose Tidyman at the age of twenty, is perhaps the most charming of Walter Robertson's works. In it, everything—bright sky, starched frills, translucent flesh, glowing pearls and powdered coiffure of marvellous

[1]See Bowen's Centennial, facing p. 51, where the miniature is attributed to Ramage.

elaboration—seems to be daintily contrived to play up a lovely pair of brown eyes.

Robert Field was probably the best known and the solidest of the foreign miniaturists working in America at this time. He came from England, arriving about a year later than Walter Robertson, fully armed and equipped for making his way as a miniature painter and engraver. Shortly after his arrival, he made his engraving, already mentioned, after Walter Robertson's Washington miniature.

Field seems to have set up his studio for the first few years in Philadelphia where he probably painted his miniature of Dr. James Sergeant Ewing, Philadelphia physician and pharmacist (Plate XVII), which is dated 1798, and also the miniature of Nicholas Waln, dated a year later. In 1801 he painted a number of copies in miniature after one of Gilbert Stuart's portraits of Washington (Plate XVIII). During 1802 and 1803, perhaps longer, he was busily painting in Baltimore, and many splendid examples of his work are still to be seen there, owned by descendants of the sitters. An excellent pair of Field's Baltimore portraits "in little" are his young Richard Lockerman and Lockerman's bride Frances Townley Chase of Annapolis (Plate XVII). The miniatures are dated 1803, the year the Lockermans were married, and signed as usual, with the initials R. F. Mrs. Lockerman's portrait is firmly drawn but exceedingly delicate in colour, the ivory being left practically white while her dress is of white muslin. Another exquisite miniature by Field, painted at this time, is the portrait of Mary Tayloe Lloyd of Talbot County, Maryland, who married Francis Scott Key (Plate XVIII). In this little painting we see again a dainty white muslin dress setting off golden hair, blue eyes, and a fair skin. Behind are blue sky with clouds and a rose-pink curtain looped back in rich billows.

Despite the delicacy of some of his feminine portraits Field's colour scheme may be said as a rule to tend to browns. His backgrounds are put in with a short, brusque slanting stroke, and the coats of his men are apt to be painted in solid body-colour. His faces, however, which are finely constructed and often very characterful, as in the portrait of James Earle (Plates XXXVII and XXX), can be seen with a magnifying glass to be painted with fine wavering lines which remind, surprisingly enough, of the handwriting of a feeble old man.

Sometime in 1805 Field moved to Boston, where he continued to follow his dual

profession of engraver and miniaturist. In 1808 he was persuaded by Sir John Went-
worth to move to Halifax.

William Birch, who came from England the same year as Field, had made a
considerable name in his own country, where Sir Joshua Reynolds employed him to
make enamel miniatures after some of his portraits. He set up his furnace in Philadel-
phia and there remained for the rest of his days. He is known for his skilful enamel
portraits of people of varying importance, especially Lafayette (Plate XIX) and Wash-
ington, portraits of whom have always found a ready sale.

Still another Englishman who came to America to stay was Edward Miles.
In England he had been painter to Queen Charlotte and was later on court painter at
St. Petersburg. He arrived in Philadelphia in 1807, when he was fifty-four years old,
and died there in 1828. But though he was a first-class painter of miniatures, and
moreover drew delightful small portraits in pastels, Miles was better known in Phila-
delphia as a teacher. He is said to have painted miniatures only occasionally of some
close friend or member of his family, and most of these little works now belong to a
descendant who owns also a portrait in oils of Miles by James R. Lambdin, his best-
known pupil.

An accomplished French miniaturist who also visited the United States at the
turn of the century was Henri Elouis. Trained under Restout in Paris, he had won a
silver medal in 1783 from the Royal Academy in London for his drawing of the human
figure. He remained in London several years and exhibited miniatures at the Royal
Academy. By 1791 he had come to America and was painting in Maryland. C. H. Hart
tells us that Elouis was at one time drawing master to Miss Nellie Custis, but neither
of the portraits of her mother Martha Washington which Hart attributes to Elouis can
now be claimed for him, the one in the Pratt collection being by Walter Robertson,
as has been pointed out, and the circular example now owned in Philadelphia being
doubtless of French workmanship but not in the style of Elouis. There are known at
least two signed miniatures by this artist, and they are entirely consistent one with
another, being lively in colour, with rosy flesh, well drawn and rather brilliant in gen-
eral effect, and painted with a comparatively short and broad stroke of the brush. One
of these represents Henry Browse Treat (Plate XIII) and the other William Waln.

Elouis accompanied Baron von Humboldt as draughtsman on his scientific ex-

34

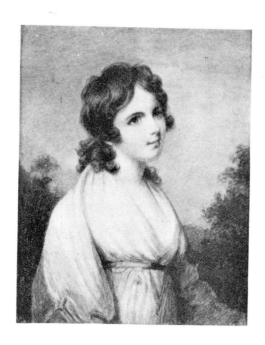

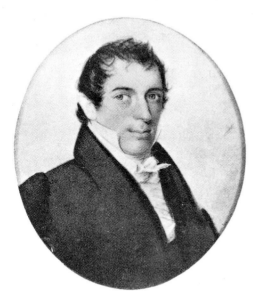

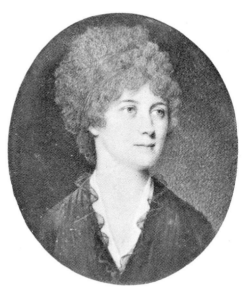

THE LITTLE SCOTCH GIRL BY MALBONE

A MAN BY MALBONE

MRS. THOMAS AMORY OF BOSTON BY MALBONE

PLATE XXIV

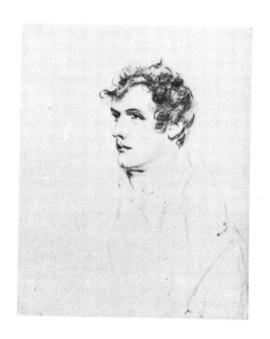

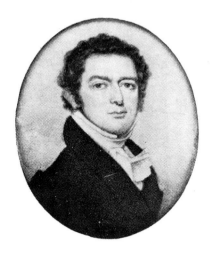

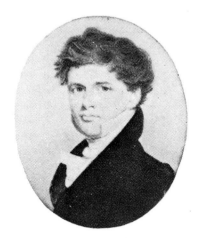

NICHOLAS BIDDLE BY TROTT

LEWIS ADAMS BY TROTT

A MAN BY TROTT

PLATE XXV

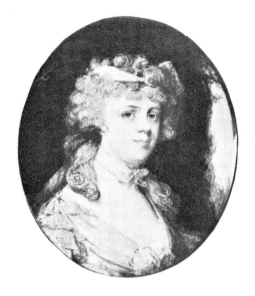

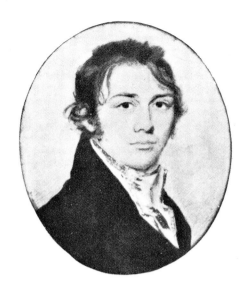

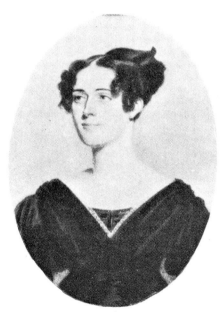

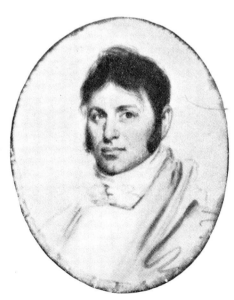

Mrs. James Greenleaf by Trott (After Stuart)
Mrs. Alexander N. Macomb by Trott

Peregrine Wroth by Trott
Edward Johnson Coale by Trott

PLATE XXVI

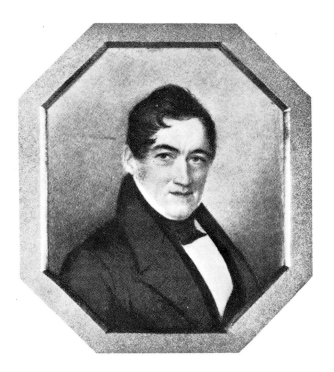

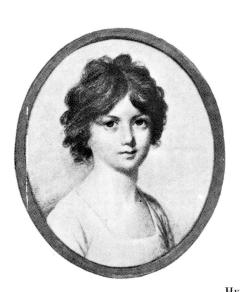

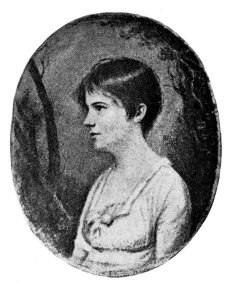

HENRY OGDEN BY FRASER

SARAH LADSON BY FRASER ELIZA FENNO BY MALBONE—ACTUAL HEIGHT $3\frac{5}{8}$ INCHES

PLATE XXVII

pedition to Mexico and South America. Humboldt returned from these travels in 1804, but we do not yet know whether Elouis resumed his miniature painting for the three remaining years of his stay in America.[1] In 1807 Elouis returned to France.

Thus we have attempted to follow the fortunes and to appreciate the respective styles of a number of foreigners who came to the newly born United States hoping to make their livelihoods by painting miniature portraits of the inhabitants. By resorting to the practice of moving from city to city, these talented and accomplished artists appear on the whole to have found all the sitters they required, and Field is probably the only one of the lot who deliberately left the country with the view of bettering his prospects. But the delicate art of portrait painting in little had now reached its full fruition in America, and if our best native artists could watch with equanimity the fortunes of these several skilled foreign competitors, it was for the most respectable of reasons. They were able to paint even better miniatures than the foreigners.

[1] Treat's costume appears to date his portrait about 1805.

VIII. THE RIPE MOMENT

MALBONE — TROTT — FRASER

Everyone knows that Malbone painted the finest miniatures in the history of the art in America. His name, for many of us who have paid no particular attention to this minor subject, constitutes about all we know of American miniaturists. Those who come from the South will know also the name of Fraser, who followed closely after Malbone but who soon developed an interesting and authentic style of his own. A third miniature painter at this time, Benjamin Trott, deserves more attention than he has received, for his miniatures at their best have a pleasing clarity together with effective simplicity of drawing and a direct and interesting statement about the sitter's personality.

There are, of course, all sorts of ways of looking at the personality of a sitter, and through him at the world in general. Copley, a man of cool observation who expressly recognized the Bostonians' demand for portraits which were likenesses, nevertheless reveals in his art an attitude toward the world. If we were allowed a seeming flight of fancy we should observe that Copley's portraits taken as a whole appear to say to us, "Yes, pretty clothes are something brave and so is a comely body, but a lively intelligence and firm and godly character are what make people worthy to be leaders in the community or to be the mothers of leaders." Charles Willson Peale, to choose at random another painter, seems to say "There are many well-favoured women and good men in the world, but handsomeness is not so important as goodness, and even the good are but poor struggling mortals." In praise of Benjamin Trott, a contributor to the *Port-Folio* in 1813 wrote, "Nothing is more common than to see portraits of men and women; but it is seldom, very seldom, that we see anything that looks like ladies and gentlemen." And the very ineptitude of this observation has its uses, for it calls attention to one of the delightful things about Trott's miniatures of his best period—that they are apt to be portraits of "just folks"—just men and women.

As to Malbone, his sitters are indeed all ladies and gentlemen. All was right with Malbone's world, where gallantry and good breeding were what mattered. His own

36

famous courtesy and natural gentlemanliness led him to draw the same conclusions about taking likenesses that had been expressed long before by Nicholas Hilliard,[1] miniaturist and accomplished courtier of Queen Elizabeth's day. "Now knowe," wrote Hilliard, "that all painting imitateth nature so far forth as the painter's skill can serve him to express it; but of all things the perfection is to imitate the face of mankind soe well after the life that not only is the party well resembled for favor and complection but even his best graces and countenance notabelly expressed, for there is no person but hath variety of looks and countenance, as well ilbecoming as pleasing or delighting." In other words, to quote the elegant language of his friend Washington Allston two centuries later, "Malbone had the happy talent among his many excellencies, of elevating the character without impairing the likeness: this was remarkable in the male heads; and no woman ever lost any beauty from his hand; nay, the fair would often become still fairer under his pencil."[2]

Edward Greene Malbone was born in Newport in 1777, but Edward Greene, simply, was his name and his several sisters bore the same surname, for their mother, Mrs. Greene, was never married to the prosperous John Malbone. One of these sisters, arrived at a sentimental and garrulous middle age, wrote a life of Malbone for Dunlap's History. In it she alludes delicately to "an accumulation of evils, not however of a pecuniary nature, but from which resulted the . . . neglect of his early education. This was the only misfortune respecting himself that I ever heard him lament."

Young Edward Greene grew up an earnest lad, filled apparently with a sense of responsibility for his sisters, and for his father even more than the usual formal respect which sons of that time manifested. We shall probably not be far wide of the facts if we imagine him growing up in a rather small and mean dwelling, called upon by his mother for a maddening number of chores, but finding time, nevertheless, to get into some out-of-the-way corner and copy prints and illustrations in books—anything he could get hold of. Something he learned of painting from the scene painter in the local theatre. From the amiable Samuel King, unsuccessful local portrait painter, now turned compass and quadrant maker, he is said to have learned something also. And no doubt Mr. King did lend him engravings to copy and gave him encouragement too,

[1]See Walpole Society Publications, 1911, p. 22. Slight omissions in the text are here made for the sake of clarity.
[2]See Dunlap's History of the Arts of Design in the United States, 1918 edition, II, p. 140.

just as he had done for Washington Allston. But not much actual instruction did he give, surely, for if he had, our decorous Malbone would never have written, as he did later, "West was surprised to find how far I had advanced without instruction." As an illustration of how Malbone taught himself to draw, there still exists a good copy which the young artist made after Bartolozzi's engraving of the Birth of Shakespeare by Angelica Kauffmann.

In 1794, when he was seventeen, Malbone quietly went to Providence to make his way as a miniature painter. He wrote to his father from that city that he anticipated success and hoped soon to be able to relieve his father of supporting the family (!), i.e., the Greene household, of course. "I must conclude," writes this model offspring, "with making use of that name which I shall study never to dishonour. Your dutiful son, Edward G. Malbone." It is not known at exactly what date the Greene children were granted, by Act of Legislature, the right to use the father's name. Young Edward's sanguine expectations in 1794 as to his success in Providence were quickly justified, and his miniature of Nicholas Power of that city (Plate XX) was probably painted at this time. The miniature and Malbone's receipted bill for it are both owned by the Providence Athenæum. The bill is written in ink and no place or date is given. Below is the date 1793 pencilled in a different hand, but the miniature with its Providence subject was probably painted the following year. It is already a remarkably accomplished work, indeed entirely professional and acceptable. Already in this youthful work is sensed Malbone's implied assertion that this is a happy and well-bred world, peopled with handsome, well-dressed people.

Young Malbone remained in Providence about two years, and when in 1796 he went to Boston, he again made an easy conquest. Here at the age of twenty he painted his beautiful portrait of himself which is signed E. G. M. (See Frontispiece.) He found Washington Allston, the South Carolinian whom he had known in Newport, now a freshman at Harvard. Excited over Malbone's wonderful miniatures, Allston tells us he tried his hand at them, too, but was disgusted with the result and gave it up after a few attempts. He tells on himself the story that someone, after many years, showed him one of these attempts without explanation and the painter, justly he says, pronounced it to be "without promise."[1]

[1]See Dunlap's History of the Arts of Design in the United States, 1918 Edition, II, p. 300.

Malbone now began the itinerant life so usual with the painters of his day, going to New York, Philadelphia, and Charleston. In 1801, he went with Allston for a few months to England, where he especially admired the portraits he saw by Lawrence and miniatures by Cosway and Shelley. To Shelley he paid the compliment of copying (possibly he made some slight changes) his Hours, sub-titled Fair Venus' Train, which had already become known through Nutter's engraving published in 1788.

On his return to America, Malbone painted in Charleston, Newport, New York, and other cities. During most of the years 1804 and '05 he remained in Boston, and during the winter of 1805–06 ᴀe painted some miniatures again in Charleston. But they were his last, for, owing to tuberculosis, his health was now gone, and about a year later he died.

Thus the professional career of America's foremost painter of miniatures lasted a little less than twelve years. If, like Nicholas Hilliard, Malbone always painted his sitter so that his "best graces and countenance was notably expressed," he, nevertheless, did actually contrive, as Washington Allston claimed for him, to give us convincing portraits—to impair the likeness to a remarkably slight degree. Where his men sitters seem too pretty to be true, we should remember that often they were mere beardless youths when their portraits were painted. Thus, it would be hard to find anywhere a truer picture of a hypersensitive adolescent than the searching little portrait of the twenty-year-old Charles Harris (Plate XXI), painted in Boston in 1804, when Malbone's talent had been fully developed. And as to virility and veracity, there is surely no lack of these desiderata in such portraits as those of Joel Poinsett, Nicholas Fish, Archibald Taylor, and the Unknown Man of Mr. Herbert DuPuy's collection.

As to Malbone's women, probably no one has ever denied their loveliness. Their variety, however, also deserves comment, for we have here no mere repetitions of an artist's favourite type, painted in the presence of separate sitters. Instead, there is the rosy, cosy little portrait of Mrs. Nicholas Bleecker:[1] there is the exquisite profile of the girlish Eliza Fenno with her "boyish bob," wondering seriously what life is going to be like; there are Mrs. James Lowndes, the airy Southern beauty, and Mrs. Richard C. Derby, the dainty beauty from Boston, whom Copley in his London days painted as Saint Cecelia; there is the human young Miss Poinsett of the liquid eyes, still a little

[1]Mrs. Bleecker's portrait is the Frontispiece in A. H. Wharton's Heirlooms. The others are illustrated in the present work.

dazed at finding herself alive after a serious illness; there is Rebecca Gratz with her compassionate mouth and her serious, intelligent brown eyes; and, lastly and one of the best, there is Mrs. Thomas Amory of Boston, a young and handsome matron whose unflinching eyes and pretty, resolute mouth, give warning to her world that she is prepared to dominate it.

As to Malbone's technical method, it would seem prosaic to attempt its analysis. Dunlap would merely have remarked that he "painted in the line style." And so he did. He hatched and cross-hatched with exquisite skill, but he appears never to have stippled. As a craftsman what must delight us most in his work is the easy accuracy of his drawing and the clear beauty of his colour. Perhaps no more beautiful example of his draughtsmanship could be cited than his miniature of Joel Poinsett, which can be all the better appreciated if we follow Horace Walpole's suggestion and submit it to the test of enlargement (Plates XXII and XXX).

His colour, as we have remarked, is another of Malbone's great charms. His favourite scheme, which we see illustrated in such miniatures as those of Miss Poinsett, Major Wragg, Archibald Taylor, and Mrs. Lowndes, is an intermingling of clear purple with Boucher blue. The effect is similar to the precious Chinese porcelain of the Sung dynasty, known as Chün-yao. In the dainty portrait of Mrs. Lowndes, Malbone has kept his shadows light and airy, even going to the length of brightening the eye sockets with touches of gold powder, as a strong magnifying glass discovers. His portrait of Rebecca Gratz, on the contrary, is all toned down to browns in accord with the sitter's brown eyes, and the portrait of Mrs. Thomas Amory is a harmony of gray and lavender.

In the work of Benjamin Trott there is discoverable no such diverting variety within the uniformity of a style triumphantly determined. Variety there is aplenty, to be sure, but of a puzzling sort. As for triumphant uniformity, there are indeed characteristic and indubitable Trotts to be found, but miniatures also come to hand which are almost surely by Trott, or probably by Trott, or merely possibly by Trott, Thus, we see at once that Trott lacked Malbone's high talent, integrity, conviction. For one thing, his active career extended somewhere near fifty years as against Malbone's twelve, which would lead us to expect some changes in style. But apart from this, Trott undoubtedly had spells of imitativeness, of passionate eclecticism. We have already

40

witnessed his attempt to discover the supposed chemical secrets of the successes of others, especially of Walter Robertson. In 1806, when his own work was strongest and Robertson was probably ten years gone from America, Dunlap tells us that Trott's mind was still possessed by this "megrim," this "most mischieveous notion." When Malbone on one occasion suggested swapping miniatures with him, Trott immediately suspected a ruse designed to demonstrate how inferior his work was to Malbone's. All this odd behaviour Dunlap shrewdly explains by observing that Trott seemed to have a consciousness of inferiority. He all but calls it an inferiority complex.

As to Trott's copies after Gilbert Stuart's portraits, if we have correctly identified them, they are of very unequal merit. The Joseph Anthony and the Joseph Anthony, Jr., which are painted in one and the same style, are a heavy travesty on the work of Walter Robertson. They were probably painted before 1800. A later work, in which we recognize Trott's very own style with its clarity and ease, is the copy after Stuart's Mrs. James Greenleaf, and no one could ask for a more beautiful miniature (Plate XXVI).

But, compared to works by Malbone and Fraser, those of Trott are rare despite his long life. If this is due partly to the difficulty of identifying them, it is also true that Dunlap more than once deplores Trott's idleness and waste of time over side issues. In 1805, however, we are told that Trott made a journey on horseback into the "Western world beyond the mountains," carrying his painting materials in his saddlebags; and thus he spent a very lucrative year. One of his finest miniatures (Plate XV) was probably painted at this time. The costume would date it between 1800 and 1810. Much of its beauty, as with all of Trott's characteristic works, lies in the clarity of its colour, the absence of artificiality or mannerism, and the pearly harmonious relation between the figure and the almost bare ivory which constitutes the background. The sitter in this case is a man of action, a vigorous man of about forty years. There is nothing of the dandy or the courtier in him, and Trott has not tried to supply the quality. In the back of the frame is a fragment cut from the end of a letter signed: "Goodbye, Chas. Wilkins." In pencil is added (later, of course): "Lexington, Ky., July 1824." Another beautiful and unquestionably veracious miniature probably resulting from the visit to the "Western world" is the portrait of Charles Floyd of Virginia. Shortly after his return to Philadelphia in 1806 Trott painted the appealingly unstudied miniature of Peregrine Wroth (Plate XXVI), who was then a young medical student at the Uni-

versity of Pennsylvania. It was perhaps two years later still that he painted his exquisite unfinished miniature of Nicholas Biddle, merely a delicate monochromatic sketch on the naked ivory (Plate XXV). The beautiful Byronic young man must have sat to Trott not long after the termination of his mission to France, whence he returned in 1807 at the age of twenty-one.

Trott continued to make Philadelphia his home until 1820 or later, and he must have painted many miniatures which are hidden away in the dark houses of old Philadelphia families. Late in his stay he made at least one brilliant little portrait of Benjamin Chew Wilcocks, and a beautiful proud miniature of Miss Waln. For some years he lived in comparative seclusion in Newark, New Jersey, where he had gone apparently to secure a divorce from a wife whom he had annexed in a rash moment. Here he painted miniature portraits that are still very fair but not so free and clear as the early ones. Among these is the John Woods Poinier belonging to the Rhode Island School of Design, and the little portrait of Mrs. Alexander W. Macomb (Plate XXVI). The miniature of Lewis Adams (Plate XXV) painted in 1828, long after Trott's best period, has still about it much that is serious and fine, as, for instance, the strong drawing of the sullen mouth.

Perhaps the discussion of Fraser's work should have taken precedence of Trott and so have followed immediately upon our remarks about Malbone, for Malbone was Fraser's early inspiration. Charles Fraser was born in Charleston, South Carolina, and spent his entire life in that city except for a few short trips North. He was born early enough to have been a grown-up lad of eighteen reading law when Malbone visited Charleston in 1800, and he lived almost until the outbreak of the Civil War. He was a friend and admirer of Malbone, the successful Yankee miniature painter, who was, after all, only five years older than he, and of course he thought the world of young Washington Allston, who was all his life such a tremendous social favourite that we are forced to wonder whether his talents might not have actually been blighted by it all.

But Fraser had strong leanings toward art before ever Malbone and Allston came to Charleston. He had tried his hand at miniatures, at water-colour sketches on paper, and at paintings. He was destined, however, for the law, and so he "read law," after a fashion, for some three or four years until the example and perhaps the persuasion of his two friends caused him to drop the law and try art as a career. To this

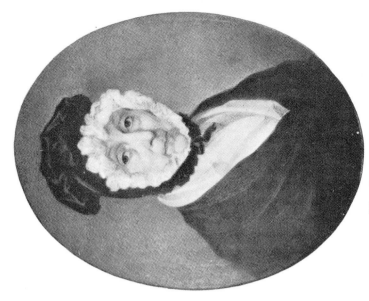

MRS. RALPH IZARD BY FRASER

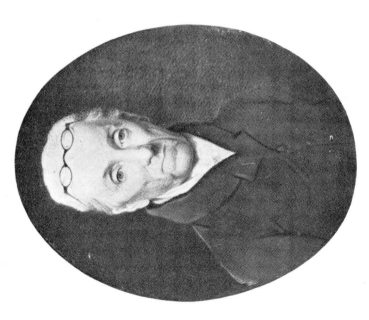

DR. ALEXANDER BARON BY FRASER

PLATE XXVIII

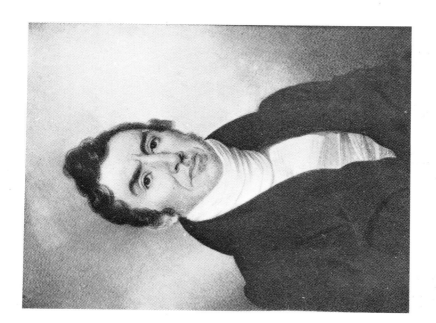

James Gourdin by Fraser

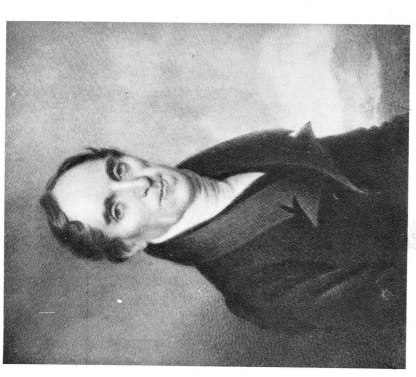

Francis K. Huger by Fraser

Plate XXIX

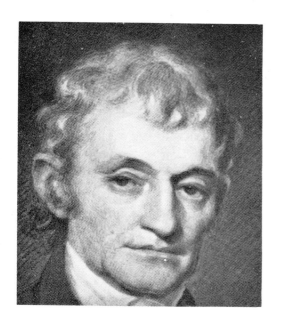

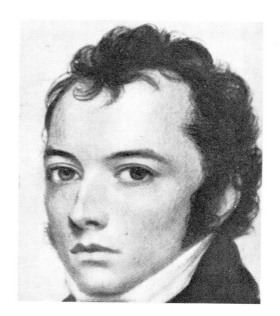

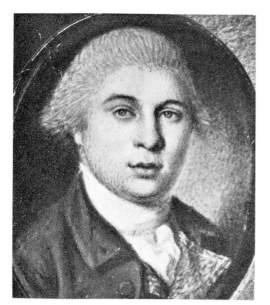

FIELD—ENLARGED DETAIL

C. W. PEALE—ENLARGED DETAIL

MALBONE—ENLARGED DETAIL

FRASER—ENLARGED DETAIL

PLATE XXX

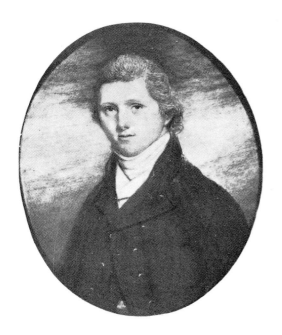

A MAN—DATED 1800—BY RAPHAEL PEALE
A LADY—DATED 1818—BY COLLAS

MRS. EDWARD SHOEMAKER BY THOMAS SULLY
DOYLE SWEENEY BY RAPHAEL PEALE

PLATE XXXI

period, about 1802, belong the charming miniature of his ten-year-old niece Jane Winthrop (illustrated by Alice R. H. Smith), and another in the same style of little Sarah Ladson, who grew up to be Mrs. Gilmor of Baltimore (Plate XXVII). The style of these early works is based on Malbone's—i.e., the "line style" again and very prettily modelled. Three years of it, however, convinced Fraser that he would have to return to the law, and finally, in 1807, he was admitted to the bar. By 1818, when he was thirty-six, he had laid by enough money to make it safe to go back finally to painting miniatures. But by this time he had developed a style of his own far in advance of his work in 1802, and we are forced to suspect him of unfaithfulness to his "jealous mistress" during all those legal years. His miniature of one of his Winthrop nieces, probably Jane again (Plate XXII), is a portrait of rare beauty and charm showing the child now arrived at the proud age of fifteen or sixteen years, and thus, if it is indeed Jane and not one of her sisters, painted about 1807 or 1808. Its fine texture reminds strongly of Malbone, as does its colour. But the method is now that of stipple, and the colour has in it more amethyst than Malbone was accustomed to use.

As the years passed, these characteristics of Fraser's work became more pronounced, the stipple becoming bolder as the average size of his ivories grew, and a deeper shade of amethyst becoming a usual note—as in the quizzical portrait of Henry Ogden (Plate XXVII). But there is an interesting variety in his colour. Of Mrs. Ralph Izard at the age of eighty, whom Copley had painted so charmingly half a century before, he paints a miniature all in tones of black and white, enlivened only by its red leather case (Plate XXVIII). Mrs. Theodore Gourdin, also no longer young, he paints becomingly in gray and lilac (Plates XV and XXX); and although one would have said his portraits of old ladies were his most delightful works, he has put the same affection into his portrait of old Dr. Baron, with his spectacles on his forehead (Plate XXVIII). The cold light of day which he turns full upon James Gourdin (Plate XXIX) is in entire sympathy with Fraser's conception of the subject's "hard-boiled" nature. Indeed, Fraser's passion for the frank observation of character and its facial indications contributes a pronounced interest to his work—constitutes, perhaps, even its chief interest. And yet Fraser's people seldom come quite alive for us, their qualities seeming as though diluted: his reading of character, interesting though it always is, never for a moment achieves profundity.

43

IX. PHILADELPHIA AGAIN—AND BALTIMORE

REMBRANDT PEALE—RAPHAEL PEALE—ANNA C. PEALE—M. J. SIMES—SULLY—FREEMAN—SAUNDERS

IN PHILADELPHIA, early in the Nineteenth Century, we find the name of Peale continues to be prominent where art is mentioned. As we have seen, James, the younger brother of Charles Willson, continued to paint in miniature at least as late as 1812. Meanwhile, the numerous second generation had begun to paint, too, and soon at least one member of the third. Charles Willson Peale had many children by his first wife, and for these he prognosticated, or perhaps rather sought through invocation, artistic careers of the first magnitude by the names he bestowed upon them. Among these were Raphael, Angelica Kauffmann, Rembrandt, Van Dyck, Titian, and Rubens.

But the only one of all the children to achieve much fame was Rembrandt. We have already seen him at the age of seventeen sitting beside his father and painting President Washington from life. He later attempted miniatures also, but just how far he went in this field is a matter for conjecture. We know one interesting miniature portrait of an unknown man (Plate XXXI) which is signed R. P. and dated 1800 and there are at least four others by the same hand, portraying Benjamin I. Cohen of Baltimore, Andrew Ellicott of Pennsylvania,[1] and Abijah Brown and Doyle E. Sweeney (Plate XXXI). There is evidence in the papers of the Peale family that Rembrandt had announced himself as a "Portrait Painter in Oil and in Miniature" during the years 1796 and 1799, while he was associated with his elder brother Raphael in Baltimore. Dunlap also calls attention to his advertisement in a Philadelphia newspaper in December of 1804 reading, "REMBRANDT, PORTRAIT PAINTER IN LARGE AND SMALL," etc.

On the other hand, there exists a letter written late in 1799 by the anxious sire of Rembrandt and Raphael in which he tells that Raphael has settled in Philadelphia

[1]See A. H. Wharton, Social Life in the Early Republic, p. 54, for the Ellicott miniature. A photograph of the Cohen miniature, attributed to Trott, is at the Frick Art Reference Library.

"and follows miniature painting," while Rembrandt is travelling through Maryland, where his portraits are admired for their force of execution.[1] An advertisement in a Philadelphia paper, August 3, 1801, reads: DEATH Deprives us of our Friends, And then we regret having neglected an opportunity of obtaining their LIKENESSES. Raphaelle Peale Painter (in Miniature and Large), Will deliver LIKENESSES At No. 28, POWELL STREET, Which is between Spruce and Pine and running from Fifth to Sixth street." Thus the possibility presents itself that the R. P. on our miniatures may refer to Raphael rather than Rembrandt. Another letter from the father written in September, 1804, states that Rembrandt, then in Philadelphia, "has only painted one miniature and is dispirited for the want of encouragement in the art of painting."

A single odd and entertaining miniature is known which may very well show Rembrandt's style at the age of twenty-three, a very different matter from the group of miniatures already described. It is the brownish, rather clumsily hatched portrait of his brother Rubens, still owned in the Peale family, which shows a solemn youth peering directly ahead through narrow spectacles with octagonal lenses. The identical pose occurred in the portrait of this young man, shown in the Peale exhibition of 1923 (No. 73) where he holds a potted red geranium in his hand—said to have been the first geranium brought to America. This painting is signed: *Rem. Peale 1801*.

The career of Rembrandt Peale extended, of course, for several decades after the time of the little Rubens Peale portrait, and many Philadelphia miniatures which exhibit rather prosaic likenesses painted in heavy browns and blacks have been attributed to him, but they are probably in reality by Thomas E. Barratt in most cases and perhaps by Jacob Eichholtz of Lancaster in some. A miniature which may with fair certainty be attributed to Barratt is the portrait of Josiah Elder of Harrisburg (Plate XXXV.) Summing up the entire matter, then, we must conclude that Rembrandt Peale can have had no real importance in the miniature field and should be taken seriously only in the field of portraits painted in oils. It is generally agreed that the best of these are the portraits of celebrities painted for his father's museum during two trips made to France in 1807 and 1809 for this express purpose. Among his sitters were Gay-Lussac, von Humboldt, Cuvier, Denon, Houdon, and David.

Returning then to Rembrandt Peale's elder brother Raphael (or Raphaelle as he

[1] From information kindly supplied by Horace Wells Sellers, Esq.

himself capriciously preferred to spell it), we definitely learn upon searching further that it is he, not Rembrandt, who painted the miniatures signed R. P. Much patient rummaging among old papers has discovered a photograph of the Andrew Ellicott miniature which is illustrated in Miss Wharton's book as noted above. The photograph reveals what the half-tone fails to show, namely, a clear signature: *Rap. Peale 1801.* Later on were discovered two little portraits of Maryland sitters both again dated 1801. That of Henry Ward Pearce, aged 64, is signed *Raphᵗ Peale*, while that of his son Benjamin is signed in full: *Raphaelle Peale.* To these three clearly signed works, Mr. Du Puy's Portrait of a Man, signed R. P., and the three unsigned portraits already mentioned may be added the unsigned but characteristic portrait of Major-General Thomas Acheson. In style the miniatures thus far identified owe much to James Peale, yet they are refreshingly untraditional. The facial expressions tend toward alertness and gentleness. The colour is comparatively undiversified, the coats being rendered in solid gauche and the features modelled in blue hatching with little colour in the flesh. The backgrounds are pale and clear and sometimes striated as though with clouds. No feminine subjects have thus far been recognized as by Raphael Peale.

Still another member of this astonishing family to make a name as a painter was Anna Claypoole Peale, a daughter of James and therefore a niece of Charles Willson. One of the earliest miniatures by her of which we happen to know is her portrait of Mrs. Andrew Jackson, which Miss Wharton tells us was painted in 1819. A charming and typical example of her work is the miniature of young Eleanor Britton (Plate XXXII), who later married William Musgrave of Philadelphia. It is signed in full, as most of Anna Peale's work is, and dated 1821. During the 'twenties she painted many miniatures in Philadelphia and Baltimore, and at least as late as 1838 she was still painting in both cities, signing her maiden name or her married name, Mrs. A. C. Staughton, as happened to please her at the moment. Though twice widowed, she continued painting in New York, Washington, and Boston, as well as Philadelphia and Baltimore, and like most of her family she lived to a ripe old age. Her work is always sprightly, charming, and entertaining, though usually shallow. If one dared, one would use the forbidden word "cute" in its colloquial American sense, to describe most of Anna Peale's miniatures of ladies.

Anna Peale's niece, Mary Jane Simes, who s a Baltimorean, carried the tradi-

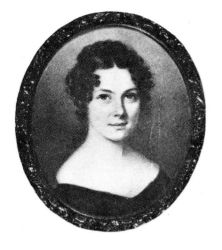

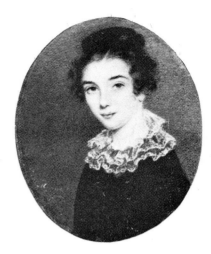

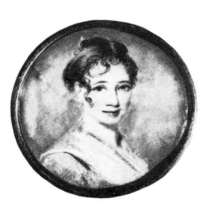

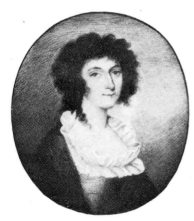

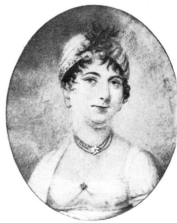

MRS. JOHN C. BRUNE BY MARY JANE SIMES ELEANOR BRITTON BY ANNA C. PEALE

THE ARTIST'S WIFE BY THOMAS SULLY

A LADY BY LAWRENCE SULLY DOLLY MADISON—ARTIST UNKNOWN

PLATE XXXII

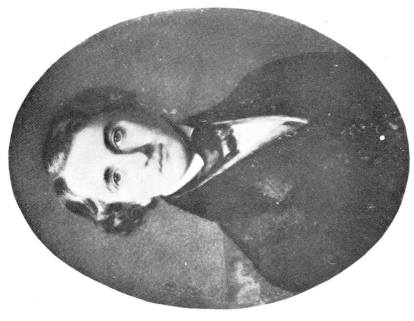

SOPHIA CARROLL SARGENT BY SAUNDERS

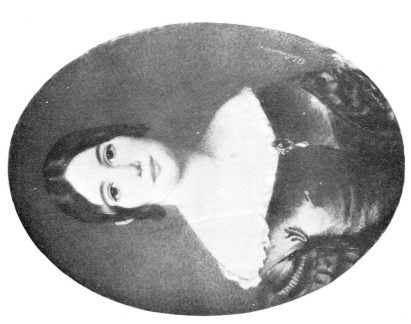

THOMAS BARTOW SARGENT BY SAUNDERS

PLATE XXXIII

tional family profession into the third generation. We know little about her except that James Peale's daughter Jane was her mother, that she was "herself a living miniature," and that her father was one Samuel Simes (whose name rhymed with "hymns"). As early as 1831 she lived in Baltimore with her Aunt Sarah Peale, the portrait painter, and her presumably widowed mother, who taught music. She painted her signed miniatures of Mr. and Mrs. Robert D. Burns of Baltimore in 1829; her portraits of Captain and Mrs. Robert Hardie are dated Baltimore, 1832, while the portrait of Mrs. John Christian Brune (Plate XXXII) should be dated yet a few years later, according to the sitter's costume. Miss Simes's miniatures while retaining the charm of her Aunt Anna Claypoole Peale's work are somewhat more serious portraiture.

Bidding farewell finally to the Peale family, we turn to the consideration of Thomas Sully as a painter of miniatures. It is with difficulty that we associate his name with any city other than Philadelphia. As a matter of fact, however, Sully had already lived about twenty-six years of his life before he settled in the City of Brotherly Love, and although that may seem a mere trifle in a life that lasted eighty-nine years, the point for us is that most of Sully's productivity as a miniature painter had occurred before Philadelphia saw him.

It was in Charleston, South Carolina, that Thomas Sully received his early schooling, such as it was, his English parents, who were actors, having come to that city in the pursuit of their calling. When he was sixteen years old, his relations with his French drawing master, Monsieur Belzons, terminated in a furious fist fight, and young Thomas managed somehow to persuade a skipper to take him to Richmond. Here he joined his brother Lawrence, a miniature painter who was thirteen years older than he and already responsible for a wife and a growing family of little girls—luxuries he could ill afford, for Lawrence Sully's success in his profession was not great, nor did the quality of his work merit general enthusiasm (Plate XXXII).

Within two years of his coming to Richmond, i. e., by 1801, according to Dunlap, Thomas Sully was the better artist of the two and the main support of the household. The scale on which the young Sullys lived in those days may be judged by the figures in Thomas's meticulous Register, then already begun, which shows that in the year 1801 he took in a total of one hundred and eighty dollars. His fifth miniature, that of Monsieur Ott, the jeweller, which he painted that year, is inscribed on the back:

T. Sully, Miniature and Fancy Painter, Norfolk, 1801. This reference to himself helps to draw our attention to an aspect of Sully's work and taste too often overlooked. Biddle and Fielding, in their book on Sully, list more than five hundred fancy pictures, and Dunlap's biography of Sully opens with a tribute to this successful portrait painter, "whose designs in fancy subjects all partake of the elegant correctness of his character." As to Sully's "elegant correctness" it may be observed that we hear no more of fisticuffs from young Thomas after his bout with Belzons. Portraits of him as he matured, advanced, and finally aged all contribute to our impression of a mild, correct, and kindly gentleman.

To return to those early days, however, we find that, while his brother Lawrence was continuing to pin his faith to Richmond, Thomas Sully was trying his luck in Petersburgh and in Norfolk in which city he was fortunate in having his first instruction in oil painting from Henry Benbridge. But in 1804 or early 1805 Lawrence died, and after a year's decent interval, Thomas married the widow, an attractive woman whom he had already perhaps been in love with for years without knowing it. She bore him several children in addition to the four daughters she had already borne to Lawrence.

By this time Thomas Sully was about twenty-three years old and had painted more than forty of the entire sixty-odd miniatures which his biographers credit him with during a long lifetime. Unlike Malbone, Sully did not come quickly into his full stride, and these early works are not particularly impressive.

But now Sully's ambitions were all in the direction of painting in oils, and he went to New York, where Jarvis helped him with useful hints, and to Boston where Stuart taught him what he conveniently could. In the autumn of 1808 he was back in New York where he found the Embargo in force and times hard, but Jarvis took him in as an assistant.

Early the next year Sully was urged by Benjamin Wilcocks to come to Philadelphia, which he was glad to do. Several gentlemen of that city joined in patronizing the promising young artist and sent him to England to complete his training. Arrived in London, Sully went as a matter of course to ask the advice of Benjamin West, bringing with him a portrait he had recently painted. West's stern advice was, "study anatomy." This advice Sully unfortunately never took with sufficient seriousness.

Instead he studied Sir Thomas Lawrence, and much that is lovely and at times even brilliant in Sully's style can be traced to this source, but also much that is facile.

The development of his style in miniature painting naturally paralleled his work in oils, and his little portrait of Mrs. Caroline Shoemaker (Plate XXXI), to take a typical example of the period after his London schooling, is lovely in the grace of the relaxed pose and in the harmony of pale flesh against the olive background relieved by touches of sky-blue; but as usual there is wanting in the face that reassuring rightness of drawing which we always get from Malbone.

Another miniature painter whom one usually, and with reason, thinks of as a Philadelphian is George Freeman. He was a farmer's boy from Connecticut who taught himself to paint miniatures and who probably never saw Philadelphia until 1837 when he was almost fifty years old. He had spent twenty-four years in England and seems to have had considerable success there, though his drawing always remained a very weak point. He was fortunate, however, in being able to catch something of the loveliness of his women sitters when they had that quality. After his return to America, he was particularly favoured in Philadelphia in having as a sitter Mrs. Edward Biddle, earlier known as the charming Miss Sarmiento and as Mrs. Craig. But for the miniature Freeman painted of this lovely lady he would probably be almost forgotten to-day. Freeman painted on comparatively large pieces of ivory, as the fashion demanded in the 'thirties and 'forties.

Another painter who flourished at about the time Freeman was painting in Philadelphia, and whose work is far from rare, is George L. Saunders. He usually signed his miniatures by scratching his signature *G. L. Saunders*, through the paint with the point of a needle. Except for his practice of signing his work, it would be hard to believe that all his miniatures come from the one artist, for they differ in quality as blue skim-milk differs from cream. Some are thin, almost devoid of modelling, harsh in colour and stereotyped in drawing, whereas the best examples, such as the portraits of Thomas Bartow Sargent and his wife Sophia Carroll Sargent (Plate XXXIII), are well modelled, and richly yet harmoniously coloured.

Saunders's sitters are mostly Baltimore people, and their portraits seem generally to have been painted between the years 1840 and 1845. But Saunders's name does not appear in the Baltimore street directories of the time. Probably he worked in Philadel-

phia also, for among his best works are his portraits of Benjamin C. Wilcocks and his wife. As to his origin, George L. Saunders should doubtless be identified with the Scottish painter of that name who frequently exhibited miniatures in London between 1829 and 1853, and who painted portraits in little of Lord Byron and Princess Charlotte.

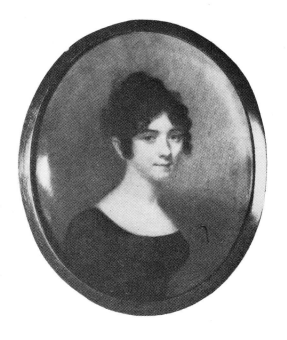

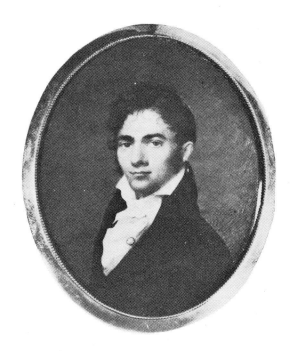

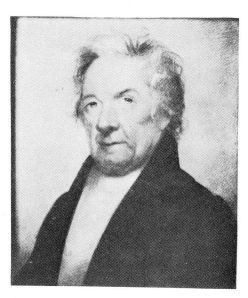

MISS ANDERSON BY JARVIS
MRS. ROBERT WATTS BY DICKINSON

ROBERT DORLON BY DICKINSON
GILBERT STUART BY EZRA AMES

PLATE XXXIV

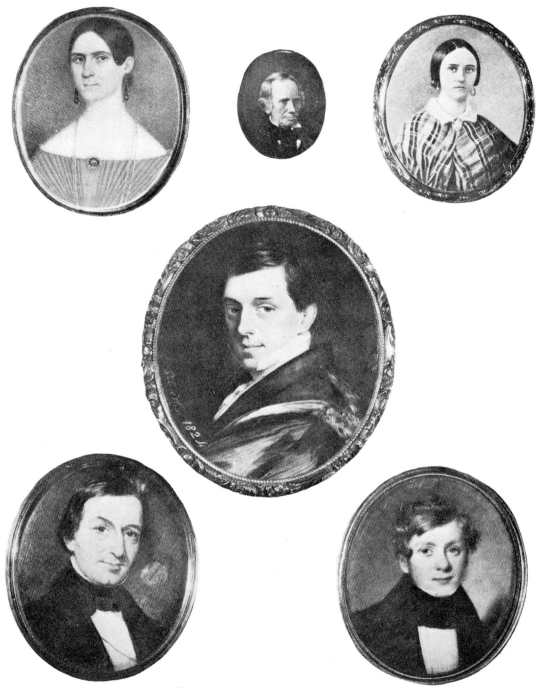

HENRY CLAY BY MACDOUGALL

MRS. HUGER—ABOUT 1845—ARTIST UNKNOWN MISS SULLY (?)—ABOUT 1860—ARTIST UNKNOWN

CHARLES E. BERGH I BY CATLIN

JOSIAH ELDER BY T. E. BARRATT GEORGE CATLIN BY J. W. DODGE

PLATE XXXV

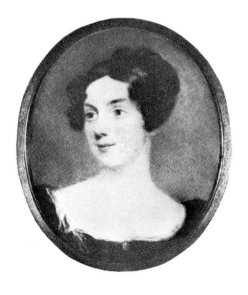

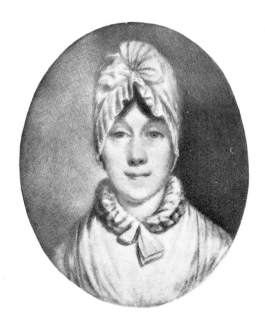

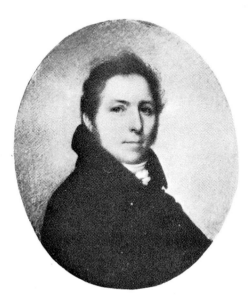

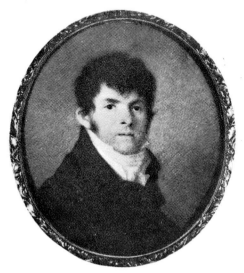

A Lady by Henry Inman
John Greene Proud by Joseph Wood

Mrs. Aaron Olmstead by Dunlap
A Man by Joseph Wood

PLATE XXXVI

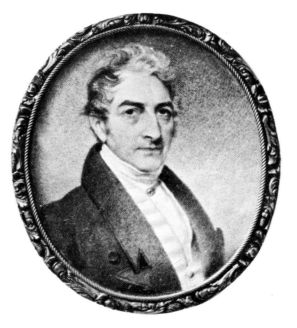

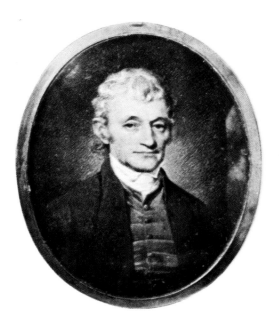
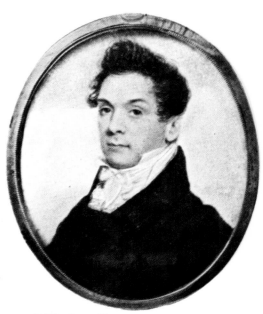

James Bogert, Jr. by Henry Inman
James Earle by Robert Field

J. W. Gale (?) by Anson Dickinson
A Man—Dated 1809—by John W. Jarvis

PLATE XXXVII

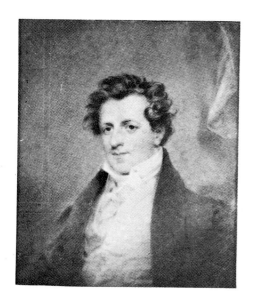

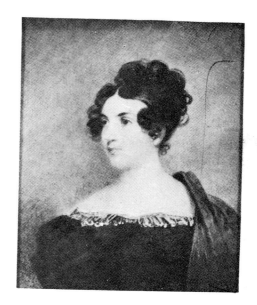

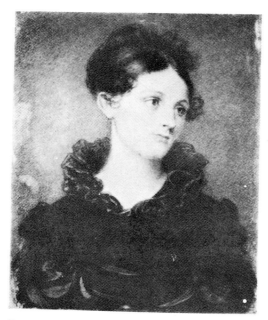

A Man by Inman

A Lady by Inman

A Lady by Inman

PLATE XXXVIII

X. EARLY NINETEENTH CENTURY NEW YORK

DICKINSON — DUNLAP — JARVIS — WOOD — INMAN

N EW YORK in the first two decades of the Nineteenth Century had become a large and bustling city which challenged the supremacy of Boston and Philadelphia. From being the least of these cities in the matter of resident artists, as it was in the active days of Copley and Charles Willson Peale, it had now become a centre to which ambitious young artists naturally gravitated. Thus a considerable group of capable portrait painters who worked in oils or in water colour on ivory or else in both media made New York their headquarters, though opportunities in other cities or else sheer *Wanderlust* beckoned some of them away sooner or later.

One of the talented young men who came to New York was Anson Dickinson. He was born near Litchfield, Connecticut, and his father, who was himself somewhat of a portrait painter, had the boy apprenticed to a silversmith and later sent him to Hartford to take lessons in drawing. He was highly talented and learned by imitating some of Malbone's miniatures. Dunlap tells us that Dickinson was painting miniatures in New York at least as early as 1804. From 1805 to 1810, he had a good practice in Albany. In 1811, he was at work again in New York, and Dunlap considered him the best miniaturist working there at the time. A very handsome and promising young man Dunlap thought him, but the promise of his youth had not been realized owing to a "wandering and irregular life." Perhaps Dunlap was too much inclined to pessimism over irregularities of conduct. He had never ceased regretting his own early indiscretions in London, and such deplorable cases as that of Jarvis had left him sad. However, as regards Anson Dickinson, H. W. French[1] agrees with Dunlap, observing that Dickinson, "Narcissus-like, was waylaid by his own beauty." In spite of this, there are fortunately some choice miniatures by Dickinson, painted during the "irregular" part of his life, namely the 1820's.

From Dickinson's earlier New York and Albany period there are such sensitive

[1]See: Art and Artists in Connecticut, Boston, 1879.

portraits as that of Robert Dorlon of Catskill, New York, painted in 1806 (Plate XXXIV) as well as the miniature of a man thought to be J. W. Gale (Plate XXXVII) and that of Mrs. Robert Watts (Plate XXXIV). One sees at a glance that Dickinson had a rare talent for revealing the gentler aspects of his male sitters without making milksops of them. The most distinguishing characteristic of his work is his love of almost monochromatic colour. His J. W. Gale has an olive skin against a dark choco-late ground (a favourite combination), and in his Mrs. Watts he has merely used va-rious shades of olive together with a white dress.

Contemporary with Anson Dickinson was William Dunlap himself, who, as we have seen, had some acquaintance with this "irregular" and very handsome young miniature painter from Connecticut. Dunlap had indeed an acquaintance with a great many American painters over many years, and this fact adds greatly to the correct-ness as well as the vividness of his invaluable *History of the Rise and Progress of the Arts of Design in the United States*. He was sixty-eight years old when this opus was published and had been knocking about the country meeting people since boyhood. Although he wrote and adapted many plays and wrote also a *History of the American Theatre*, and although, moreover, he painted many miniatures and was a more or less active painter of portraits and religious pictures during not less than twenty years of his life, Dunlap's activities as the "American Vasari" remain his life's chief contribution so far as we are concerned to-day.

In his *History*, Dunlap has written a long autobiography which shows him to have been a frank, likable, and unassuming man, with too many conflicting interests and curiosities ever to have trained himself thoroughly to any one accomplishment. In London, as a boy of eighteen, he continued to indulge himself as he had always been indulged at home—but with a difference. He had little or nothing to do with the drawing and painting he had come to London to learn, and for the rest of his life, as we have seen, regretted those early dissipations and lost opportunities.

But in other forms he continued through life to indulge his insatiable curiosity and love of change. From painting, after his return from England, he went into really heart-felt Abolitionist activities, from Abolitionist activities into business with his father, and from business into theatrical ventures which bankrupted him. He now tried miniature painting as a way to make a living, and in pursuit of sitters managed

to see Albany, Boston, Philadelphia, and Baltimore. It was at this time, 1806, that he painted several miniatures of his friend Charles Brockden Brown, the amiable Philadelphia novelist. Dunlap was now forty years old and married into the cultivated Connecticut family of Woolsey, which gave him President Dwight of Yale for a brother-in-law. But, when an offer suddenly came to manage a theatre, painting was again utterly forgotten for six years. The theatrical work having next developed disagreeable aspects, and a magazine (!) having exhausted his funds, Dunlap returned to painting miniatures in 1812, and it must have been at this time that he painted in Hartford his miniature of Mary Langrell Bigelow, wife of Major Aaron Olmsted (Plate XXXVI).

"I was discouraged," Dunlap once wrote, "by finding that I did not perceive the beauty or effect of colours as others appeared to do. Whether this was a natural defect, or connected with the loss of the sight of an eye, I cannot determine." However this may be, certainly his miniatures bear testimony to the defect described, for besides being ill-drawn, they have scarcely more colour than a freshly caught halibut.

After he had filled his commissions in Hartford and New Haven, Dunlap proceeded to Boston, where he showed some of his miniatures to Stuart and was solemnly advised to try painting in oils. Accordingly, he returned to New York and had been painting in oils for two years when, out of a clear sky, came the offer of a position as assistant paymaster general of the state militia. Of course, Dunlap took the job, for didn't the work include the exploration of parts of New York State which he had never seen—not to mention a regular salary?

And so it went. But after 1819 (he was then fifty-three years old) he actually did devote a large part of his time to painting, and a few miniatures were included in his output. Oil portraits he painted in considerable numbers, finding sitters from Virginia to Vermont, and some of these works were attractive and well painted. Part of his income, meanwhile, came from the public exhibition of large religious paintings which, to judge from his own descriptions, must have been in the bombastic (or heroic) style which had grown famous with Benjamin West. His Christ Rejected, Dunlap exhibited in scores of cities and even in towns and villages.

John Wesley Jarvis was another of the young artists who came to New York early in the century. Fourteen years younger than Dunlap, Jarvis was in some ways

even more eccentric, though lacking Dunlap's disinterested and distracting enthusiasm for causes and worthy enterprises. He had, in any case, far more talent for painting than Dunlap ever revealed and was better at sticking to his last.

Jarvis had his early training mostly from David Edwin, the English engraver, when they were both employed in Philadelphia by Edward Savage, Jarvis being an apprentice at the time. In 1802, the termination of his apprenticeship found him in New York, and he set himself up as an engraver on his own account. He was now twenty-two years old. Soon he fell in with a young man of about his own age, named Joseph Wood, and the two agreed to become partners and open a studio together for painting miniatures. This they did, and according to all accounts they had a very hilarious time of it together, both being convivial by nature and young by the accident of birth. For a while, they did a rushing business in *eglomisé* silhouettes—gold-leaf and black on glass—but gradually Wood got commissions for miniatures and Jarvis went in for oil painting. The attention of both these gay young men was a good deal taken up at this time with what Dunlap (in stage-whisper italics) calls *mysterious marriages*, and it is hinted that the breaking up of the partnership after a few years was due to a difficulty over such dark matters.

It was about this time that Jarvis painted the signed miniature of a man (Plate XXXVII) dated 1809, which belongs to the Metropolitan Museum of Art. It is typical of Jarvis's portraits of men, whether in oils or miniature, in being virile and solidly constructed with a tendency toward coarsening the features, and in being handled honestly and directly almost to the point of bluntness. His portraits of women, on the other hand, could be gentle and charming and very subtle in colour, as in the miniature of Miss Anderson (Plate XXXIV). Dunlap tells us that, for all his seeming frivolity, Jarvis was at times a hard student. He kept at his drawing and worked long hours over books on anatomy. Dunlap acclaims him probably "the first painter in this country who applied phrenological science to the principles of the art of portrait painting." But have we the right to smile?

It was in 1810, when Jarvis had reached the age of thirty, that he began to exploit the Southern cities, especially in the winters. At first he visited Charleston and Baltimore, and later, taking his boy apprentice Henry Inman with him, he went more than once to New Orleans where, according to his own account, he was able to "clean

up" six thousand dollars in a season, of which he would spend one half living in luxury and entertaining bountifully. His clients enjoyed sitting to him, for he was high-spirited and unfailingly witty after his own somewhat boisterous fashion. Dunlap devotes considerable space in his *History* to accounts of Jarvis's jokes, practical and otherwise.

His work meanwhile continued perversely to improve, and some of his masculine portraits of this period are especially strong and fine. It was at this time, toward the close of the War of 1812, that Jarvis received the coveted commission to paint several full-length portraits of heroes of that war for the City Hall in New York. Absorbed as he was in the pursuit of larger game, he appears by this time to have entirely given up painting miniatures. Portraits in oil he continued to paint for a number of years until marital difficulties seemed to take the heart out of him and conviviality gave place to sottishness. By the age of fifty, according to Dunlap's description, he had become an old and broken man.

Mention has already been made of Joseph Wood, who was Jarvis's care-free partner in their early New York days. Young Wood, who was the son of a self-respecting farmer in Orange County, New York, was blessed, or cursed, with that unaccountable, seemingly innate passion for drawing which in the course of the world's history has unfitted so many boys for living normally at home. His father adopted stern measures with the hope that he might still make a decent farmer of the boy, but Joseph, then aged fifteen years, ran away to New York.

We have no authentic history of how Joseph Wood, who longed to make landscape paintings and had of necessity to make a living, ever came to take up painting miniatures. An anecdote of a miniature seen in a silversmith's window would make it appear that Wood taught himself by copying the work of others. Later on, Malbone is said to have given him a demonstration of his personal method of preparing the ivory and proceeding with the work. In any case, Wood developed an excellent style of his own. A typical illustration of it is the miniature of John Greene Proud (Plate XXXVI), which was painted in 1812 when Wood had his studio at 160 Broadway, and after, perhaps long after, the dissolution of the firm of Jarvis and Wood. The figure of the subject is well placed in the oval, and the delicately modelled face has a somewhat olive cast. Wood's backgrounds are often of a rich, pellucid green, becoming lighter as

they approach the dark figure, but in the portrait of Proud there is a blue sky with clouds, against which the figure makes an interesting silhouette..

In 1813, Joseph Wood appears to have left New York for Philadelphia where he remained for several years. Later still, he is said to have painted miniatures in Baltimore, and finally he settled in Washington. Dunlap tells us that Nathaniel Rogers helped him and his children in the days of his adversity and that he died in Washington at the age of fifty-four, but the exact dates of his birth and his death are unknown.

It was in 1814 that Henry Inman came upon the scene in New York. His parents had moved down from Utica two years before, and Henry, who had a passionate desire to become a painter, had thus a better opportunity for instruction than could have been found in the raw town up-state. And now the celebrated Danaë by the Swedish painter Wertmüller was on exhibition at the painting rooms of Mr. Jarvis, so, of course, young Henry Inman, scarcely yet thirteen, must go and admire. But while Henry was admiring, Jarvis himself came into the room and, liking the boy's looks and speech, asked to have him as an apprentice. And so it was all arranged, and Inman became one of the New York painters.

It was at the peak of Jarvis's success that this important event took place, when that mad wag was beginning his glittering winter seasons in New Orleans and was on the point of setting about his big portraits of the naval heroes for the City of New York. In New Orleans, young Inman helped on the work by painting in backgrounds and parts of costumes, and on the great canvases in New York there must have been plenty for the boy to do, what with painting in battle flags, epaulettes, and so forth.

He stayed out his full term with his master, and a very entertaining and instructive time he must have had of it. As late as 1822, his term of apprenticeship now being ended, Dunlap tells of seeing him still in the company of Jarvis, knocking about Boston in search of commissions, but apparently finding none. Yet, despite his excellent opportunities to become a jovial and undependable fellow like his master and Anson Dickinson or a restless Jack-of-all-trades like William Dunlap, Henry Inman promptly settled down, took a pupil, found a wife, and became a cultivated and respectable gentleman. The sentimental Mr. H. T. Tuckerman writes a passage descriptive of the matured Inman which may be repeated for what it is worth: "His, however, is no confined ability, but rather the liberal scope of an intellectual man. He converses

delightfully, recites with peculiar effect, has a discriminating sympathy for literature, the drama, and the comedy of life, with genial social instincts, and a warm appreciation of whatever appeals to the imagination or involves any principle of taste."

With the exception of a few years in the 'thirties when he lived in Philadelphia or near by, and a year or two in the early 'forties when he was painting some excellent portraits in London, Inman's life was identified with New York. Here he painted many portraits of varying merit, including such excellent full-lengths as those of W. H. Seward and Richard Varick and several fine portraits of President Van Buren. When the National Academy of Design was organized in 1826, he became its vice-president and served in that capacity for many years. In 1842, at a dinner for Charles Dickens, where Washington Irving was toastmaster, Inman was one of the speakers.

As to Inman's miniatures the broad juicy strokes with which the heads, and especially the hair, are painted give unmistakable evidence that the artist is accustomed to working in oils. The backgrounds, however, are usually made with a fine stipple after the manner of the true miniaturist, while the colour, which is usually dainty and pastel-like, is not only unlike the colour of Inman's oil paintings, but is quite distinct from that used by other painters in miniature. One of his finest miniatures is the little rectangular portrait of Mrs. Alexander Hamilton, painted when she was aged sixty-eight (Plate XXXIX). A fine characteristic male portrait is that of James Bogert, Jr. (Plate XXXVII), where, against a light stippled background, the artist has played the sitter's delicate flesh, gray hair, pea-green coat, and pink and white striped waistcoat. His Portrait of a Man (Plate XXXVIII) shows, against a sandy yellow background, a pink-faced blond young person in a light gray coat. Inman painted very few miniatures, if any, after 1827, in which year he agreed with his partner, T. S. Cummings, to give up painting "in little," Cummings on his part agreeing to paint no portraits in oils.

XI. NEW YORK LATER IN THE NINETEENTH CENTURY

CUMMINGS — CATLIN — DODGE — N. ROGERS — MacDOUGALL —

ANN HALL

When Henry Inman settled down so sedately in 1821 after his time with Jarvis was up, he took into his service a pupil, as we have already observed. This pupil was Thomas Seir Cummings, who soon became a capable and prolific painter of miniatures and an important figure in the artistic life of New York. The arrangement between Inman and Cummings in 1821 was not the old-fashioned relation of master and bound apprentice. Cummings had already had some two or three years of creditable training in the drawing academy of John R. Smith whereas Inman himself was at the time a mere youth of twenty, the difference in age between master and pupil being less than three years.

In 1824, a partnership known as Inman and Cummings was formed. There had been a steady demand for Inman's miniatures, and Cummings had now begun to specialize in this unostentatious field. Inman, however, was far more interested in oil painting than in miniatures and therefore raised his price for miniatures to fifty dollars while Cummings kept his at twenty-five. In spite of this arrangement and the good quality of Cummings's work, many commissions for miniatures continued to come to Inman. Finally, in 1827, at about the time the partnership was dissolved, Inman definitely refused to accept further orders for miniatures, and for a time it was arranged that Cummings should charge fifty dollars, one half to go to Inman. Dunlap calls Cummings "the best instructed miniature painter then in the United States."

Cummings settled down very early to the serious things of life. At the age of eighteen he married a young English lady, Jane Cook by name, and became a steady family man. At the age of twenty-three he was elected treasurer of the newly organized National Academy of Design and continued to serve in that capacity for nearly forty years, serving also for many years as a member of the council and from 1850 to 1859 as

58

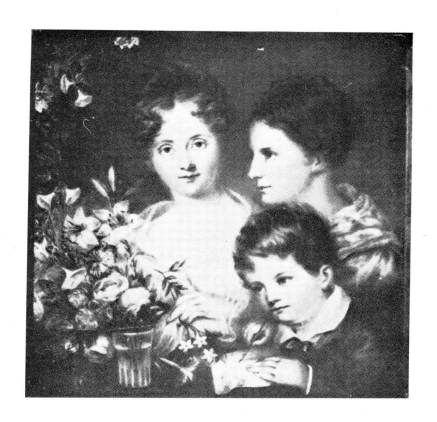

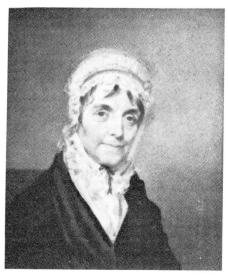

THE ARTIST WITH HER SISTER AND NEPHEW BY ANN HALL.
MRS. ALEXANDER HAMILTON BY INMAN

PLATE XXXIX

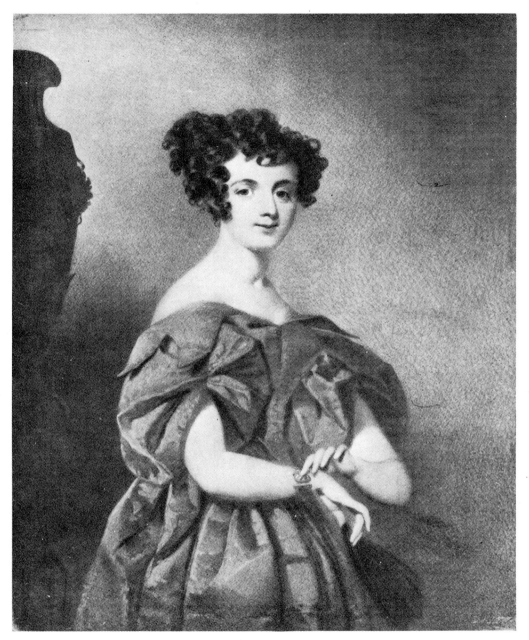

JANE COOK CUMMINGS BY THOMAS SEIR CUMMINGS

PLATE XL

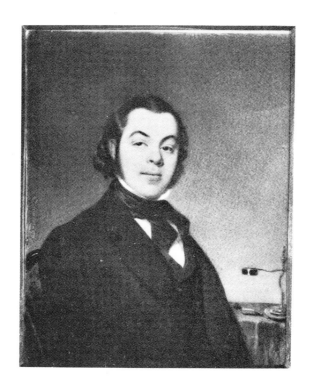

Benson J. Lossing by Cummings

A Lady of the Hancock Family—about 1840—by John Carlin (?)

PLATE XLI

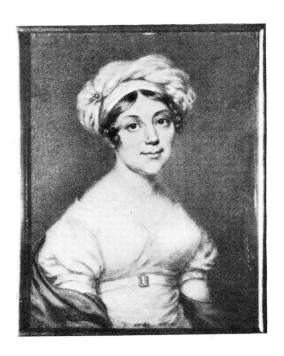

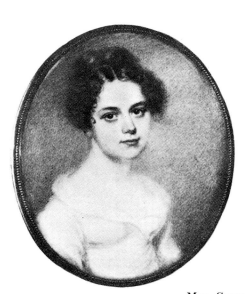

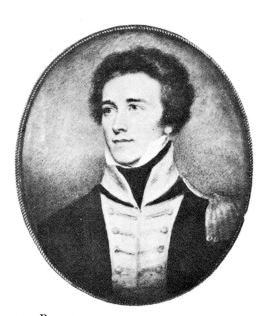

MRS. GABRIEL MANIGAULT BY ROGERS

A LADY BY ROGERS EDWARD ARMSTRONG BY ROGERS

PLATE XLII

vice president. He became professor of drawing and painting at the National Academy and later at New York University.

One of Cummings's early works in miniature is the delightful golden-brown portrait of his wife, painted at about the time of their marriage in 1822 (Plate XL). The dress is an elaborate evening confection, and the shoulders and arms are quaintly drawn according to the vogue of the day. On her wrist the young lady wears a bangle in honour of which the artist gave the miniature the name, The Bracelet.

As a rule miniatures by Cummings lack the freedom of Inman's work, and occasionally they seem almost pedantic, but they are faithful studies of the sitters, pleasing in colour, and well executed. An interesting portrait is that of Benson J. Lossing (Plate XLI), a delightfully real transcription of personality made all the more pungent by the play of the sitter's richly black coat against the emerald-green of the tablecloth and the upholstered chair in which he sits

According to his manuscript notes, now in possession of one of his daughters, Cummings did not exhibit any miniatures after 1851. His time after that was devoted to teaching and to writing his *Historic Annals of the National Academy*. In 1866 he definitely retired from his profession and moved to Mansfield, Connecticut.

None of the other New York miniaturists working in the second quarter of the Nineteenth Century was nearly so prolific as Cummings, and none, unless it may have been MacDougall, kept so long at the profession. George Catlin, for one, stopped painting miniatures in 1832 or earlier, after a professional career of less than eight years. Though born and brought up in Pennsylvania, Catlin belonged to a numerous family of that name in Litchfield, Connecticut. It was to Litchfield that he returned to study law, and there he was duly admitted to the bar, which ceremony marked the close of his legal career. Thereupon Catlin entered West Point and prepared himself for the military life, and when this had been satisfactorily accomplished he moved to Philadelphia, throwing himself devotedly into the study of art. He appears to have been self-taught.

In 1824, Catlin inaugurated his professional life as a painter by opening a studio at Hartford, but he evidently very soon moved to New York, for his miniature of young Charles Edwin Bergh, which was painted in that city, is signed: *G. Catlin*

1824 (Plate XXXV). It is a strong, clean-cut, and very handsome piece of work, and one looking at it can readily understand Catlin's prompt election to membership in the National Academy.

Catlin painted in oils, too, and was at this time awarded by the State of New York the commission to paint a portrait of DeWitt Clinton for the Governor's room in the City Hall. The result is dark and far from impressive. He also painted portraits of Mrs. Clinton and others for the Spring Exhibition, but quarrelled with the National Academy over their hanging. A miniature by Catlin of Mrs. Clinton, dated 1828, which belonged to the estate of President Andrew Jackson, is not nearly so fine as his miniature of Bergh.

In 1832 Catlin suddenly became interested in American Indians, and thereupon devoted eight years to making studies and sketches of forty-eight tribes in the valley of the Yellowstone River, in Arkansas and in Florida. He wrote an illustrated book on the subject which brought him fame. Following this, he spent several years in London, where he was lionized, and more years travelling and exploring in Central and South America, where he gathered material for lectures, books, and cabinets of curiosities. "In 1874," writes the pithy H. W. French in his *Art and Artists in Connecticut*, "he exhibited and sold at auction his entire collection of Indian sketches and relics, and a year after, a white-haired, very deaf old man came to the close of his eventful life as a lawyer, a soldier, a tourist, an artist, a showman, an explorer, a lecturer and a historian, that after all, through its own versatility failed to register in any way proportionate with itself."

The Metropolitan Museum owns a miniature of a gentle, merry, rosy-cheeked blond young man which would appear from the evidence to be a portrait of George Catlin (Plate XXXV). A folded paper found inside the frame bears in a middle-Nineteenth Century handwriting the inscription: "Painted by John W. Dodge, Miniature Painter No. 42 Franklin St., May 21, 1835. Likeness of George Catlin." Catlin would have been in his thirty-ninth year in 1835 and furthermore, if our data are correct, he would have been away off among the Indian tribes. But since the document seems to be otherwise in order we may assume that the portrait of Catlin was painted some years earlier than the writing of the paper.

The workmanship of the miniature is very direct and capable, like the work of an

accomplished painter in oils, and one cannot but wonder how so many young men in the Age of Innocence became such excellent painters.

About John Wood Dodge, who painted the miniature in question, we know very little. In 1832, he was made an Associate of the National Academy. Ten years later, he painted a miniature of Andrew Jackson. His activities during the fifty years which followed have not been traced, so far as we know. He lived until 1893, reaching the age of eighty-six.

The life of Nathaniel Rogers was briefer than that of Dodge, and its events have been sketched by Dunlap. Rogers came from Bridgehampton near Sag Harbor, Long Island, where his father was a farmer. As a partly trained artist, aged twenty-three, he arrived in New York in 1811, and Joseph Wood accepted him as a pupil. When Dunlap wrote in 1834, Rogers had been profitably practising his profession in New York for twenty-three years and was thinking of retiring on the proceeds to his old home on Long Island. This he did before many years, and died there in 1844, at fifty-six years of age.

Miniatures by Nathaniel Rogers are fairly plentiful in New York. In drawing they always leave something to be desired, and his sitters' faces are often very nearly expressionless. His flesh colour furthermore so often borders on a buff-brown shade that it becomes a trying mannerism. The fashionable insistence during an entire generation that Mr. Rogers and none other must paint one's miniature must have arisen from other circumstances than the artistic merits of his work. Dunlap liked and admired him. Besides being a good provider for his large family, he was a trustee of the public schools and of several charitable and moral institutions (See Plate XLII).

Not long after Nathaniel Rogers withdrew to his home on Long Island, John Alexander MacDougall enjoyed several years of popularity as a miniature painter. These were the years 1840 to '45, during which time he had a studio on Broadway. He had a host of interesting friends and acquaintances and his clients included Henry Clay (Plate XXXV), Edgar Allan Poe, Charlotte Cushman, James Kelso, and "Commodore" Vanderbilt. He painted very small miniatures, which were careful, sober likenesses.

About the year 1846, MacDougall left New York with all its stimulating people and opened a large studio in Newark, New Jersey, where he not only painted minia-

tures but also took portraits by means of the newfangled photographic process. Here he is said to have settled down to a comparatively humdrum life, though he continued to have interesting friends about him. (See p. 91.) His photographic studio lost money, for he was not a man of business, but he seems to have been finical about his painting and to have kept up his standards.[1]

Ann Hall, the first woman member of the National Academy, came into prominence as a miniature painter a little earlier than MacDougall. She grew up in Pomfret, Connecticut, and her father, Dr. Jonathan Hall, encouraged her childhood passion for drawing pictures of the flowers, fishes, birds, and insects which she could find near home. Later, her brother sent her from Europe some oil paintings and water colours which she at once set about copying. During a visit to Newport, old Samuel King, who had once encouraged Malbone and Allston, showed her how to paint on ivory. Later still, in New York, she had systematic instruction in oil and miniature painting at Alexander Robertson's academy, but she never lost her early passion for flowers, and painted them into her pictures whenever she could.

After she had finished her training, Miss Hall remained in New York, supporting herself by her profession, and her services were in considerable demand. H. W. French claims that she sometimes got as much as five hundred dollars for a single group miniature. Her draughtsmanship was not her strong point, but her colouring was sprightly and original, and she showed a dainty invention in her arrangements. The temptation to quote Dunlap's exceptionally enthusiastic comments is irresistible. "Miss Ann Hall stands very prominent among our best painters of miniatures," and again, "Her later portraits in miniature are of the first order. I have seen groups of children composed with the taste and skill of a master, and the delicacy which the female character can infuse into works of beauty beyond the reach of man—except it might be such a man as Malbone, who delighted in female society and caught its purity." Dunlap further refers to a miniature "in which children and flowers combine in an elegant and well-arranged bouquet," and gives high praise to "a group of two ladies and a boy combined with flowers." This last probably refers to the little portrait which Miss Hall painted in 1828 of herself with her sister Eliza Hall Ward and Mrs.

[1] See Walt MacDougall, "This Is the Life," New York, 1926.

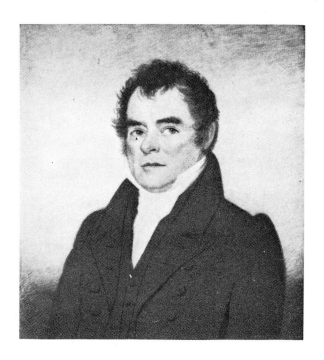

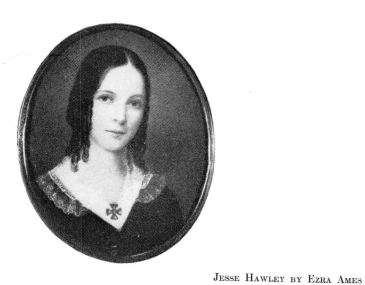

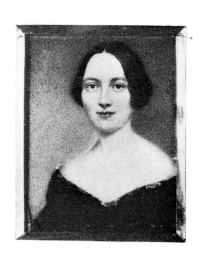

Jesse Hawley by Ezra Ames

A Lady—about 1840—Artist Unknown

Polly Vincent by James R. Lambdin

PLATE XLIII

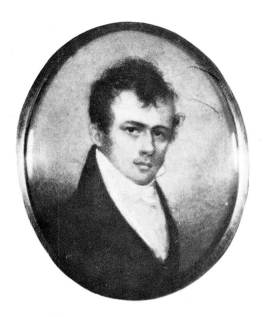

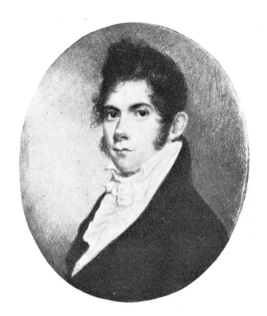

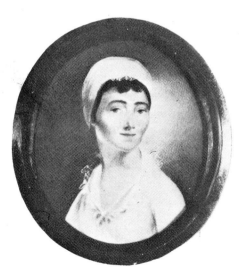

HENRY BURROUGHS BY H. WILLIAMS EDWARD COVERLY BY H. WILLIAMS

A LADY—ABOUT 1800—ARTIST UNKNOWN

PLATE XLIV

Ward's little boy Henry (Plate XXXIX). It is a dainty and lovable little confection. No one but Ann Hall could have painted it, and she could have painted it in no age but the one which we are considering.

Miss Hall lived to be seventy-one years old and died a spinster. At Saratoga, New York, in 1840, Edouart cut a quaint silhouette showing her at the age of forty-eight. She stands before her easel with her palette and brushes in her hands, a lady of somewhat severe aspect, but with handsome regular features.

XII. NINETEENTH CENTURY NEW ENGLAND

WILLIAMS — STUART — GOODRIDGE — ALVAN CLARK — STAIGG

AFTER the activities of the mysterious Joseph Dunkerley in the 1780's there seems to have been a temporary lapse in the production of fine miniatures in Boston. The hiatus was closed about 1810 by the art of Henry Williams. A signed miniature by him of Henry Burroughs (Plate XLIV) was painted in the year just mentioned. It is the portrait of a handsome young man, drawn with delicacy and accuracy. The shadow beneath the nose is curiously outlined instead of being expressed by hatching in the usual way. The scheme of colour is very restricted, consisting of little besides a smoky blue for the background, black for the coat and the drawing of the head, and white, somewhat forced up, for the ruffled shirt. A miniature of Edward Coverly owned by the Metropolitan Museum of Art shows the same characteristics (Plate XLIV).

Henry Williams was born in Boston in 1787, the year that Dunkerley painted his miniature of Henry Burroughs's mother. He appears to have had a very comprehensive training as an artist, for besides being an excellent miniature painter, he made silhouettes, relief profiles in wax, and portraits in oils and pastels. A delightful and very capable example of his work in pastels is the buff and white portrait of Sally Bass at the Boston Museum of Fine Arts. It has been attributed to John Johnston, but a pastel portrait lately come into the market, which resembles it closely in colour and style, is signed "Williams," and the drawing of it has, moreover, several of the distinctive earmarks which we find in Williams's miniatures.

Williams, who died in 1830, had advertised himself as a portrait and miniature painter at least as late as 1824. In the meanwhile, a young lady had also entered the profession of miniature painting in Boston. Sarah Goodridge was her name. She was born in 1788 in the pretty little hill town of Templeton, Worcester County, Massachusetts, and there she grew up. At the age of twenty-five, when she had had some experience at teaching a district school and a taste of city life during visits to her married sister, Mrs. Thomas Appleton, in Boston, she returned to Templeton and began to

64

paint portraits in crayons or water colours at rates that would appeal to her farmer neighbours. Before very long, however, she was back in Boston, living with members of her family and drilling herself at painting in oils and in miniature. She soon gave up oil painting, and as late as 1820, when she was a woman of thirty-two, her miniatures were still simple, earnest, and literally countrified performances (See Plate XLVII).

It must have been around this time that Gilbert Stuart took an interest in her, and it is through her that he came to paint his one miniature. The story of this interesting event is as follows: One day Miss Goodridge was in Stuart's studio working away over a miniature copy after his portrait of General Knox, which happened then to be in the room. After watching her groping methods for a while Stuart lost patience and, taking up a piece of ivory for the first (and last) time in his life, set about to demonstrate how a miniature should be painted. He naturally took for his subject the one which had been giving Miss Goodridge such a difficult time. The miniature which resulted is now privately owned in Philadelphia (Plate XLV). It consists merely of a bare rectangular piece of ivory with a rapidly painted head placed toward the upper left corner and just enough background hatched in to give the head relief. Unmistakably the work of a painter in oils, this, one would say, yet as beautiful a piece of miniature painting as any in the history of the art in America—quickly and broadly painted, with scarcely any colour on the ivory, yet the head in strong relief and marvellously subtle in construction. The miniature belonged to Miss Goodridge's nephew, Edward Appleton of Reading, Massachusetts, who died in that town, July 30, 1898, at the age of eighty-two. When it was brought to Philadelphia for sale in the year 1897, Emily Drayton Taylor, the well-known miniaturist of that city, was struck by its beauty and wished to make a copy of it. She received written permission to do so from the owner, Mr. Appleton, and she still has in her possession the excellent copy she then made.

But as to Sarah Goodridge. Did she profit by the brilliant demonstration she had witnessed? Not noticeably, most people would say. Her copy after Stuart's unique miniature is owned by Bowdoin College and it is interesting to compare its laboured crudeness with the easy assurance of Stuart's original. Still, the kindly advice and brilliant example of this blunt-spoken and snuff-stained old artist must have had some effect. Certain it is that Miss Goodridge's work between 1820 and 1824 bettered a

great deal, the characterizations of the sitters improving considerably and the high lights on the flesh becoming complex and rather tender, as we find them in the portrait of Mrs. Benjamin Joy (Plate XLVI). Probably Miss Goodridge's most delicate and finished workmanship is to be found after all in her miniatures of Gilbert Stuart himself, for the old man, he was then about seventy, sat to her several times (Plate XLVI).

A New Englander of great natural ability who turned his hand for a few years to painting miniatures was Alvan Clark. He was born in 1804, the son of a Massachusetts farmer. From 1827 to '36, he was an engraver for calico print factories in Lowell, Providence, Fall River, and New York, and thus began his training as an artist. In 1835, he began to paint miniatures and oil portraits professionally. The following year he moved to Boston and received a gratifying patronage.

Alvan Clark was thus an additional example of that curious but apparently not rare phenomenon, the self-taught American artist. His miniatures are painted ably and with perfect self-assurance. His portrait of his wife owes the tenderness of its effect largely to the delicate flesh tones and the pretty blue dress (Plate XLVII). His portrait of the Honourable Walter Forward (Plate XLVII) is confined to browns and is an accomplished and splendidly sturdy piece of characterization.

When Clark had been about eight years in Boston he became deeply interested in lenses and, forgetting his palette and brushes, he established a factory in Cambridgeport, where he and his sons are said to have made the first achromatic lenses in this country, and all the important American telescopes used in that generation.

The name of the miniature painter Richard Morrell Staigg is associated especially with Newport, Rhode Island, but he worked also in Boston and finally in New York. He was an English boy who had been an architect's assistant before he came to America in 1831 at the age of fourteen. He settled in Newport, and there he was encouraged by Washington Allston and Jane Stuart to take up miniature painting. He is said to have assiduously copied Malbone's Hours and some of his miniatures, but Staigg's work is technically at the opposite pole from that of Malbone. By 1838, he was actively engaged in painting miniatures in Newport. His typical miniature is fairly large in scale with a rich prevailing tone of purple and crimson, and a strikingly modern and able handling consisting of broad brush strokes flowing easily. He was particularly successful in

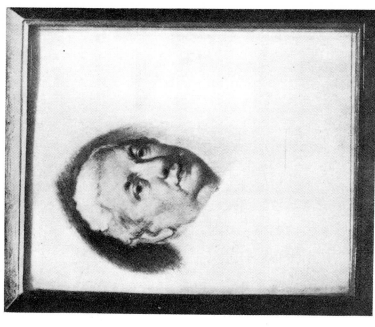

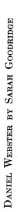

GENERAL KNOX BY GILBERT STUART

GENERAL KNOX BY SARAH GOODRIDGE

PLATE XLV

DANIEL WEBSTER BY SARAH GOODRIDGE

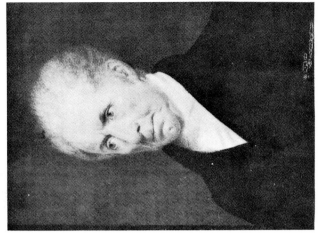

GILBERT STUART BY SARAH GOODRIDGE

PLATE XLVI

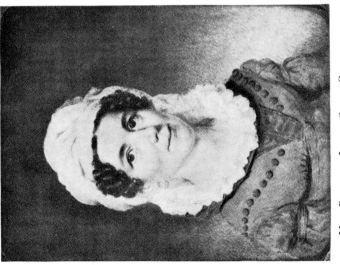

MRS. BENJAMIN JOY BY SARAH GOODRIDGE

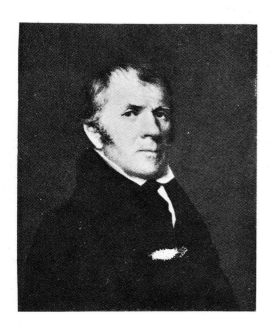

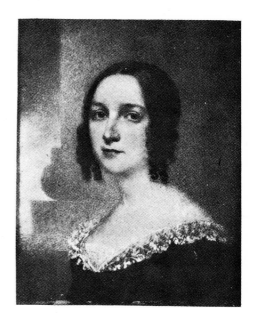

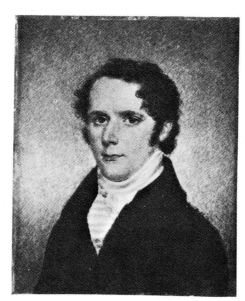

Hon. Walter Forward by Alvan Clark The Artist's Wife by Alvan Clark

Theophilus Parsons by Sarah Goodridge

PLATE XLVII

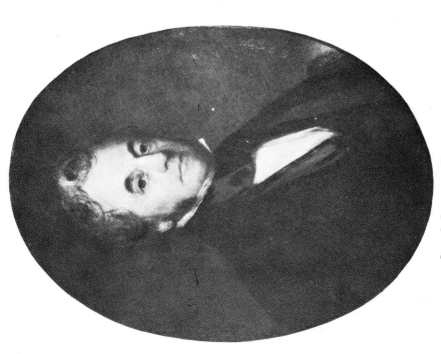

JOHN I. LINZEE BY STAIGG

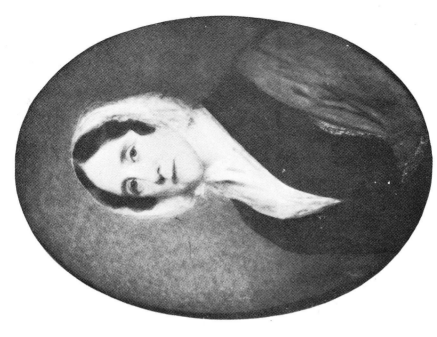

MRS. JOHN I. LINZEE BY STAIGG

PLATE XLVIII

catching in his portraiture the easy self-assurance and simple bearing of middle-aged sitters of position and refinement, his miniatures of John Inman Linzee and his wife (Plate XLVIII) being fine examples of his work.

Staigg made frequent professional visits to Boston and painted many of the most important people of that city, including Dr. James Russell Lowell and his wife, Edward Everett, Abbott Lawrence, and David Sears. About 1851 or '52, he began to spend his winters in New York and turned his attention more and more to portraits and small genre paintings in oils. A full list of his paintings which belongs to his niece, Mrs. George O. G. Coale, mentions only two or three miniatures as having been painted by Staigg after 1855, though he continued active as a painter for another twenty years.

XIII. THE MARCH OF PROGRESS

EARLY in the Sixteenth Century, before the art of the detached miniature was born, the delicate art of illuminating books had already received its death blow. The march of progress was its undoing. Following the invention of movable types in the middle of the Fifteenth Century, the printing industry spread rapidly over Europe, and books from these early presses were almost invariably illustrated by means of the cheap wood engraving. The older art did not die at once, however, and fully two generations after the printing of Gutenberg's Bible, illuminated books were still produced, books of such marvellous beauty as the Grimani Breviary and the Book of Hours of Hennessy.

In the middle of the Nineteenth Century, some four hundred years after the invention of printing, the miniature portrait in its turn received a knock-out blow as the world continued its ruthless advance. This time it was the marvellous cheapness and accuracy of the photograph—not to mention its delightful novelty—which made the competition of the artist impossible. In 1839, the secrets of Daguerre's process had been published in France, and the introduction of the dry collodion process by Scott Archer in 1851 was the beginning of modern rapid processes of photography. The well-known daguerreotype of Daniel Webster dates from this year.

America, at this time, presents a picture of bustling activity and of deep pre-occupation with the material problems of the rapidly developing continent. The aristocratic heritage of Colonial and early Republican days had given way before an aggressive democracy. The war with Mexico had brought about a further addition of territory, the McCormick reaper, invented in 1834, had simplified large-scale farming, steam navigation was well established on the sea as well as on inland waterways, and railways had attained a mileage of over ten thousand.

It was not a propitious time for the arts in America. Romantic gingerbread work had corrupted architecture, and portrait painting was at a comparatively low ebb. Among the miniaturists, there were none at work, excepting Staigg, whose calibre could

be compared with that of the men at the turn of the century, with such men as Robert Field, Walter Robertson, Malbone, and Trott. Saunders was probably dead or returned to England. Fraser was an old man who had ceased to paint. And now, what with the coming of the photograph, Cummings, as we have seen, definitely gave up the exhibiting, and probably gave up the painting, of miniatures though he continued active as a teacher and writer for another fifteen years. Staigg, whose career also was far from run to the end, now abandoned miniatures for oil painting. Sarah Goodridge retired to Reading, Massachusetts. Only MacDougall in Newark and John Henry Brown in Philadelphia continued to paint miniatures, and their work, or, at any rate, that of Brown, following the craze of the time, became more and more stupid and photographic.

"Photography has done and is doing much to banish mediocrity in portraiture," wrote Tuckerman[1] in 1867, "and it has in a great measure superseded miniature painting . . ." but "mechanical ingenuity and scientific success can never take the place of art; for the latter is a product of the soul." A few such portrait painters as Charles Loring Elliott, G. P. A. Healy, and Daniel Huntington did indeed continue to practise their art, and were eventually reinforced or else superseded by William Morris Hunt, Eastman Johnson, and others of the newer school. But the miniature in the presence of the photograph was like a bird before a snake: it was fascinated—even to the fatal point of imitation[2]—and then it was swallowed. It is only within a generation that a revival of interest in miniature painting has manifested itself and the public has begun to show signs, in this minor field, of tiring of its mechanical and almost exclusively black-and-white world, its world of books, newspapers, photographs, and motion pictures.

[1] See Henry T. Tuckerman, Book of the Artists, p. 398.
[2] For an interesting example, see Plate XXXV.

A BIOGRAPHICAL DICTIONARY
OF THE ARTISTS
by
THEODORE BOLTON

A BIOGRAPHICAL DICTIONARY OF THE ARTISTS
BY
THEODORE BOLTON

AMES, EZRA, b. May 5, 1768, Framingham, Massachusetts; d. February 23, 1836, Albany. Portrait painter in oils and miniature.

Ezra Ames was the youngest son of the six children of Jesse Emes or Ames and Bette (Bent) Ames. Jesse Ames was a farmer. While his son Ezra was still a minor, he moved his family to a farm at Staatsburg, New York.

By 1790, Ezra Ames was established as a painter of furniture and coaches. In December of the same year he recorded, in his memorandum book covering the years 1790 to 1802 and now owned by the New York Historical Society, his first commissions as an artist. These were two miniatures for which he received eighteen shillings each. In 1793 and 1794 he visited Albany and Staatsburg "several times." On October 6th of the latter year he married Zipporah Wood at Uxbridge, Massachusetts. He apparently made his home at Worcester until early in 1795, when he settled in Albany.

From the entries in his memorandum book, his livelihood was earned from his work as miniaturist, carriage and coach painter, frame gilder, plate letterer, and silver engraver. He records the painting of about twenty-five miniatures between 1794 and 1798 noting the names of the purchasers, but none of these has been identified to-day.

His first recorded work as a portrait painter in oils is his portrait of a Mr. Glen, for which he received four pounds in February, 1794. He painted his well-known, full-length portrait of Governor Clinton for the State of New York in 1813. He also painted a bust portrait of Governor Clinton which was engraved by Maverick.

The Albany Institute owns several of his portraits in oil as well as six miniatures.

Of his four children, one, Julius R. Ames, who was born January 1, 1801, is listed in the Albany directories as a miniature painter during 1834 to 1850.

See Dorothy C. Barck, "Ezra Ames, Painter," in *New York Historical Society Quarterly Bulletin*, January, 1927; W. Dunlap, *History of the Arts of Design*, New York, 1834, J. Windsor, *Narrative and Critical History of America*, Boston, 1885, Vol. VI, for information as to the Clinton Portraits; C. W. Bowen, *Centennial Celebration of the Inauguration of George Washington*, New York, 1892; D. M. Stauffer, *American Engravers upon Copper and Steel*, New York, 1907; T. Bolton, *Early American Portrait Painters in Miniature*, New York, 1921.

Bᴇɴʙʀɪᴅɢᴇ, Hᴇɴʀʏ, b. May 20, 1744, Philadelphia; d. there February, 1812. Portrait painter in oils and miniature.

Henry Benbridge was sent to Italy by his stepfather, Thomas Gordon, who was a well-to-do man. He studied at Rome under Mengs and Battoni. At the age of twenty-four he painted for James Boswell, a portrait of General Paoli which was exhibited in London. An engraving of this portrait published in London in 1769 gives the artist's name at the bottom as "Bembridge," an error that has been frequently repeated. In 1769, Benbridge studied in London, under West. A portrait he painted of Benjamin Franklin in 1770 and exhibited at the Royal Academy is now lost. The same year he returned to America and lived in Philadelphia. In 1773, he went to live in Charleston, South Carolina, frequently visiting Philadelphia. Some of the portraits he painted in Charleston are mistakenly attributed to Copley. Benbridge was in Norfolk about 1800.

See Articles by W. Roberts and C. H. Hart, *Art in America*, February and June, 1918.

Bɪʀᴄʜ, Wɪʟʟɪᴀᴍ Rᴜssᴇʟʟ, b. April 9, 1755, Warwick, England; d. August 7, 1834, Philadelphia. Etcher, engraver, and miniature painter in enamel.

Nothing is known of the early life of William Birch. In 1781 and 1782 he exhibited forty-one miniatures at the exhibition of the Royal Academy. He was employed by Sir Joshua Reynolds to make copies of his portraits in enamel. In 1785 he received a medal for excellence in his art from the Society of Arts. In 1791 he published his engravings after views by Wilson, Rowlandson, and other artists, which he called "Délices de la Grand Bretagne." In 1794 he came to the United States, settling in Philadelphia. Here he built himself a furnace and established his reputation as a miniature painter in enamel and as an engraver. He made about sixty enamel copies of Gilbert Stuart's portrait of George Washington besides his own original work. His two volumes of engravings of the drawings of scenes in Philadelphia are eagerly sought after by collectors. Extracts from his unpublished autobiography are printed in Anne H. Wharton's *Salons Colonial and Republican*.

See also *Dictionary of National Biography*, London, 1886; T. Bolton, *Early American Portrait Painters in Miniature*, New York, 1921; W. Dunlap, *History of the Arts of Design in the United States*, New York, 1834; D. M. Stauffer, *American Engravers upon Copper and Steel*, New York, 1907.

CATLIN, GEORGE, b. June 26, 1796, Wilkesbarre, Pennsylvania; d. December 23, 1872, Jersey City, New Jersey. Author and portrait painter in oils and miniature.

George Catlin studied law at Litchfield, Connecticut, and practised his profession in Philadelphia, but after a few years he gave up his law practice and devoted his time to painting. From 1832 to 1840, he travelled in the Yellowstone River region, Indian Territory, Arkansas, and Florida, painting the series of pictures of Indian life for which he is famous. Most of the 470 portraits of Indians that he painted in addition to the scenes of Indian manners and customs are now at the United States National Museum. The results of his travels he published in his well-known *Manners, Customs, and Condition of the North American Indians*, London, 1841. In 1852–1857 he travelled in South and Central America. From 1857 to 1871 he lived in Europe.

CLARK, ALVAN, b. March 8, 1804, Ashfield, Massachusetts; d. August 19, 1887, Cambridge, Massachusetts. Optician and portrait painter in oils and miniature.

Alvan Clark was the son of a farmer. He left his native town as a young man and went to Lowell, where he became an engraver for a calico printing works. From 1827 until 1836, he followed this branch of engraving in Providence, Fall River, and New York. The latter year, he settled in Boston, where he became a successful portrait painter in oils and miniature. His miniatures were all painted after 1835. About 1844, he began to manufacture telescopes. With the assistance of his sons, he established a factory at Cambridge called Alvan Clark and Sons. He made the first achromatic lenses in the United States. His son Alvan Graham Clark became a prominent astronomer.

See Royal Astronomical Society, *Proceedings*, Vol. XVII, No. 9; Appleton's *Cyclopædia of American Biography*; T. Bolton, *Early American Portrait Painters in Miniature*, New York, 1921.

COPLEY, JOHN SINGLETON, b. July 3, 1737, Boston; d. September 9, 1815, London. Historical, portrait, and miniature painter.

John Singleton Copley was the son of Richard Copley of Limerick, Ireland, and Mary Singleton of County Clare. Both parents were of English descent. The Copleys came to Boston in 1736. Richard Copley, who was a tobacconist, died at sea on a voyage to the West Indies shortly after the birth of his son. In 1748, according to the records of Trinity Church, Boston, Mrs. Copley married Peter Pelham, an artist. Young Copley was probably taught drawing by his stepfather, who died, however, when Copley was fourteen years old. At fifteen he had already painted his first portrait. His success, which came early, was such that Trumbull wrote in

1772, of his amazement at the style in which he lived. In 1766, Copley sent the portrait of his half-brother, Henry Pelham, known as The Boy with the Squirrel, to the Exhibition at Somerset House, London. He was elected Fellow of the Society of Artists the same year. In 1769 he married Susannah Clarke. From June to December, 1771 he painted portraits in New York making a short visit to Philadelphia the latter part of September. In 1773, to use his own words, he "expostulated with the Sons of Liberty against their proceedings" when they compelled his father-in-law, Richard Clarke, who owned the famous consignment of tea destroyed by the Boston Tea Party, to flee for his life. In June, 1774, he sailed for Europe never to return. By July he was in London. But he did not stay long and immediately began a tour of the Continent. In August, he was in Normandy. In September, he was in Paris, leaving on the 9th for the tour south with a travelling companion named Carter who has left a journal, long portions of which are quoted by Allan Cunningham in his *Lives of the Most Eminent British Painters and Sculptors.* Travelling by way of Lyons, Marseilles, and Genoa, they reached Rome in October where the travelling companions parted company after constant bickerings. On June 4, 1775, Copley left Rome for Parma, stopping at Florence and Bologna. At Parma he stayed long enough to copy a painting by Correggio. It was at this time that he wrote his half-brother, Henry Pelham, to resist conscription into the Colonial Army by force if necessary, adjuring him "for God Sake, don't think this a Triffling matter."

By the latter end of the year 1775, Copley was settled in London at 25 George Street, where he remained the rest of his life and where his son, the future Lord Lyndhurst and thrice Lord Chancellor of England, continued to live after his father's death. In 1779, Copley was elected a member of the Royal Academy, but his election was not sanctioned by the King until 1783. The following are titles of some of Copley's historical compositions: Watson and the Shark; The Death of Major Pierson; The Death of Chatham; and Charles II Demanding the Surrender of the Five Members.

See A. T. Perkins, *Sketch of the Life and a List of Some of the Works of John Singleton Copley,* Boston, 1873; M. B. Amory, *Domestic and Artistic Life of Copley,* Boston, 1882; *Masters in Art,* "Copley," Boston, 1904—illustrated; Massachusetts Historical Society Collections, 1914, *Letters and Papers of Henry Pelham and John Singleton Copley,* 1739–1776; F. W. Bayley, *Life of J. S. Copley,* Boston, 1915.

CUMMINGS, THOMAS SEIR, b. August 26, 1804, Bath, England; d. September 24, 1894, Hackensack, New Jersey. Miniature painter.

William Dunlap's account of Thomas Seir Cummings is, in part, as follows: "He is the only child of Charles and Rebecca Cummings. Shortly after Thomas' birth his father removed to Bristol, and from thence came to America, when our subject was yet in early childhood. . . .

When he was about fourteen years of age Augustus Earl, the traveller and painter, came to New York, and took part of the house (as an office) occupied by the father of Mr. Cummings. Earl saw the boy's drawings and encouraged him to proceed. His father placed him at the drawing school of J. R. Smith, and in 1821 he was received as a pupil by Henry Inman, who had but recently left the guidance (as an artist) of Jarvis. During three years' study with so excellent a master as Inman, Mr. Cummings became a painter in oil and water colours (or miniature), but preferred, and of course succeeded best in the latter, which he had made peculiarly his study. At the end of three years the teacher and pupil entered into a partnership, which continued three years, and a friendship was founded which is unbroken."

The partnership mentioned above was called Inman and Cummings, and upon its dissolution in 1827, Inman retired from the field of professional miniature painting in favour of the junior partner. The miniatures of Cummings were so ably painted that he found constant employment, and by 1822 felt independent enough to marry. His wife, who was an English girl named Jane Cook, bore him fourteen children.

Cummings also studied at the American Academy while John Trumbull was the president. Dunlap states: "In the year 1824–25, the American Academy again invited students to draw from casts, provided they came between the hours of six and nine, A. M. There was no keeper or instructor . . ." and Cummings and Frederick Agate were often refused admittance. Dunlap, seeing them turned off upon one occasion, was discussing the matter with a director when John Trumbull came into the room. The director mentioned the matter of the disappointment of Cummings and Agate, and Trumbull replied, "They must remember that beggars are not to be choosers." This situation led S. F. B. Morse, Cummings, and others to form another academy called the New York Drawing Association, which, in January, 1826, became the National Academy of Design. Cummings was treasurer of the National Academy from 1827 to 1865, vice president from 1850 to 1859, and chairman of the committee that erected the first building of the Academy.

In 1831, he was elected by the National Academy to a professorship in drawing, and when Winslow Homer first came to New York, in 1861, it was in the class of Thomas S. Cummings that he studied. The Lyceum of Natural History, the New York Gallery of Fine Arts, the American and Mechanics Institute, the Century Club, of which he was one of the founders and first treasurer, and the Old Sketch Club all owed much to his energy. The University of New York City also elected Mr. Cummings Professor of the Arts of Design, to fill the chair left vacant by the retirement of Professor Morse. At the same time Professor Cummings established his own successful School of Design.

In 1865, were published Cummings's *Historic Annals of the National Academy of Design*, which rank with William Dunlap's *History* in importance as a source book of information con-

cerning the early American artists. The year after the publication of this work, he moved to a farm near Mansfield, Connecticut, finally settling in Hackensack in 1889. His son, Thomas Augustus Cummings, also was an artist.

See H. W. French, *Art and Artists in Connecticut*, Boston, 1879; W. Dunlap, *History of the Arts of Design*, New York, 1834; H. T. Tuckerman, *Book of the Artists*, New York, 1867; T. Bolton, *Early American Portrait Painters in Miniature*, New York, 1921; T. S. Cummings, *Historic Annals of the National Academy of Design*, Philadelphia, 1865.

DICKINSON, ANSON, b. April 19, 1779, Milton, Litchfield County, Connecticut; d. there March 7, 1852. Portrait painter in miniature and oils.

Anson Dickinson was the son of Oliver Dickinson, Junior, who was born in 1757 and died in 1847. Oliver Dickinson painted a few portraits in oils, and two of his ten children, Anson Dickinson and Daniel Dickinson, inherited his artistic ability.

Starting life as a silversmith, Anson Dickinson turned finally to painting as a career and began painting miniatures about 1804. It is highly probable that he received some instruction in the art from Malbone. At all events he sat to Malbone for his portrait in 1804, and, during the sitting, according to a story that has been handed down, the funeral procession of Alexander Hamilton was passing by in the street below; but Malbone was so absorbed in his work that he would not allow Dickinson to get up and look out of the window at the scene. From 1805 to 1810, Dickinson was in Albany, and by 1811, he was back in New York. In 1818, he visited Canada. After 1840, he lived in New Haven and Hartford.

See T. Bolton, *Early American Portrait Painters in Miniature*, New York, 1921; H. W. French, *Art and Artists in Connecticut*, Boston, 1879; A. T. Gesner, *The Dickinson Family*, 1913; W. Dunlap, *History of the Arts of Design*, New York, 1834.

DODGE, JOHN WOOD, b. November 4, 1807, New York City; d. December 16, 1893. Miniature painter.

Dunlap writes: "With the common propensity of boys for *making pictures*, he bound himself apprentice to a sign painter at the age of seventeen, who was to instruct him in drawing, but was incapable. Young Dodge, however, instructed himself; and, borrowing a miniature from a friend, succeeded so well in copying it that he attempted painting from the life, and, as soon as free from his apprenticeship, he commenced miniature painting. He has succeeded by making nature his instructor, and now stands among the prominent professors of the art in New York." The miniature, of General Andrew Jackson by Dodge, painted from life in 1842, is the original from which the postage stamp of 1863 was engraved. Dodge also painted a portrait of Henry Clay in 1843. He was elected an Associate Member of the National Academy of Design in 1832.

DUNKERLEY, JOSEPH. Flourished 1784–87, Boston. Miniature painter.

Two notices in the *Independent Chronicle* of Boston for December, 1784, and February 17, 1785, were inserted by Joseph Dunkerley. In the first, he notes that he "still carries on his Profession of Painting in Miniature at his home in the North Square." In the second, he notes that he and John Hazlitt, the portrait painter who was the brother of William Hazlitt the essay-

ist, are going to start a drawing school "as soon as a sufficient number of scholars apply. N. B. Miniature Pictures executed in the neatest manner." The date of Dunkerley's activity is extended at least to 1787, which is the date of the miniature he painted of Mary Burroughs.

DUNLAP, WILLIAM, b. February 19, 1766, Perth Amboy, New Jersey; d. September 28, 1839, New York City. Dramatist, art historian, and portrait painter in oils and miniature.

William Dunlap vacillated between writing and painting almost all his life. Although he was the first important native American dramatist, his chief claim to fame is his *History of the Rise and Progress of the Arts of Design in the United States*, published in 1834. He knew many of the artists personally and corresponded with them directly for his information; so that what Vasari was to the Italian artists William Dunlap was to the American artists. In fact, "The American Vasari" is the title of an illuminating paper on William Dunlap by Theodore S. Woolsey published in the *Yale Review* for July, 1914.

As early as 1783, Dunlap made a portrait in crayons of George Washington. The next year he went to London with a letter to Benjamin West. He was a dilatory student spending but a brief period with West and an extended period wandering aimlessly about England. However, upon his return to America, he painted portraits successfully in New York City. From 1789 to 1805, he abandoned painting, entered civic affairs, became a merchant, and finally took to writing plays. His best play, *The Father of American Shandyism*, was produced in 1789. In 1798, he became the manager of the Park Theatre, where his play *André* was produced the same year. His enterprise contributed greatly to the development of the drama in the United States. Besides producing, he wrote or adapted more than sixty plays. His last play, *A Trip to Niagara*, was performed November, 1828, and published in 1830.

Failure and bankruptcy in 1805 had forced him to resume painting as a profession. In 1812, he had painted miniatures in New Haven without giving much satisfaction and told Gilbert Stuart about it shortly after. Stuart is said to have remarked: "Friend Dunlap, it appears to me the good people of New Haven may have had some cause." After 1821, he gained a reputation throughout the country by exhibiting large religious paintings and charging admission fees. Of these compositions his Death on the Pale Horse and Christ Rejected are the most famous. In 1830, he settled permanently in New York City. He was one of the founders of the National Academy of Design and its vice president from 1831 to 1838. The loss of one eye early in life handicapped Dunlap's work as an artist. Forty-eight of Dunlap's miniatures are listed in *Early American Portrait Painters in Miniature*.

Dunlap's *History of the Rise and Progress of the Arts of Design in the United States* was reprinted at Boston, in 1918, by Bayley and Goodspeed, who expanded the original work of two volumes to three. The new edition gives an exhaustive bibliography upon the subject of early

American artists. An extensive list of painters, sculptors, architects, and engravers working in this country before 1834 but not mentioned by Dunlap, forms a sixty-two page addenda. Other books by Dunlap are a *History of the American Theatre*, 1832; *George Frederick Cook*, 1813; and *Charles Brockden Brown*, 1815.

See also, Oral S. Coad, *William Dunlap*, New York, 1917.

ELOUIS, JEAN PIERRE HENRI, b. January 20, 1755, Caen, France; d. there, December 23, 1840. Portrait painter in oils and miniature.

The name Elouis is a Gallicized version of the German name von Ludwig. Jean Pierre Henri Elouis, or as he called himself in America, Henry Elouis, studied art under Restout in Paris and at the Royal Academy in London where he went in 1783. He exhibited at the Royal Academy in 1785, 1786, and 1787. At about the time of the outbreak of the French Revolution, he sailed for the United States, settling in Baltimore. In 1791, he was in Annapolis where Charles Willson Peale saw him and wrote: "he paints in a new stile," and wondered "if this gentleman so cried up will do better than Mr. Pine, whose reputation was equally cried up." In 1792, he settled in Philadelphia where he remained until 1799. During his life in that city he gave drawing lessons to Eleanor Custis, and Hart states (without giving his reasons) that he painted miniatures of George and Martha Washington. About 1799 to 1804 he travelled with von Humboldt in Mexico and South America. He returned to France in 1807. He exhibited portraits in oil at the Paris Salon from 1810 to 1819. In 1814 he was made curator of the Museum at Caen.

See *Pennsylvania Magazine of History and Biography*, 1911.

FIELD, ROBERT, b. about 1770 (?), Gloucester, England; d. August 9, 1819, Jamaica, West Indies. Portrait painter in miniature and oils.

Nothing is known of the life of Robert Field before he came to the United States except the fact that he was born in Gloucester. He sailed for Baltimore on the ship *Republic* in April, 1794, painting the Captain's portrait in miniature at sea. The same year he was both in New York and in Philadelphia.

He almost immediately engraved a portrait of George Washington, painted by Walter Robertson, an Irish miniature painter who accompanied Gilbert Stuart to America. This engraving, which has an ornate design running about it engraved by Barralet, is inscribed as being "Published by Walter Robertson, Philadelphia & New York 1st August 1795." The same year he was in Baltimore, where Thomas Twining, in his *Travels in America One Hundred Years Ago*, notes sitting to Field for his miniature. He also made an engraving of the Chandos Portrait of Shakespeare for the first American edition of Shakespeare's works, published in Philadelphia. His portrait in oils of Charles Carroll, which was engraved by Longacre, may be assigned to this period. John Pintard notes, in his journal for July 1, 1801, that Field was in Washington City and painted miniature portraits of Washington for fifty dollars apiece. Rembrandt Peale, in a letter quoted in full by E. B. Johnston in her *Original Portraits of Washington*, tells an entertaining story of his friend Robert Field and explains that "Field was an Englishman, painted in a beautiful style and commanded good prices."

In 1805, Field moved to Boston and frequented the gatherings at the home of Andrew Allen, the British Consul. He was constantly occupied. Charles Fraser notes his meeting with Field in the latter part of the year 1806 in a letter as follows: "There is a miniature painter there named Field, who associates with the first circles: He is a fine artist. I received many attentions from him."[1] While he was in Boston, Field published two engravings, one in 1806, after Trumbull's portrait of Hamilton, and another in 1807, after Stuart's portrait of Jefferson.

About May, 1808, Field sailed for Halifax, Nova Scotia, acting upon the advice of Sir John Wentworth. In the Halifax *Royal Gazette* for June of that year he advertised: "Robert Field at Alexander Morrison's, book seller, intends, during his residence in Halifax, to exercise his profession as portrait painter in oil and water colour, and in miniature, where specimens of his painting may be seen and his terms made known." Whereas Field worked largely in miniature in the United States, his work in Nova Scotia is mainly in oils. Among the first of his portraits in Halifax were portraits of members of the Rockingham Club which were later hung upon the walls of the Rockingham Inn, where the Club had rooms. He painted a portrait of Governor

[1] See Charles Fraser, by A. R. H. Smith and D. E. H. Smith.

General Sir John Cope Sherbrooke for the Government House in Halifax, which he also engraved and published in 1816. Other portraits of this period are of Sir George Prevost, William Bowie, Dr. John Haliburton, and Bishop Inglis. The last named is now in London at the National Portrait Gallery. Mr. Harry Piers, of Halifax, notes in his paper on "Artists of Nova Scotia," *Nova Scotia Historical Society Collections*, Vol. XVIII, that, "tradition in Halifax states that he was somewhat of a dandy and wore Hessian boots, with tassels at the tops." William Dunlap, who knew him, described him as follows: "He was a handsome, stout, gentlemanly man, and a favourite with gentlemen." He did not, as Rembrandt Peale wrote, go into the ministry.

He exhibited in London during 1818, and is listed as a portrait painter of Halifax. In the Nova Scotia *Royal Gazette* September 15, 1819, his death is recorded as follows: "Died at Jamaica August 9th, Robert Field, Esq., an Eminent Artist very much regretted."

See, Harry Piers, *Robert Field, Portrait Painter*, New York, 1927, which contains a full bibliography.

FRASER, CHARLES, b. August 20, 1782, Charleston, S. C.; d. there October 15, 1860. Portrait painter in miniature and oils.

Charles Fraser was born at Charleston in 1782, the youngest of fourteen children. His father, Alexander Fraser, was the son of a Scotsman who settled in South Carolina about the year 1700. Mary Grimke, his mother, was of German descent. The Fraser family genealogy is traced in the *South Carolina Historical Magazine*, Vol. V.

Charles Fraser had only just started school when his father died in 1791. Concerning his youthful days he wrote: "I date my earliest recollections of Charleston from about the year 1792; at which time it was completely surrounded with remains of its old revolutionary fortifications. . . . I was at this time a pupil in the Charleston College, which was kept in one of the old brick barracks." Miniatures and small water-colour paintings signed by Fraser date as early as this period. The next year he had as a school friend an English boy who later became one of the eminent American portrait painters. This was Thomas Sully, who later recorded his indebtedness to Fraser's instruction in art at this early period as follows: "His kindness and the progress made in consequence of it, determined the course of my future life." Two excellent water-colour sketches by Fraser, dated 1796, are reproduced in A. R. H. and D. E. H. Smith's *Dwelling Houses of Charleston*. Yet, in spite of these and other strong signs of his early artistic inclination, Charles Fraser's guardians trained him to be a lawyer. "This unfortunate error," he wrote years later in a letter printed by Dunlap, "by which the destiny of my life was directed or rather *mis-directed*, will ever be, as it has always been, a source of regret to me." He left college and entered a lawyer's office in 1798.

He read law assiduously for the next three years, but found time to draw during his scant

leisure. He must have met Edward Greene Malbone in or before the year 1800, since Washington Allston wrote: "On quitting college I returned to Charleston, where I had the pleasure to meet Malbone, and another friend and artist, Charles Fraser, who, by the bye, now paints an admirable miniature." In May, 1801, Allston and Malbone sailed for England to further their art studies under Benjamin West. Encouraged by their example, Fraser attempted the professional career of an artist. But at the end of three years he became so discouraged that he returned to the study of law, entering the office of John Julius Pringle, the Attorney General of the state.

He saw Malbone again upon that artist's last visit to Charleston from January to June, 1806. He saw him for the last time in the late summer of the same year at Newport. This was during an extended tour Fraser made of various Northern cities. In a letter dated September 5th, he tells of meeting Gilbert Stuart and Robert Field at Boston. He speaks in the same letter of excursions to Portsmouth, Salem, and Newburyport, and to New York City, where he called on John Trumbull. He also visited Philadelphia.

His trip to the North came at the end of his long course of legal studies. "He was admitted to the Bar[1] on the 19th of February, 1807, in the City of Charleston. . . . His master in the law, full of years and honours, began, about this time, to wind up his affairs at the Bar, and soon returned from the Attorney-Generalship. He well knew Mr. Fraser's integrity and ability; to him he entrusted much of his unfinished legal business, recommended him to his clients, and by his countenance and commendation, promoted the progress of his young friend." In the fall of 1810, Fraser helped to found the Conversation Club. For this Club he wrote his admirable "Remininscences of Charleston," which were published as a book in 1854.

In 1816 he again went on a visit to the North. After a stay at Stafford Springs, he made his headquarters in New York. In his letters he tells of excursions to Staten Island and Long Island. He was elected a trustee of the College of Charleston in 1817, and soon after he was appointed treasurer of the board of trustees. On the Fourth of July, 1818, he made an oration before the Cincinnati and Revolutionary Society. In the same year, having put by enough through eleven years' practice as a lawyer, he commenced painting professionally in miniature. His first commission was a portrait of Nathaniel Russell.

A letter written February 4, 1819, by S. F. B. Morse, and printed in *The Letters and Journals of S. F. B. Morse*, notes that "Mr. Fraser, Mr. Cogdell, Mr. Fisher of Boston, and myself meet here of an evening to improve ourselves"—drawing from a small collection of casts. In this year the Charleston Directory gives Fraser as an attorney-at-law with an office on Tradd Street, and although he abandoned law in 1818, Fraser is called an attorney-at-law in the city directory as late as 1831. In 1837–38 the directory finally gives his occupation as a

[1]See John Belton O'Neall, Bench and Bar of South Carolina, 1859.

"portrait painter" at 93 Tradd Street. Fraser was one of the directors of the short-lived South Carolina Academy of Fine Arts, established in 1821.[1] In 1824, he revisited Boston and again saw Gilbert Stuart, who was an admirer of Fraser's work. During Lafayette's visit to Charleston in 1825, Fraser was chosen by the city to paint his portrait in miniature, and a portrait of Francis K. Huger, which was presented to Lafayette as a memento of the episode at Olmutz.

During the summer of 1831 Fraser visited Hartford, Connecticut, according to Dunlap, and painted miniatures there. He extended his visit to Boston and saw Allston at Cambridgeport. In a letter by Allston to Cogdell, dated Cambridgeport, October 9, 1833, the writer states, "I have had a pleasant visit from Fraser; he brought with him several landscapes that do him honor." Admiration for the man and appreciation of his art led a number of prominent citizens to form an exhibition of Fraser's work in February, 1857, and the catalogue lists three hundred and thirteen miniatures and one hundred and thirty-nine oil paintings and sketches.

See W. Dunlap, *History of the Arts of Design in the United States*, New York, 1834; A. H. Wharton, *Heirlooms in Miniatures*, Philadelphia, 1898; *Art in America*, Vol. III, June, 1915: A. R. Huger Smith, "Charles Fraser, the Friend and Contemporary of Malbone"; A. R. Huger Smith and D. E. Huger Smith, *Charles Fraser*, New York, 1924, well illustrated; T. Bolton: *Early American Portrait Painters in Miniature*, New York, 1921, containing a check list of 337 miniatures by Fraser; C. Fraser, *Reminiscences of Charleston*, 1854; *Exhibition Catalogue of Miniature Portraits* "accompanied by a life of the artist." (Fraser) Charleston, South Carolina, 1857.

FREEMAN, GEORGE, b. April 21, 1789, Spring Hill, Connecticut; d. March 7, 1868, Hartford, Connecticut. Miniature painter on porcelain and ivory.

George Freeman, the son of a farmer who could not afford to give him proper training in art, was self-taught. However, he painted miniatures well enough to adopt the art as a profession. Among the earlier miniatures he painted are those of Mrs. Sigourney and several painted about 1810, which were, in 1879, in the possession of Mrs. H. B. Beach of Hartford, according to H. W. French. In 1813, he went to Europe, where he studied in Paris and London and also painted miniatures professionally. He lived for many years in London, where his work was in great demand and where he painted miniatures of Queen Victoria and Prince Albert.

Twenty-four years after leaving his native land, he "returned without warning," notes H. W. French, "and took dinner with his father, telling him he had met his son in London, without being recognized."

He painted many miniatures in Philadelphia, where among his sitters were Nicholas Biddle (1838), Mrs. Edward Biddle, and Dorothy Francis Willing. He also painted a miniature portrait of President Tyler.

[1]See Dunlap's History.

His miniatures are generally rectangular, and his signature, when he used it, was: "G Freeman."

See T. Bolton, *Early American Portrait Painters in Miniature*, New York, 1921; H. W.. French, *Art and Artists in Connecticut*, Boston, 1879; A. H. Wharton, *Heirlooms in Miniatures*, Philadelphia, 1898.

FULTON, ROBERT, b. November 14, 1765, Little Britain, Pennsylvania; d. February 23, 1815, New York City. Inventor and artist.

The father of Robert Fulton came from Kilkenny, Ireland, sometime before 1735. From 1782 to 1785 Robert Fulton painted landscapes in Philadelphia. In 1785, he is listed in the Philadelphia directory as a miniature painter. The next year he sailed for London and studied with Benjamin West. From 1791 to 1793, he exhibited at the Royal Academy and the Society of Artists.

Late in 1806, he returned to America after twenty years' absence. On August 11, 1807, the first successful steamboat, the *Clermont*, which he designed, went up the Hudson River from New York to Albany in thirty-two hours.

See A. C. Sutcliffe: *Robert Fulton*, 1909; H. W. Dickinson, *Robert Fulton, Engineer and Artist*, 1913.

GOODRIDGE, SARAH, b. February 5, 1788, Templeton, Massachusetts; d. December 28, 1853, Boston. Miniature painter.

Sarah Goodridge, or Goodrich as the name is sometimes spelled, was the sixth child of Ebenezer Goodridge and Beulah Childs. She stayed alternately with her brother or her father until she was seventeen. Then she taught a district school for two summers. After that, she went to Boston and lived with her sister Mrs. Thomas Appleton, until she was twenty-four. In the summer of 1812, she began her professional life as an artist at Templeton, where she made portraits in coloured crayons for fifty cents and in water colours for a dollar and a half. She returned to Boston in the autumn. Gilbert Stuart took an interest in her and sat to her several times. She visited Washington in 1828–29 and in 1841–42. In 1851, she bought a home in Reading, Massachusetts, and moved there with the Appletons. In 1853, while on a Christmas visit to Boston, she had an attack of paralysis and died three days later.

See A. C. Mason, *Life and Works of Gilbert Stuart*, 1879.

HALL, ANN, b. May, 1792, Pomfret, Connecticut; d. 1863, New York City. Miniature painter.

Ann Hall was the third daughter of Jonathan Hall of Pomfret. When she was very young, she received some slight instruction in miniature painting from Samuel King during a visit to Newport. William Dunlap, who gives an extended account of Ann Hall, quotes from a letter that she "received instruction in oil painting from Mr. Alexander Robertson, at that time and still an excellent teacher of painting. She painted some pleasing pictures in oil, but eventually relinquished it to devote herself more exclusively to miniature painting."

She became very proficient in her art and was finally elected the first woman member of the National Academy, to whose exhibitions she sent miniatures from 1845 to 1849.

See W. Dunlap, *History of the Arts of Design in the United States*, New York, 1834; T. S. Cummings, *Historic Annals of the National Academy*, Philadelphia, 1865; T. Bolton, *Early American Portrait Painters in Miniature*, New York, 1921.

Inman, Henry, b. October 28, 1801, Utica, New York; d. January 17, 1846, New York City. Portrait painter in oils and miniature.

Henry Inman, who moved to New York with his parents about 1812, became the apprentice to John Wesley Jarvis in 1814. Together the master and apprentice frequently visited the Southern cities during the winter. In 1822, they visited Boston. Being now emancipated from his apprenticeship, Inman married a Miss O'Brian and remained in New York for the next ten years, his studio being on Vesey Street. He was the vice president of the National Academy from 1826 to 1831, moving in the latter year or in 1832 to Philadelphia and shortly thereafter to Mount Holley, New Jersey, where he bought a farm. Because of lack of employment, he was soon forced to return to Philadelphia. There he was constantly occupied with portrait painting and also as partner in the lithographic firm of Inman and Childs until 1835, in which year he returned to New York. In 1838, he was again elected vice president of the National Academy, and was reëlected annually until a year before his death. In 1843, his health being broken, his friends James Lenox, Edward L. Cary, and Henry Reed commissioned portraits from him of Chalmers, Macaulay, and Wordsworth, so that he could go to England and have the advantage of a sea trip. After completing these commissions, he returned to New York, arriving in April, 1845. In an entry under December 9, 1846, T. S. Cummings, in his *Historic Annals*, describes a visit of the Academicians to the bedside of Henry Inman. In a later entry, a notice of his death is given, and later still, an account of the formation of an Inman gallery with admission charges to assist the artist's family. During the exhibition of his work, the burial procession of Inman was moving in a long silent line extending from Mulberry Street to Reade.

See W. Dunlap, *History of the Arts of Design in the United States*, New York, 1834; H. T. Tuckerman, *Book of the Artists*, New York, 1867; T. S. Cummings, *Historic Annals of the National Academy of Design*, Philadelphia, 1865; T. Bolton, *Early American Portrait Painters in Miniature*, New York, 1921.

JARVIS, JOHN WESLEY, b. 1780, South Shields, England; d. January 14, 1839, New York City. Portrait painter in oils and miniature.

The father of John Wesley Jarvis sailed for the United States and left him in the care of his maternal uncle, John Wesley, the founder of Methodism, after whom he was named. In 1785, the boy was taken to Philadelphia by his father. Later, he was apprenticed to the engraver Edward Savage, who at the time also employed David Edwin. He moved to New York with Savage in 1800, and after two years set up independently as an engraver on Frankfort Street. In 1804, he formed a miniature painting partnership with Joseph Wood, which lasted until 1809 or later.

In 1810, Jarvis visited Charleston, and in letters to his friend Henry Brevoort, Washington Irving mentions seeing Jarvis in Baltimore. The letters are dated January 13, March 16, and April 2, 1811. Jarvis is listed in the catalogue of the Pennsylvania Academy for 1813 and 1814 as from Baltimore. However, in the latter year, his name also appears in the New York directory for it was at this time that he painted his full-length portraits of heroes of the War of 1812 for the New York City Hall. Henry Inman became his apprentice, in 1814, and helped paint the backgrounds and; draperies in his pictures. At the end of the year, the master and apprentice went to New Orleans, the first of repeated visits during winters to that city. A lengthy description of Jarvis during a visit to New Orleans is given by Audubon in his *Ornithological Biography*. In 1822, Jarvis and Inman were in Boston, and when summer came, during a yellow-fever epidemic, Jarvis stayed at a farmhouse on Long Island. In 1830, Dunlap records visiting Jarvis at his room on Vesey Street. The same year, his name appears in the New Orleans directory as living at 48 Canal Street. In 1834, a stroke of paralysis partially deprived him of speech.

Jarvis had and cultivated the character of being an eccentric. His irregular life prevented him from accomplishing all he might have. He died in extreme poverty at the home of his sister. His son, Charles Wesley Jarvis, who was born in 1821 and died in 1868, was also a portrait painter in oils and miniature.

John Neal gives some account of Jarvis in a paper published in the *Atlantic Monthly* for December, 1868. Dunlap gives the longest account, but portions of it are omitted from the new edition of Dunlap's book.

MacDougall, John Alexander, b. 1810 or 1811(?) Livingston, New Jersey; d. 1894. Miniature painter and photographer.

John Alexander MacDougall was the son of a cabinet maker named Hugh MacDougall whose shop was at Broadway and Vesey Street. He studied art at the National Academy of Design, and from about 1840 to 1845 had a studio on Broadway. From 1841 to 1849, he exhibited miniatures at the National Academy. During this period, he is recorded as having "a wide acquaintance and many clients," among them Henry Clay and Charlotte Cushman. In 1846, he moved to Newark and opened a studio as a miniature painter and photographer on Broad Street. His photographic venture proved a failure in the panic of 1878.

For several winters he visited New Orleans (1839 e. g.), and Charleston, South Carolina, painting miniatures, and he was likewise employed for several summers at Saratoga Springs, New York. He is said to have been actively engaged as a miniature painter until about 1880. His son, Walt MacDougall, who became a famous cartoonist for the New York *World*, gives in his recent book of reminiscences[1] the following information concerning his father's shabby studio three flights up in Broad Street, Newark: "Father was a handsome man who rather resembled William Cullen Bryant. He was of attractive, lovable character and was an omnivorous reader. He had a remarkable avidity for new methods and ideas and constantly experimented with novelties in pigments, mediums, and papers. The latest of Newark's products, celluloid, appealed to him as a substitute for ivory in miniature painting, in which art he was then the leader in this country, having painted Edgar Allan Poe, Commodore Vanderbilt, and other celebrities, and he devoted much time to ascertaining the fitness of celluloid for the purpose.

"His studio was then the resort of a number of men who, whether young or old, all called him Jack, to my intense disgust and mortification. Here came constantly George Inness, with whom he often went sketching in the Orange Mountains; Thomas Moran, young and handsome, just back from the Colorado Cañon and then painting his great pictures, now in the Capitol at Washington. . . . A. B. Durand, the painter who, like Moran and Drake, had been an engraver and was then devoting all his talent to raising giant strawberries; Thomas Dunn English, who had written 'Ben Bolt,' but was then editing the *Register* in Newark, and Thomas A. Edison, who kept an electrical shop around the corner."[2]

Malbone, Edward Greene, b. August, 1777, Newport, Rhode Island; d. May 7, 1807, Savannah, Georgia. Portrait painter in miniature.

[1]"This Is the Life," New York, 1926.

[2]Part of the information in this note was supplied by Professor Robert Bruce MacDougall.

Captain Godfrey Malbone, a mariner of Norfolk, Virginia, settled in Newport before 1715 and built Mansion House in Thames Street, which, until its destruction by fire in 1766, was one of the most sumptuous in the vicinity. His son, John Malbone, born 1735, was the father of Edward Greene Malbone, the subject of this sketch. At the time of Malbone's birth, August, 1777, Newport was occupied by British troops, and the town was under martial law.

Mrs. Whitehorne, one of Malbone's three sisters, wrote an extended account of her brother, which was published by Dunlap in his *History*. Mrs. Whitehorne observes that he always possessed such "equanimity of mind that nothing ruffled or put him out of his course," and even at an early age he determined to study art in Europe as soon as he was old enough. Upon one occasion, he painted some scenery for the theatre in Newport. Then he became interested in drawing small portraits and appears to have had some hints on painting from Samuel King, painter and instrument maker of Newport. About the age of sixteen, Mrs. Whitehorne continues, he painted "upon paper, Thomas Lawrence, which was so universally admired by every person of taste who saw it, that his father could no longer shut his eyes to his decided talent." An attempt was made to apprentice the boy to a French artist in Philadelphia, but nothing came of the negotiations. "But this spirit of procrastination not being in accordance with the youth's feelings," continued Mrs. Whitehorne, "at seventeen he determined to throw himself upon his own resources. Communicating his plans to no one but myself, he proposed a visit to Providence, and immediately brought himself before the public as a miniature painter, and so warmly was he received, that several weeks passed away before he apprised his father of the step he had taken." The letter he wrote to his father, dated October 11, 1794, is published by R. T. H. Halsey in *Scribner's Magazine*, May, 1910.

He remained in Providence for thirteen months continuously employed, visiting Newport in 1795 to attend the burial of his father. Upon his return to Providence, he painted with such great success that Mr. Moore, the British Consul, invited him to England with every promise of success. However, the thought of his three sisters without support made him decide to remain rather than to take chances. Mrs. Whitehorne writes: "A friend now advised his going to Boston in 1796, to which he acceded, and was immediately introduced to, and found friends in many of the most distinguished characters." At this time he met a former acquaintance, Washington Allston, who wrote later, "I became acquainted with Malbone but a short time before he quitted Newport. . . . Our intimacy, however, did not begin till I entered college, when I found him established at Boston."

Malbone went to New York in 1797, where he "was liberally employed," and in the spring of 1798 he went to Philadelphia, "where he met equal success." The yellow-fever epidemic, Mrs. Whitehorne says, "obliged him to go into the country; even here he found full employment.

After this he passed his time alternately in different cities until 1800, the summer of which both Mr. Allston and himself passed in Newport, and perhaps it was the happiest of his life."

Charles Fraser wrote concerning Malbone to William Dunlap: "In the winter of 1800, he came to Charleston, where his talents and the peculiar amenity of his manners enhanced the attentions which he received from the hospitality of its inhabitants." Allston writes: "On quitting college I returned to Charleston, where I had the pleasure to meet Malbone, and another friend and artist, Charles Fraser." Dunlap quotes from one of Allston's letters which gives a glimpse of the friendship of the three artists: "Mr. Bowman was an excellent scholar, and one of the most agreeable talkers I have known. Malbone, Fraser, and myself were frequent guests at his table, and delightful parties we always found there."

About the middle of May, 1801, Malbone sailed for England with his friend Allston, arriving about the middle of June, 1801. Together they visited the great art galleries of London, according to J. B. Flagg in his *Life and Letters of Washington Allston*, and Allston was shocked that Malbone had no admiration for the old masters. After seeing the pictures of Titian, Veronese, Rembrandt, and others he pointed to a portrait by Sir Thomas Lawrence and said he would rather possess that than all the other pictures in the collection. For a short time in 1801 he studied drawing at the Royal Academy, Somerset House. A letter by Malbone written in London at this time and printed by Dunlap reads in part as follows: "Mr. West complimented Mr. Allston and myself, and tells us we shall excel in the art. Yesterday was the first time he had seen a picture of my painting; to-day he condescended to walk a mile and pay me a visit, and told me I must not look forward to anything short of the highest excellence. He was surprised to see how far I had advanced without instruction. . . . I have not painted many miniatures since I left Charleston: I am painting one now which I shall bring with me. It is 'The Hours,' the past the present and the coming." This miniature, based on a design by Samuel Shelley, the miniature painter, represents three young women in classical drapery. It is now at the Providence Athenæum. It is signed and dated August, 1801.

To carry out commissions in Charleston, Malbone sailed at the close of the year and reached that port in December, 1801. He quickly finished his engagements and, in 1802, sailed for Newport. After that, he visited most of the seaboard cities. In 1803, he was in New York City. In 1804, he was in Boston. He was still in Boston in the autumn of the next year, where Dunlap found him successfully following his profession. His price for a head was fifty dollars.

Malbone's health was at this time delicate. He suffered from phthisis, but, to quote Dunlap, "physical suffering did not change the mild and amiable temper of his mind, or impart any asperity to his manners. Eight hours of the four-and-twenty were devoted to the pencil, and those in which he mingled in society were not clouded by gloom or complaint. . . . I met Malbone at the house of Colonel David Humphreys, one of the aids of Washington and long Am-

bassador to Spain, and . . . the champagne notwithstanding, he showed me the method of preparing the ivory and furnished me with many valuable hints in addition." According to S. A. Drake's *Landmarks of Boston*, Malbone stayed, during his visit to that city, at a fashionable boarding house at the corner of Park and Beacon streets, kept by a Mrs. Carter, which was formerly the home of Thomas Amory.

Mrs. Whitehorne's letter to Dunlap continues: "He yearly contemplated another visit to Europe; but being so fully employed . . . he found it difficult to put his wishes to execution until 1805, when he sailed for Charleston in December with the intention of going to London the following spring. But alas! in March he took a violent cold which settled upon his lungs; his sedentary mode of life contributing greatly to hasten on the disease which proved so fatal that medical aid was vain." After painting numerous miniatures, he returned to New York in June, 1806.

Malbone remained but a short time in New York before going to Newport, where, according to Mrs. Whitehorne, "he appeared to recruit a little; laying aside his pencil, indulging in riding and exercises of various kinds." His friend Charles Fraser visited him during the summer. "Poor Malbone," he wrote to Charleston in October, "is not in a condition to paint." Malbone was very fond of hunting, and one day that autumn, while he was out shooting birds, he overexerted himself. "His physicians recommended a warmer climate," concluded Mrs. Whitehorne, "which he very reluctantly consented to try; . . . he accordingly started for Jamaica, December, 1806. The voyage not proving of any advantage, and finding himself rapidly declining, he was anxious to return, and took passage to Savannah, hoping to be able to reach Newport as soon as spring opened," but he died in Savannah, May 7, 1807, at the home of his cousin, Robert Mackay. He lies buried in the cemetery at Savannah, and the long inscription on his memorial stone is given in the *Macbeth Gallery Art Notes* for November, 1913.

Malbone has left two portraits of himself, one a portrait in oils which is now owned by the Corcoran Gallery of Art, and the other a miniature owned by Mr. R. T. Haines Halsey.

See *Analectic Magazine*, Vol. IV, 1815, pp. 225–27; W. Dunlap, *History of the Arts of Design*, New York, 1834; *Godey's Lady's Book*, Vol. XXXV, 1847, p. 119; H. T. Tuckerman, *Book of Artists*, New York, 1867; J. B. Flagg, *Washington Allston*, New York, 1892; A. H. Wharton, *Heirlooms in Miniatures*, Philadelphia, 1898; A. H. Wharton, *Salons Colonial and Republican*, Philadelphia, 1900; T. Bolton, *Early American Portrait Painters in Miniature*, New York, 1921; M. F. Sweetser, *Washington Allston*, Cambridge, 1876; R. T. H. Halsey in *Scribner's Magazine*, May, 1910.

PEALE, ANNA CLAYPOOLE, b. March 6, 1791, Philadelphia; d. there December 25, 1878. Miniature painter.

Anna Claypoole Peale inherited her talent from her father, James Peale, and from her maternal grandfather, James Claypoole. She painted in Philadelphia, Washington, New York, and Boston. She married twice and exhibited under three names: Anna Claypoole Peale, Mrs. Staughton, and Mrs. Duncan. Her first husband was the Reverend William Staughton, a popular preacher. Her second husband was General William Duncan. Some account of her life is given in Wharton's *Heirlooms in Miniatures*, where several of her miniatures are reproduced.

PEALE, CHARLES WILLSON, b. April 15, 1741, Saint Paul's Parish, Queen Ann's County, Maryland.; d. February 22, 1827, Philadelphia.

Naturalist and portrait painter in oils and miniature. At the age of thirteen, Charles Willson Peale was apprenticed to a saddler. At twenty he was released from what he called "a bondage of seven years and eight months, a release from labour from sunrise to sunset, and from the beginning of candlelight to 9 o'clock during one half of each year under the control of a Master." In 1761, he established himself as a saddler and in addition to this trade he was also coachmaker, watchmaker, and silversmith. In 1762, he married Rachael Brewer of Annapolis. His life is written in a delightful twenty-four-page account by Anne Hollingsworth Wharton in her *Heirlooms in Miniatures*, where extended extracts from Peale's autobiography are given.

He found time to be interested in painting, and during a business trip to Norfolk the sight of some paintings by Frazier led him to think seriously of art as a profession. He also received assistance from John Hesselius, who accepted one of the best of Peale's saddles in return for the instruction. In 1764, however, Peale became so engrossed in politics that he did not paint again until 1765, when he visited Copley in Boston. In 1766, he was painting in Virginia. The same year, several wealthy citizens of Annapolis, including Governor Sharp, got up a purse and sent Peale to London with letters to Ramsay and West. In 1769, he returned to America and painted both in Philadelphia and in New York, as well as in Maryland and Virginia. He was in Philadelphia during 1771 and 1772. In 1774, he rented a house in Baltimore and was constantly occupied until 1776, when he settled permanently in Philadelphia.

During the Revolution, Peale saw service as an officer of a company of infantrymen under Washington at Trenton and Germantown. At Valley Forge he found time to paint a portrait of George Washington and miniatures of many of his brother officers. Portions of Peale's diary covering his life as a soldier were published by H. W. Sellers in the *Pennsylvania Magazine of History*, 1914, Volume XXXVIII. In 1779, he was elected to the state legislature. In 1780, he bought a house in Philadelphia at the southwest corner of Lombard and Third streets. In 1784,

he established what was known as "Peale's Museum," later transferred to the hall of the Philosophical Society. It was moved again to Independence Hall in 1802. Besides its curiosities and specimens of natural history, the museum contained a series of portraits of eminent Americans by Peale and his son Rembrandt.

In 1790, Peale's first wife died, and in 1791, he married as his second wife Elizabeth de Peyster of New York. Shortly after his second marriage, he visited the Eastern Shore of Maryland. About 1795, he is said to have abandoned his brush in favour of his son Rembrandt and to have become more interested in natural history, painting portraits only to add to his museum collection. An important reference to his activity at this time in Washington City is given in *McClure's Magazine* for July, 1897.

His third wife was Hannah Moore of Pennsylvania. His children were Rembrandt, Rubens, Titian, Raphaelle, Sophonisba, Angelica Kauffman, Linnæus, and Franklin. E. L. Dider, in "A Family of Painters," published August 26, 1882, in the *American Magazine*, quotes from Rembrandt Peale's account of his father the following passage: "The last years of his life he luxuriated in the enjoyment of a country seat near Germantown, with hanging gardens, a grotto and a fountain and a hospitable table for his friends."

PEALE, JAMES, b. 1749, Chestertown, Maryland; d. May 24, 1831, Philadelphia. Portrait painter in miniature and oils.

James Peale was the younger brother of Charles Willson Peale. He was apprenticed to his brother as a saddler in Annapolis. During the Revolution, he served as an officer, rising to the rank of captain in the Continental Army. He was a member of the Maryland Society of the Cincinnati. Except for a period when he lived in the South, his life after the war was spent in Philadelphia. He had six children, and of these James, junior, Anna, Maria, and Sarah became artists.

His copies of the portrait by C. W. Peale of George Washington painted in 1787 are alluded to by his nephew Rembrandt Peale in his lecture on *Portraits of Washington* as follows: "This portrait, which was only a head size, was copied by my uncle James Peale on a larger canvas, adding the figure in military costume and an attendant with a horse in the background. The attendant is a portrait of himself. It is now the property of Mr. James Fenno, and was copied many times by my Father's Nephew, Charles Peale Polk."

Besides this portrait in oils, which was not painted from life, James painted several small-sized portraits of Washington, which undoubtedly were from life. One of these, a miniature on ivory painted at the time Washington sat to the Peale family in 1795, is now lost.

James Peale was a prolific painter of miniatures. His brother, Charles Willson Peale, painted a half-length portrait of him seated at a table, brush in hand, and his head turned toward the

spectator as if momentarily interrupted in the painting of two miniatures which are on a tilted drawing board before him. A glass of water and some of the implements of his crafts are near by.

PEALE, RAPHAEL (OR RAPHAELLE), b. February 17, 1774, Annapolis, Maryland; d. March 25, 1825, Philadelphia. Miniature and still life painter.

Raphael Peale was a son of Charles Willson Peale. His address and occupation are given in a catalogue of an exhibition at the Pennsylvania Academy of the Fine Arts as follows: "Portrait, miniature and Still Life Painter, 24 Powel between Fifth and Sixth Streets." He painted a profile in water colour of George Washington.

From 1796 to 1799, he joined with his younger brother Rembrandt in attempting to establish in Baltimore a portrait gallery of distinguished persons. After 1799, he followed his profession for some years in Philadelphia. In 1803, he painted in Norfolk, and in the following year, joined his brother Rembrandt in visiting Savannah, Charleston, Baltimore, and Boston. He also made some profile portraits, using the physiognotrace, and after his health declined in 1815 devoted himself to painting still life.

PEALE, REMBRANDT, b. February 22, 1778, Bucks County, Pennsylvania; d. October 4, 1860, Philadelphia. Historical and portrait painter.

Rembrandt Peale was the second son of C. W. Peale. In 1795, he and his father painted Washington from life in Philadelphia. About 1796-99, Rembrandt Peale, with his elder brother Raphael, was in Baltimore and later in Charleston, South Carolina, and other cities. The winter of 1799 he spent in Annapolis. He studied under West in London during 1802-03. In 1804, he was established in Philadelphia. In 1807 and 1809, he made two trips to Paris to paint portraits of distinguished men for "Peale's Museum."[1] During 1812-13 he was in Baltimore, during which period he experimented in illuminating gas and founded the Baltimore Gas Company. He was in Philadelphia, Boston, and New York during 1822-28. In 1828, he sailed for Europe. He first visited Paris and Naples; by 1829, he was in Rome, where he stayed a few months; he then revisited Paris; next he went to London, and returned finally to New York in September, 1830, publishing an account of his visit the following year. In 1832-33, he made a final visit to England, staying in London, Sheffield, and Liverpool. In 1834, he settled in New York. He succeeded Trumbull as the president of the American Academy and was a charter member of the National Academy. He settled permanently in Philadelphia some time before the year 1843, where, according to the directory, he is listed as a "Naturalist, Philadelphia Museum, home 6 South Penn Square." From 1849 to 1860, he lived on Vine Street. He published several books on art. His reminiscences, published in the *Crayon* during 1855-56, give much valuable information concerning the early American Artists.

[1] "Peale's Museum" in New York is described in Mrs. A. Royal's Black Book, 1828, Vol. II.

In addition to his portrait of Washington from life in 1795, Peale painted a composite likeness that has no merit as a document and little as a work of art. It is called the "Port Hole Portrait" because of the port hole painted about it as a frame. According to his own statement, he made seventy-nine replicas of this portrait and thirty-nine copies of his father's bust portrait of Washington.

PELHAM, HENRY, b. February 14, 1749, Boston; d. 1806, Kenmare River, Ireland. Engraver and portrait painter in oils and miniature.

Henry Pelham was the half-brother of John Singleton Copley. In a letter dated March 29, 1770, from Henry Pelham to Paul Revere, the writer protests: "When I heard that you was cutting a plate of the late Murder, I thought it impossible as I knew you was not capable of doing it unless you copied it from mine." This was apropos of the engraving of The Boston Massacre by Paul Revere. In a letter dated May 1, 1770, from Henry Pelham to Charles Pelham, the writer notes: "Inclosed I send you two of my prints of the late massacre." According to Mantle Fielding, in his *Dictionary of American Painters, Sculptors and Engravers*, "no such prints by Pelham are known"; the opinion of some writers is recorded that the water-colour versions of the scene are by Pelham and possibly might be the "prints" referred to. He left America at the time of the Revolution. In 1778, he was in England exhibiting two miniatures and a religious composition at the Royal Academy. The next year, he exhibited four miniatures. He then went to Ireland where he married a Miss Butler and exhibited at the Society of Artists in 1780. He illustrated Grose's *Antiquities of Ireland* with small engraved landscapes, and also made a map of County Clare. He was drowned in Kenmare River by the capsizing of a boat while acting as the supervisor, in the service of the Marquis of Lansdowne, of some engineering construction.

The letters and papers of Henry Pelham and John Singleton Copley from 1739 to 1776 were published as Volume LXXI of the *Massachusetts Historical Society Collections* in 1914. See also the same publication for 1866–67.

PETICOLAS, PHILIP A., b. 1760, Italy; d. 1843, Richmond, Virginia. Miniature painter.

He made several miniature copies of Gilbert Stuart's first portrait of Washington. His son, Edward F. Peticolas, was likewise a miniature painter.

Most of the miniatures by the elder Peticolas were painted in or about Richmond, and they are apt to be dated, and signed: P. A. Peticolas. A portrait of Philip Larus is so signed and dated: 1797 Winc-ter.

See T. Bolton, *Early American Portrait Painters in Miniature*, New York, 1921; W. Dunlap, *History of the Arts of Design*, 1918 edition.

PRATT, MATTHEW, b. September 23, 1734, Philadelphia; d. there, January 9, 1805. Portrait painter in oils and miniature.

Matthew Pratt was the son of Henry Pratt, a goldsmith who was a friend of Franklin. After serving an apprenticeship with his maternal uncle, James Claypoole, the portrait painter, which lasted for six years and eight months, he began painting independently in 1755, forming a partnership with Francis Foster. In 1757, he sailed, on a business trip, for Jamaica, where he remained six months. In 1760, he married Elizabeth Moore. In 1764, he went to London with John West, the brother of Benjamin West, and Elizabeth Shewell, to whom Benjamin was betrothed; and was present at the wedding. He remained two years and six months in London and eighteen months in Bristol, returning to Philadelphia in 1768. In 1770, he sailed for Ireland with his wife, who had to attend to an inheritance, returning to Philadelphia by June of the same year. In 1772, he painted portraits in New York. Tuckerman notes that Pratt painted between fifty or sixty portraits in New York.

Some autobiographical notes by Matthew Pratt were published in the *Pennsylvania Magazine of History*, Vol. XIX, 1895. See also *Harper's Weekly*, July 4, 1896, C. H. Hart, *A Limner of Colonial Days, Matthew Pratt.*

RAMAGE, JOHN, b. before 1763, Ireland; d. October 24, 1802, Montreal. Miniature painter.

According to Strickland's *Dictionary of Irish Artists*, Ramage entered the school of the Dublin Society of Artists in 1763. As early as 1775, he was a practising goldsmith and miniature painter in Boston. He was a second lieutenant in the Royal Irish Volunteers, organized in 1775 for the defence of that city. He went with his company to Halifax, Nova Scotia, in 1776, and later to New York, where he was commissioned in February 2, 1780, as Lieutenant of Company 7, City Militia. He remained in New York after the evacuation of the city by the British troops, and, according to the city directory, established himself as a miniature painter at 25 William Street.

Dunlap notes: "... he continued to be the best artist in his branch for many years after. Mr. Ramage occasionally painted in crayons or pastile, the size of life. His miniatures were in the line style, as opposed to the dotted. ... Mr. Ramage was a handsome man of the middle size, with an intelligent countenance and lively eye. He dressed fashionably and, according to the time, beauishly."

Ramage painted a miniature of George Washington, who notes the sitting in his diary for October 3, 1789, as follows: "Sat for Mr. Rammage near two hours to-day, who was drawing a miniature Picture of me for Mrs. Washington." According to an article by H. S. Stabler, called "Two Unpublished Portraits of Washington," in *McClure's Magazine*, February, 1894, a miniature by Ramage of Washington descending to H. S. Stabler and his brothers from Betty Washington is the original miniature from life.

In 1794, Ramage left New York for Montreal, according to F. W. Bayley in his *Little Known Early American Portrait Painters*. While in Canada, according to a letter published in Stabler's article aforementioned, he was put under guard for thirty days for speaking favourably of the American people.

ROBERTSON, ARCHIBALD, b. May 8, 1765, Monymusk, near Aberdeen, Scotland; d. December 6, 1835, New York City. Miniature painter.

There were three Robertson brothers, Alexander, Archibald, and Andrew, who were miniature painters, and two of them, Alexander and Archibald, came to the United States.

Archibald Robertson was a friend of both Raeburn and Weir in Edinburgh, and all three artists used the green room of the theatre as a studio. Robertson went to London in 1786, receiving instruction in miniature painting from Peacock and Sheriff. He also studied under West at the Royal Academy. In 1791, he came to New York. Emily Robertson, a niece of the artist, noted in a letter, printed in Wharton's *Heirlooms in Miniatures*, that he was invited to New York by Dr. Kemp of Columbia College, Chancellor Livingston and Dr. Samuel Bard,

through Dr. Gordon of King's College, Aberdeen. Hearing of his intended visit, the Earl of Buchan at Edinburgh requested that he take to George Washington a box made of part of the oak tree that sheltered William Wallace. Letters concerning the delivery of this box, as well as other information, are published in the *Century Magazine* for May, 1890. Robertson took advantage of the occasion of this visit to Philadelphia to paint a miniature portrait of Washington on a slab of marble which is now owned by the New York Historical Society. He settled permanently in New York City and established the Columbian Academy with his brother Alexander who came to the United States in 1792.

See also Dunlap, *History of the Arts of Design in the United States*, New York, 1834.

ROBERTSON, WALTER, b. 17—? Dublin, Ireland; d. 1802, Futtehpur, India. Miniature painter.

Walter Robertson is said to have been the son of a jeweller in Dublin. His brother, Charles Robertson, was likewise a miniature painter. He studied at the Dublin Society Schools which he entered in November, 1765, and by about 1768, he established himself as a miniature painter. He exhibited miniatures at the Society of Artists displays in Dublin from 1769 to 1775 and in 1777. About 1784, he went to London, returning to Dublin in 1792, where he was declared bankrupt. He had met Gilbert Stuart in London, and early in 1793, he took the same ship with him for the United States. For a time, he is said to have made copies in miniature from Stuart's portraits in oils.

In 1794, he painted a miniature from life of George Washington which was engraved by several artists, among them Robert Field, and which was reproduced in the *Century Magazine* for May, 1890. He also painted a miniature of Martha Washington which he engraved for Longacre's National Portrait Gallery, and a miniature of Alexander Hamilton which is now lost.

His first wife, whom he married in 1771, was Margaret Bently of Dublin. His second wife, whom he married in 1781, was Elinor Robertson.

His portrait in miniature by his brother Charles Robertson is in the National Gallery of Ireland. Strickland notes: "No miniatures which can be identified as his have been met with."

See T. Bolton, *Early American Portrait Painters in Miniature*, New York, 1921; W. G. Strickland, *Dictionary of Irish Artists*, Dublin, 1913; C. H. Hart, *Engraved Portraits of Washington*, New York, 1904.

ROGERS, NATHANIEL, b. 1788, Bridgehampton, Long Island; d. there, December 6, 1844. Miniature painter.

William Dunlap in his *History of the Arts of Design* devotes several pages to Nathaniel Rogers. In 1811, after Joseph Wood had severed his partnership with John Wesley Jarvis and was painting with great success at a studio on Broadway, Nathaniel Rogers became his pupil

but soon set up independently as a miniature painter at 86 Broadway. In 1818, he married Caroline Matilda Denison, daughter of Captain Samuel Denison of Sag Harbor. In 1825, failing health forced him to live largely on Long Island, but he found time to paint "most of the fashionables of his day," according to Cummings in his *Historic Annals of the National Academy*. He was elected a member of the National Academy in 1826 and later was retired as Honorary Member for non-residence.

SAUNDERS, GEORGE L., b. 1774, Kingshorn, Scotland; d. after 1848. Miniature painter.

George L. Saunders worked in Edinburgh and London. He was a pupil of Smeaton and exhibited in London during 1829–53. He painted Lord Byron and the Princess Charlotte. His miniatures are rather large in size. Graves, in his *Dictionary of Artists*, gives 1853 as the latest year Saunders was exhibiting in London. One art historian gives March 26, 1846, as the date of his death. However, Thomas Sully, writing in 1848 to his brother-in-law Professor Porcher, of Charleston, South Carolina, asks: "Has Fraser told you how Mr. Saunders, the miniature painter, has mended?" This, added to the fact that a number of American miniature portraits of Baltimore and Philadelphia people are signed "G. L. Saunders," would indicate that the artists spent some time in the United States. (See *Antiques* for August, 1925, where one of these miniatures is reproduced.)

SAVAGE, EDWARD, b. November 26, 1761, Princeton, Massachusetts; d. there July 6, 1817. Engraver and portrait painter.

The grandfather of Edward Savage also named Edward Savage, was born in Ireland, the son of a Frenchman named Abraham Sauvage, who left St. Algis, Picardy, on the Revocation of the Edict of Nantes. The father of Edward Savage, the artist, was Seth Savage.

Edward Savage is said to have been a goldsmith before turning to painting as a profession. In 1789–90 Washington notes in his diary sitting for his portrait to Savage, who was commissioned by Harvard University. In 1791, Savage studied under West in London, and may possibly have learned engraving at that time. Later he went to Boston and then, about 1794, settled in Philadelphia. In Philadelphia he employed as engravers David Edwin and J. W. Jarvis. In 1800, he moved to New York, where, in 1812, he became interested in the New York Museum. His collection in Boston was bought by E. A. Greenwood, and this, with additions, became the nucleus of the Boston Museum.

Edward Savage's portrait of Washington is owned by Harvard University. Of this portrait he made several replicas. He also painted the group portrait of Washington and his family. Miniatures by Savage are rare.

See C. H. Hart, "Edward Savage, Painter and Engraver," in the *Massachusetts Historical Society Proceedings;* and *Pennsylvania Magazine of History*, Vol. XXIX, 1905.

SIMES, MARY JANE. Flourished 1826–34, Baltimore. Portrait painter in oils and miniature.

Dunlap prints the following as a footnote to the chapter on Rembrandt Peale in his *History of the Arts of Design:* "Anna Peale, now Mrs. Staughton of Philadelphia, is well known as a miniature painter. Her sister, Sarah, residing in Baltimore (says my informant), practises the

boldest branch of portrait painting in oil, and their niece Mary Jane Simes, herself a living miniature, rivals her aunt in the same style."

Mary Jane Simes exhibited for several years at the Pennsylvania Academy. Her mother was James Peale's daughter Jane; her father was Samuel Simes. Baltimore directories, 1831–33, show her as living with her mother, who is listed as a music teacher, and her Aunt Sarah, the portrait painter. Their address was the southeast corner of Pleasant and Charles streets. Later they moved to Fayette near Hollyday Street, one block from Peale's Museum.

STAIGG, RICHARD MORRELL, b. September 7, 1817, Leeds, England; d. October 11, 1881, Newport, R. I. Portrait painter in oils and miniature; and crayon portrait draughtsman.

Richard Morrell Staigg, or Stagg as the name is sometimes spelled, worked in England as an architect's assistant about 1830–31. The latter year he came to the United States and settled in Newport, where he was encouraged by Allston to become an artist. Much of his work was done in Boston. His early work is exclusively in miniature on ivory and comparatively large in scale. His later work, which is in oils, includes genre subjects as well as portraits. Staigg was elected National Academician in 1861, and displayed his work annually at the Academy Exhibitions. In 1867–69 and 1872–74 he visited Europe. He settled finally at Newport, where, immediately after his death, a sale of his effects included twenty-five miniatures, one hundred and three oil paintings, as well as water colours. Twenty of Staigg's miniatures are listed in *Early American Portrait Painters in Miniature*, in which volume is also to be found a reproduction of his miniature of John Lothrop Motley. In the *Book of Artists*, by H. T. Tuckerman, there is mention of a "series of crayon heads of children remarkable for delicate accuracy and truth."

STUART, GILBERT, b. December 3, 1755, North Kingston, Rhode Island; d. July 27, 1828, Boston. Portrait painter.

As Gilbert Stuart is one of the greatest portrait painters that this country has produced, and as he has two large works written about him, the latest in four volumes, it is unnecessary here to do more than give the outstanding dates of his life, which, until recently, have not been stated accurately.

From 1768 to perhaps 1770, he attended school at Newport. In 1770 to perhaps 1772, he received casual instruction in art from Cosmo Alexander with whom he travelled South, probably in the autumn of the latter year, and whom he later accompanied to Scotland. He returned to Newport probably in 1774.

On the eve of the Battle of Bunker's Hill, not from any Tory inclination, so far as is known, perhaps to avoid conscription, but most probably to follow his bent as an artist, he sailed on June 16, 1775, for England.

In December, 1776, he wrote a letter to Benjamin West asking for his instruction and assistance. By 1777, he exhibited for the first time at the Royal Academy, and by 1782, he set up independently as an artist.

Late in October, 1787, he went to Dublin, Ireland, leaving about December, 1792, for the United States. In 1793 and 1794 he was painting in New York, leaving in November of the latter year for Philadelphia, where he painted his first portrait of George Washington. From the early spring of 1796 to 1803, he worked at Germantown, moving thence to Washington, where he remained until 1805. That year, after a short stay in Bordentown, he went to Boston, where he finally died.

See Lawrence Park, *Gilbert Stuart*, New York, 1926, 4 vols.; G. C. Mason, *Life and Works of Gilbert Stuart*, New York, 1879.

SULLY, THOMAS, b. June, 1783, Horncastle, England; d. November 5, 1872. Portrait painter in oils and miniature.

The parents of Thomas Sully were English actors who came to Charleston, South Carolina, in 1792. After a brief schooling at Charleston College, Thomas Sully entered an insurance office at an early age. Neglecting his work, he was soon sent to study art with a French miniature painter named Belzons, who was an uncle by marriage. In 1799, the master and pupil came to blows after a short period together, and Sully left for Norfolk, where he joined his brother Lawrence, who was a miniature painter. Adopting the same branch of the art, Thomas started painting professionally in 1801. In 1804, he went to Richmond, then to Petersburgh, and finally to North Carolina, where he married his brother Lawrence's widow. He lived in Richmond again until 1806, in which year he went to New York and received advice about painting from John Wesley Jarvis. He also called upon Trumbull for advice, but received far different treatment than he had from the eccentric but generous Jarvis. In 1807, he made a trip to Boston to see Gilbert Stuart, who gave him every assistance. In 1808, he was back in New York; in 1809, he was in Philadelphia; and during 1809–10 he was in London. Returning to Philadelphia in the spring of 1810, he made his home there from then on, although he frequently made visits to other cities, as the Register which he kept of his portraits shows. Thus, in 1818, he visited New York; in March, April, and November of 1820, he visited Baltimore; in 1821, he went to Virginia; from July to September of 1831, he was in Boston; he made a second trip to England from 1837 to 1838, at which time he painted a full-length portrait of Queen Victoria; from April to June, 1840, he was in Washington, D. C., from June to September of the same year, he visited Baltimore, and by December, he was in Boston. He visited Charleston during the winter of 1841–42 and in 1845–46, and he was in Providence in June, 1847, and in Boston in July, 1848. From April to June, 1849, and again in October, 1850, and June, 1851, he was in Richmond, Virginia, and his last recorded visits were those to Baltimore in October, 1852, and June, 1853.

The dates of these professional visits to other cities than Philadelphia may help in identifying further portraits by Sully which he failed to list in his Register.

His address in Philadelphia from 1828 until his death forty-four years later was 11 South Fifth Street, at the corner of Chestnut. A notice of his death appeared in the Philadelphia *Inquirer* for November 6, 1872.

At the memorial exhibition of portraits by Thomas Sully held at the Pennsylvania Academy of the Fine Arts in 1922, there were shown two hundred and thirty-five paintings. The catalogue of that display is well illustrated. In 1921, Edward Biddle and Mantle Fielding published their authoritative volume *Thomas Sully*, which lists more than two thousand portraits in addition to miniatures and several hundred fancy subjects. In addition to his portraits on a large scale, Sully painted in water colours both on ivory and on paper and also in oils on small-sized canvases. Long extracts from Sully's account of himself appeared in William Dunlap's *History of the Arts of Design*. Some recollections were published in *Hours at Home* for November, 1869.

THEÜS, JEREMIAH, b. before 1720, in Switzerland; d. May 18, 1774, Charleston, South Carolina. Portrait painter.

Jeremiah Theüs is said to have been one of three brothers who came from Switzerland in 1739 with the Swiss-German colonists who settled Orangeburg County, South Carolina. He soon established himself as an artist, for the next year he inserted the following advertisement in the *South Carolina Gazette* for August 30, "Jeremiah Theüs, limner gives notice that he is removed into Market Square, near John Laurens, Sadler, where all gentlemen and Ladies may have their pictures drawn, likewise Landscapes of all sizes, Crests and Coats of Arms for Coaches and Chaises. Likewise for the convenience of those who live in the country he is willing to wait on them at their respective plantations." He married Elizabeth Schaumlöffel in January, 1742, who died in 1754, leaving five children. He later married a widow, Mrs. Eva Hilt, by whom he had four children.

Portraits by Theüs were formerly frequently attributed to Copley. A portrait of Bolzius by Theüs was engraved. As Bolzius was a clergyman in Georgia, it is possible that Theüs made a visit to that state. More than seventy portraits by Theüs have been identified. John S. Dart, Johann DeKalb, William Elliott, Daniel Heyward, Gabriel Manigault, Stephen Mazyck, Robert Pringle, Samuel Prioleau, Daniel Ravenel, and James Skirving were some of the men whose portraits he painted.

See Robert Wilson, "Art and Artists in Provincial Carolina," in the *Charleston Year Book*, 1899; John Hill Morgan, "Notes on Jeremiah Theüs," in the *Brooklyn Museum Quarterly*, April, 1924, etc.

TROTT, BENJAMIN, b. about 1770, probably in Boston; still living in Baltimore in 1841. Portrait painter in oils and miniature.

According to Dunlap's *History*, Benjamin Trott probably came from Boston. The first definite information concerning him is that he was painting miniatures in New York about 1791 and left a few years later for Philadelphia to make miniature copies for Gilbert Stuart.

Dunlap notes: "Notwithstanding Stuart's approbation, Trott longed to be able to imitate the colouring of Walter Robertson; and I remember to have seen in his possession one of the Irishman's miniatures, half obliterated by the Yankee's experiments, who, to dive into the secret, made his way beneath the surface like a mole, and in equal darkness. He followed or accompanied Stuart when he removed from New York to Philadelphia; and that city was his headquarters for many years. His copies on ivory with water colours, from Stuart's oil portraits were good—one from 'Washington,' extremely beautiful and true."

About the year 1796, Trott accompanied Elkanah Tisdale on a visit to Albany, where they took a room and painted some heads.

In 1798, he moved to the Falls of the Schuylkill, where he had as neighbours David Edwin and Gilbert Stuart. The same year his name appears in the New York directory as a miniature painter living at Number 1 Wall Street.

"In 1805," according to Dunlap, "Mr. Trott visited the Western World beyond the mountains, travelling generally on horseback, with the implements of his art in his saddle-bags. This was a lucrative journey. He returned to Philadelphia in 1806, at which time I was there with my friend Charles Brockden Brown; and I became somewhat intimate with Trott, and pleased with the pungency of his remarks and amused by the eccentricity of his manners. At this time his reputation was at its height, and he might have commanded more employment than he did, but he was visited by a most mischievous notion, a disease of the mind, which occasionally affects painters—this was a firm conviction that some vehicle had been discovered for conveying colours to the ivory, which gave force, clearness and every good quality; but that it was kept secret by those who used it, and gave great advantages to certain colourists. . . . I must, however, acknowledge, that by his distillations and filterings he produced some of the cleanest pigments that ever I used; and he bestowed upon me specimens of all the necessary colours for miniatures."

The partially defaced inscription on the back of a miniature by Trott of Peregrine Wroth which is in Wroth's own handwriting runs as follows: "Peregrine Wroth Painted by Mr. Trott, Sansom . . . Philadelphia . . . Anno Domini 1806." Trott must have had simply a studio on Sansom Street, for, according to the Philadelphia directory for 1806, he lived at 231 Mulberry Street. In 1807, he moved to Sixth and Minor streets, where he stayed until 1801. In 1811 and 1812, he exhibited at the Pennsylvania Academy. From 1813 to 1819, he lived at 7 Little George Street, leaving in the winter of the latter year for Charleston, South Carolina. He again stayed for some years in Philadelphia, until, having made an unfortunate marriage, he moved to Newark, where he lived in obscurity for a number of years. In the New York directory for 1829–30 he is thus listed: "B. Trott, portrait and miniature painter. 15 Pine. Upstairs." In 1832–33 his address was 40 Arcade. He painted portraits in oils at this time, according to Dunlap, "with no success." In the Boston directory for 1833, his name appears as follows: "Benj. Trott, Miniature painter. 3 Scollay Buildings." C. H. Hart notes that he was painting in Baltimore in September, 1839, and his name appears once more in the Baltimore directory for 1840–41: "B. Trott portrait and miniature painter. Office cor. St. Paul and Fayette Sts." Twenty-six miniatures by Trott are listed in *Early American Portrait Painters in Miniature*, and several of his miniatures are reproduced in *Heirlooms in Miniatures*, by A. H. Wharton.

TRUMBULL, JOHN, b. June 6, 1756, Lebanon, Connecticut; d. November 10, 1843, New York City. Historical and portrait painter in oils and miniature.

Trumbull, the son of Jonathan Trumbull, governor of Connecticut, was educated in his native town and later at Harvard, where he graduated in 1773. Law and the ministry were both suggested by his father as possible careers. However, he went into the army. After witnessing the Battle of Bunker's Hill from the heights of Roxbury, as adjutant of the First Connecticut Regiment, he was appointed Deputy Adjutant General with the rank of Colonel under General Gates in June, 1776, accompanying his commander to Albany and Ticonderoga. In February, 1777, he received his commission, dated September, 1776, and indignantly resigned owing to the discrepancy in the time. He returned shortly to Lebanon and then went on to Boston, where he remained until 1779. In May, 1780, he sailed for Paris in a French ship of war, met Benjamin Franklin, who gave him a letter to West, and proceeded to London. While studying under West in London, he was seized and sent to prison as a retaliatory measure for the capture of André, in America, but was released through the intercession of Copley and West. He returned to America in June, 1781.

He was a contractor for army supplies at New Windsor on the Hudson in 1782–83. In 1784, he returned to London and studied with West. In 1785, he "made his first attempt at the composition of a military scene," to use his own words, and presently "began to meditate seriously the subjects of National history events of the Revolution," which he notes further, "became the great object of my life." The "Battle of Bunker's Hill" was the first subject decided upon. He visited Paris in 1785–86 and 1789, and in the latter year witnessed the destruction of the Bastille.

From 1789 to 1794, he lived principally in New York, visiting various cities, in the meanwhile, to obtain portraits for his historical dramas. Many of these small likenesses are now at Yale and may be taken to constitute his best work. The dates of his visits to various cities at this time are: 1790, Boston and Philadelphia; 1791, Charleston, S. C., Yorktown, Williamsburg, Richmond, and Fredericksburg; 1792, Philadelphia; 1793, Boston.

In May, 1794, he embarked for London with John Jay, acting as his secretary to the commission for the settlement of claims against Great Britain. In July, 1797, he visited Stuttgart to see Johann Gotthard von Müller, the engraver, who was making a plate of his Battle of Bunker's Hill. Passing through Paris on his way to England he was delayed by the authorities, who refused to grant him a passport. Finally the eloquence of the artist Louis David procured the passport from Talleyrand, and he returned to London. In 1804, after ten years in Europe, he left London for New York, but from 1808 to 1812 he was again in London. His latter years were spent for the most part in New York except for a four-years' (1837–41) visit to Dr. Silliman, in New Haven, where he wrote his *Autobiography*. In 1816, he became the president of the American Academy of Fine Arts. In 1831, he deposited his large collection of paintings at Yale University, receiving in return an annuity of $1,000.

Although he died in New York City, Trumbull was buried at one end of the Trumbull Gallery at Yale University. Goethe mentions, in a letter to Schiller dated August, 1797, seeing the painting, The Battle of Bunker's Hill, while it was being engraved in Stuttgart.

See T. S. Cummings, *Historic Annals of the National Academy*, Philadelphia, 1867; *Pennsylvania Magazine of History and Biography*, Vol XXXI, 1907; J. Trumbull, *Autobiography*, New York, 1841; W. Dunlap, *History of the Arts of Design in the United States*, New York, 1834; *New England Magazine*, January, 1896; T. Bolton, *Early American Portrait Painters in Miniature*, New York, 1921.

WATSON, JOHN, b. 1685, Scotland; d. August 22, 1768, Perth Amboy, New Jersey. Portrait painter.

John Watson was a Scotsman who came to the Colonies in 1715, settling at Perth Amboy. Upon a visit to Europe, he brought back a collection of pictures which Dunlap remarks constituted the first of its kind in America. It was later destroyed.

Watson was known to his neighbours as a miser and a usurer and a man of irascible disposition. William A. Whitehead reproduces in his *Contributions to the Early History of Perth Amboy* (New York, 1856) three small portraits by Watson, in pencil and India ink, of the artist himself and of the Rev. Edward Vaughan and Governor William Burnet. These belonged at the time to the author, together with similar portraits of Governor Keith of Pennsylvania and his Lady (now both belonging to the Historical Society of Pennsylvania) and of Governor Spotswood of Virginia and Judge Bunnel.

WEST, BENJAMIN, b. October 10, 1738, at what is now Swarthmore, Pennsylvania: d. March 10, 1820, in London. Historical and portrait painter.

Benjamin West was one of the ten children of John West and Sarah (Pearson) West.

An incident of West's youth that remains to be verified is the statement that he served in a company of volunteer soldiers under "Mad" Anthony Wayne. It is definitely known that he had established himself in Philadelphia as a portrait painter when he was eighteen years old. His next move was to New York, where, through the good offices of one of his sitters, a Mr. Kelly, he was enabled to sail for Italy. He arrived at Rome on July 10, 1760.

Here he remained several years, receiving generous financial assistance from Governor Hamilton and Chief Justice Allen, both of Pennsylvania. Before his Italian stay was over he was made a member of the academies of Parma, Florence, and Bologna.

He then went to England, arriving in London, June 20, 1763, and was met by three American friends, Chief Justice Allen, Governor Hamilton, and Doctor Smith of the College of Philadelphia, an indication of the esteem he early commanded.

In London, he took lodgings in Bedford Street, Covent Garden, and later in Castle Street. He finally rented a studio at Number 14 Newman Street, which he kept the rest of his life and which became the meeting place for most American artists visiting London. Shortly after he was comfortably settled, he sent for Elizabeth Shewell of Philadelphia, to whom he was engaged before going to Italy, and whom he married in 1764.

He painted huge historical canvases with general public applause, which is now, however, reserved for his work in portraiture.

See unpublished letters of Benjamin West, in *Pennsylvania Magazine*, Vol. XXXII,

1908; W. Dunlap, *History of the Arts of Design in the United States*, New York, 1834; Notes of Matthew Pratt in *Pennsylvania Magazine*, Vol. XIX, 1895; M. Fielding, *Dictionary of American Painters, Sculptors and Engravers*, Philadelphia, 1926.

WILLIAMS, HENRY, b. 1787, Boston; d. there, October 21, 1830. Engraver, pastellist, and portrait painter in miniature.

Henry Williams painted portraits and also engraved in stipple. Several of his portraits were engraved by Rubens Smith. An engraved portrait of Elias Smith by Williams was published at Portsmouth, New Hampshire, in 1816. In the *New England Palladium* for 1824, "H. Williams" advertised as a portrait and miniature painter, concluding with the following information: "He also continues to paint from the dead in his peculiar manner by masks." It is entirely possible that Henry Williams is the author of silhouettes signed "Williams" in a reverse manner.

William Dunlap, writing of the year 1813, notes: "Williams painted both in oil and miniature at this period in Boston. He was likewise a professor of electricity; and in addition modelled in wax. He was a small, short, self-sufficient man, very dirty, and very forward and patronizing in his manner." A portrait in wax by Williams of Eben Larkin is owned by the Worcester Art Museum.

See M. Fielding, *Dictionary of American Painters, Sculptors and Engravers*, Philadelphia, 1926; T. Bolton, *Early American Portrait Painters in Miniature*, New York, 1921

WOOD, JOSEPH, b. about 1778, Clarkstown, Orange County, New York; d. about 1832, Washington. Portrait painter in oils and miniature.

Joseph Wood was the son of a farmer who was also Sheriff of Clarkstown, New York. His early inclination toward art is indicated by the story that his father locked him up in the courthouse steeple, when he was a boy, because he neglected his work about the house for drawing.

Against the wishes of his father, he decided to become an artist, and with that end in view he started for New York, about 1794, with only a few dollars in his pocket. He wanted to paint landscapes, but chance turned his talents toward miniature painting, which happened in the following manner: after several years of struggling to exist, doing odd work in the winter and playing the violin in summer, he happened to see a miniature in the shop window of a silversmith, and he asked for permission to copy it. He worked as a silversmith for several years, continuing to paint during his odd moments. John Wesley Jarvis formed a miniature painting partnership with him in 1804 at 37 Chatham Street, and Dunlap records a visit to their studio during the winter of 1805–06 in the company of Malbone, from whom both artists received some slight assistance. Wood left Jarvis and set up independently somewhere between 1807

and 1811. In 1812–13, his address in the New York directory is given as 160 Broadway. The latter year his name also appears in the Philadelphia directory, with 93 South Third Street as his address. His name occurs in the Philadelphia directories until 1817, and also in the exhibition catalogues of the Pennsylvania Academy. He moved, sometime later, to Washington, and there, according to the directory, he had a studio in 1827 on the north side of Pennsylvania Avenue between 9th and 10th Streets. He is said by Hart to have painted also in Baltimore. Dunlap gives some account of Joseph Wood, but the most extensive information is to be found in the *Port-Folio* for 1811. Besides painting miniatures on ivory, Joseph Wood also painted cabinet-sized portraits in oil.

GENERAL BIBLIOGRAPHY OF EARLY AMERICAN MINIATURE PAINTING

GENERAL BIBLIOGRAPHY OF EARLY AMERICAN MINIATURE PAINTING

BAKER, William S. *The Engraved Portraits of Washington*, with biographical sketches of the painters. Philadelphia, 1880. Contains accounts of Field.

BAYLEY, F. W. *Little Known Early American Portrait Painters.* 4 pamphlets. Boston, 1915–17. Contains account of Ramage, etc. Illustrated.

BOLTON, Theodore. *Early American Portrait Painters in Miniature.* New York, 1921. A dictionary of early American portrait painters in miniature with check lists of their work. Illustrated.

CUMMINGS, Thomas S. *Historic Annals of the National Academy of Design.* Philadelphia, 1865. Ranks next to Dunlap's *History* in importance as a source book for information concerning early American artists.

DUNLAP, William. *History of the Rise and Progress of the Arts of Design in the United States.* New York, 1834, 2 vols. New edition, Boston, 1918. 3 vols. Illustrated. The most important source book for information concerning early American artists.

FOSTER, Joshua J. *Miniature Painters, British and Foreign*, with some account of those who practised in America in the Eighteenth Century. New York, 1903. 2 vols. Several illustrations after Malbone, Fraser, and Trumbull.

FRENCH, Harry W. *Art and Artists in Connecticut.* Boston, 1879.

HART, Charles Henry. Catalogue of the works of American artists in the collection of Herbert L. Pratt. Privately printed. New York, 1917.

JOHNSTON, Elizabeth B. *Original Portraits of Washington.* Boston, 1882. Accounts of Birch, Robertson, Field, *et al.* Illustrated.

KELBY, William. *Notes on American Artists, 1754–1820.* New York, 1922.

GENERAL BIBLIOGRAPHY OF EARLY AMERICAN MINIATURE PAINTING

RHODE ISLAND SCHOOL OF DESIGN Bulletin, July, 1918. American miniatures. Illustrated.

ROBERTSON, Emily. *Letters and Papers of Andrew Robertson.* 1895. Contains a treatise on miniature painting by Archibald Robertson.

STAUFFER, D. M. *American Engravers upon Copper and Steel.* New York, 1907. 2 vols. Many of the miniature painters were also engravers, and this work contains biographies of Field, Pelham, *et al.*

TUCKERMAN, H. T. *Book of the Artists.* New York, 1867.

WHARTON, Anne Hollingsworth. *Heirlooms in Miniatures.* Philadelphia, 1898. Deals almost exclusively with the early American miniature painters. Well illustrated.

WILLIAMSON, G. C. *The Miniature Collector.* London, 1921. Contains a chapter on the American miniature painters. Charles Fraser is called James Fraser. Richmond and Petersburgh, Virginia, are located in the state of Vermont. Eight pages. Four miniatures are attributed to Stuart.

INDEX

INDEX

Acheson, Major-General Thomas, portrait by Raphael Peale, 46.

Adams, John, portrait by Trumbull, 28.

Adams, Lewis, portrait by Trott, 42; ill. pl. XXV.

Allston, Washington, encouraged Clark, 66; mentioned, 38, 39, 42; quotation from, 37.

Ames, Ezra, biography of, 73; work by, ill. pl. XXXIV, XLIII.

Amory, Harcourt, Copley, self-portrait in pastels, property of. 25.

Amory, Mrs. Thomas, portrait by Malbone, 40; ill. pl. XXIV.

Anderson, Miss, portrait by Jarvis, 54; ill. pl. XXXIV.

Anthony, Joseph, portrait by Stuart copied by Trott, 41.

Appleton, Edward, Stuart miniature, formerly property of, 65.

Appleton, Mrs. Thomas, mentioned, 64.

Archer, Scott, mentioned, 68.

Armstrong, Edward, portrait by Rogers, ill. pl. XLII.

Armstrong, Col. and Mrs., portraits by W. Robertson, 32.

Barlows, portraits by Fulton, of the, 22.

Baron, Dr. Alexander, portrait by Fraser, 43; ill. pl. XXVIII.

Barralet, J. J., engraver, 31.

Barratt, Thomas E., work of, 45; ill. pl. XXXV.

Barrell, Joseph, portrait by Copley, ill. pl. IX.

Bartolozzi, engraving of, copied by Malbone, 38.

Bass, Sally, pastel portrait by Williams, 64.

Battoni, teacher of Benbridge and West, 22.

Bayley, F. W., mentioned, 31.

Beck, Paul, portrait by J. Peale, ill. pl. V.

Belzons, drawing master to Sully, 47.

Benbridge, Henry, biography of, 74; instructor of Sully, 48; work of, 22, 23; ill. pl. VII.

Bening, Alexander, mentioned, 8.

Bergh, Charles Edwin I, portrait by Catlin, 59; ill. pl. XXXV.

Biddle, Mrs. Edward, portrait by Freeman, 49.

Biddle, Nicholas, portrait by Trott, 42; ill. pl. XXV.

Biddle and Fielding, book on Sully, 48.

Bigelow, Mary Langrell (Mrs. Aaron Olmsted), portrait by Dunlap, 53.

Bingham, William, portrait by C. W. Peale, 19; ill. pl. III.

Birch, William Russell, biography of, 74; work of, 34; ill. pl. XIX.

Blackburn, possible teacher of Copley, 25.

Bleecker (?), Anthony, portrait by Tisdale, ill. pl. XIX.

Bleecher, Mrs. Nicholas, portrait by Malbone, 39.

Blight, Mrs. Robert Fulton, mentioned, 22.

Bogert, James, Jr., portrait by Inman, 57; ill. pl. XXXVII.

Boston *Independent Chronicle*, Dunkerley's professional notices in, 27.

Boston Museum of Fine Arts, 18, 64.

Bowdoin College, 65.

Britton, Eleanor, portrait by A. C. Peale, 46; ill. pl. XXXII.

Bromfield, Sally, fiancée of Pelham, 26.

Brooklyn Museum, Exhibition of Early American Paintings, 17.

Brown, Abijah, portrait by Raphael Peale, 44.

Brown, Charles Brockden, portrait by Dunlap, 53.

Brown, John Henry, mentioned, 69.

Brune, Mrs. John Christian, portrait by Simes, 47; ill. pl. XXXII.

Bulfinch, Mr. and Mrs. Charles, portraits by Dunkerley, 27.

Burns, Mr. and Mrs. Robert D., portraits by Simes, 47.

Burroughs, Henry, portrait by Williams, 64; ill. pl. XLIV.

Burroughs, Mary, portrait by Dunkerley, 27; ill. pl. X.

Byron, Lord, portrait by Saunders, 50.

Calvert, George, portrait by Oliver, 13.

Calvert, supposed to be Ariana, portrait by W. Robertson, 32.

Carlin, miniature by, ill. pl. XLI.

Cary, Mr. and Mrs. Samuel, portraits by Copley, 25; ill. pl. IX.

121